Christiane Paul is the Adjunct Curator of New Media Arts
at the Whitney Museum of American Art in New York and
Professor in the School of Media Studies, The New School,
New York. She has curated numerous exhibitions at the
Whitney Museum and internationally, written and edited books
on new media arts, and lectures widely on issues of art
and technology.

Thames & Hudson world of art

This famous series provides the widest available range of
illustrated books on art in all its aspects.

To find out about all our publications, including other titles in the
World of Art series, please visit **thamesandhudsonusa.com**.

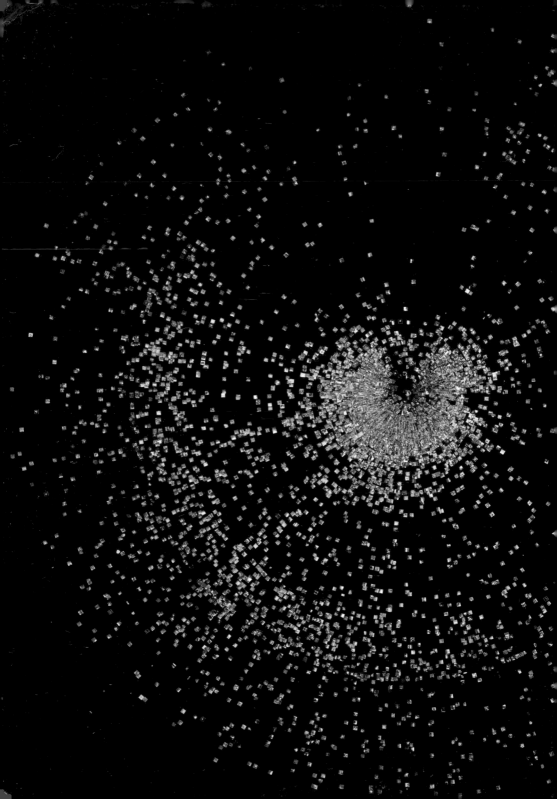

Digital Art

Christiane Paul

338 illustrations, 270 in color

 Thames & Hudson *world of art*

For my parents

Acknowledgments

My special thanks go to all the artists, curators, and critics who,
for over a decade, have generously shared their knowledge and ideas
with me. This book would not have been possible without them.

Digital Art © 2003, 2008 and 2015 Thames & Hudson Ltd, London

First published in paperback in the United States of America in 2003 by
Thames & Hudson Inc., 500 Fifth Avenue, New York, New York 10110

thamesandhudsonusa.com

Second edition 2008
Reprinted 2011
Third edition 2015

Library of Congress Catalog Card Number 2014949679

ISBN 978-0-500-20423-8

Printed and bound in China by Everbest Printing Co. Ltd

1. (title page) **Nadav Hochman,
Lev Manovich and Jay Chow**,
Phototrails.net, 2012. Radial image
plot visualization of 11,758 photos
shared on Instagram in Tel Aviv,
Israel, 25–26 April 2012.

Contents

2. **Jeffrey Shaw**, *The Legible City*
(Amsterdam), 1990

Introduction

From the 1990s to the early twenty-first century, the digital medium has undergone technological developments of unprecedented speed, moving from the 'digital revolution' into the social media era. Even though the foundations of many digital technologies had been laid up to sixty years earlier, these technologies became seemingly ubiquitous during the last decade of the twentieth century: hardware and software became more refined and affordable, and the advent of the World Wide Web in the mid-1990s added a layer of 'global connectivity'. Artists have always been among the first to reflect on the culture and technology of their time, and decades before the digital revolution had been officially proclaimed, they were experimenting with the digital medium. At first, the fruits of their labours were mostly exhibited at conferences, festivals, and symposia devoted to technology or electronic media, and were considered peripheral, at best, to the mainstream art world. But by the end of the century, 'digital art' had become an established term, and museums and galleries around the world had started to collect and organize major exhibitions of digital work.

The terminology for technological art forms has always been extremely fluid and what is now known as digital art has undergone several name changes since it first emerged: once referred to as 'computer art', then multimedia art and cyberarts (from the 1960s–90s), digital art now is often used interchangeably with 'new media art', which at the end of the twentieth century was used mostly for film and video, as well as sound art and other hybrid forms. The qualifier of choice here – 'new' – points to the fleeting nature of the terminology. But the claim of novelty also begs the question, what exactly is 'new' about the digital medium? Some of the concepts explored in digital art date back almost a century, and many others have been previously addressed in various 'traditional' arts. What is in fact new is that digital technology has now reached such a stage of development that it offers entirely new possibilities for the creation and experience of art. Some of these possibilities will be outlined here.

The term 'digital art' has itself become an umbrella for such a broad range of artistic works and practices that it does not

describe one unified set of aesthetics. This book will provide a survey of the multiple forms of digital art, the basic characteristics of their aesthetic language, and their technological and art-historical evolution. One of the basic but crucial distinctions made here is that between art that uses digital technologies as a tool for the creation of more traditional art objects – such as a photograph, print, or sculpture – and digital-born, computable art that is created, stored, and distributed via digital technologies and employs their features as its very own medium. The latter is commonly understood as 'new media art'. These two broad categories of digital art can be distinctly different in their manifestations and aesthetics and are meant as a preliminary diagram of a territory that is by its nature extremely hybrid. Definitions and categories can be dangerous in setting up predefined limits for approaching and understanding an art form, particularly when it is still constantly evolving, as is the case with digital art. Many artists, curators, and theorists have already pronounced an age of post-media and post-Internet that finds its artistic expression in works both deeply informed and shaped by digital technologies, yet crossing boundaries between media in their final form. While this book tries to be as inclusive as possible when it comes to the various manifestations of digital art, it still presents only a small selection of the broad range of digital work that has been created. Many of the forms and themes of digital art outlined in the following pages could easily be subjects of entire books of their own.

A short history of technology and art

For obvious reasons, the history of digital art has been shaped as much by the history of science and technology as by art-historical influences. The technological history of digital art is inextricably linked to the military-industrial complex and to research centres, as well as to consumer culture and its associated technologies (a fact that plays a prominent role in many of the artworks discussed in this book). Computers were essentially 'born' in an academic and research environment, and still today research centres play a major role in the production of some forms of digital art.

In 1945, *Atlantic Monthly* published the article 'As We May Think' by army scientist Vannevar Bush, an essay that had a profound influence on the history of computing. The article described a device called the Memex, a desk with translucent screens that would allow users to browse documents and create their own trail through a body of documentation. Bush envisioned

that the Memex's contents – books, periodicals, images – could be purchased on microfilm, ready for insertion, and that there would also be possibilities for direct data entry by the user. The Memex was never built, but it can be seen as a conceptual ancestor to electronic linking of materials and, ultimately, to the Internet as a huge, globally accessible, linked database. It was essentially an analogue device, but in 1946, the University of Pennsylvania presented the world's first digital computer, known as ENIAC (Electronic Numerical Integrator and Computer), which took up the space of a whole room; and 1951 saw the patenting of the first commercially available digital computer, UNIVAC, which was capable of processing numerical as well as textual data. The 1940s also marked the beginnings of the science of 'cybernetics' (from the Greek term *kybernetes*, meaning 'governor' or 'steersman'). American mathematician Norbert Wiener (1894–1964) coined the term for the comparative study of different communication and control systems, such as the computer and the human brain. Wiener's theories formed the basis for an understanding of the so-called man–machine symbiosis, a concept later explored by a number of digital artists.

3. **UNIVAC**, date unknown. The UNIVAC (Universal Automatic Computer) was used successfully to predict that Dwight D. Eisenhower would win the 1952 US presidential election.

The 1960s turned out to be a particularly important decade for the history of digital technologies – a time when the groundwork for much of today's technology and its artistic

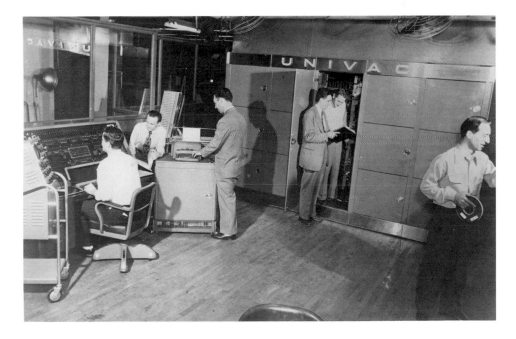

exploration was laid. Vannevar Bush's basic ideas were carried to a further level by American Theodor Nelson who, in 1961, created the words 'hypertext' and 'hypermedia' for a space of writing and reading where texts, images, and sounds could be electronically interconnected and linked by anyone contributing to a networked 'docuverse'. Nelson's hyperlinked environment was branching and nonlinear, allowing readers/writers to choose their own path through the information. His concepts obviously anticipated the networked transfer of files and messages over the Internet, which originated around the same time (and, indeed, the World Wide Web as a global network of linked webpages, which was developed in the 1990s). Earlier, in 1957, the USSR's launch of Sputnik at the height of the Cold War had prompted the United States to create the Advanced Research Projects Agency (ARPA) within the Department of Defense in order to maintain a leading position in technology. In 1964, the RAND corporation, the foremost Cold War think-tank, developed a proposal for ARPA that conceptualized the Internet as a communication network without central authority that would be safe from a nuclear attack. By 1969, the infant network – named ARPANET, after its Pentagon sponsor – was formed by four of the 'supercomputers' of the time: at the University of California at Los Angeles, the University of California at Santa Barbara, the Stanford Research Institute, and the University of Utah.

The end of the decade saw the birth of yet another important concept in computer technology and culture: the information space and 'interface'. In late 1968, Douglas Engelbart from the Stanford Research Institute introduced the ideas of bitmapping, windows, and direct manipulation through a mouse. His concept of bitmapping was groundbreaking in that it established a connection between the electrons floating through a computer's processor and an image on the computer screen. A computer processes in pulses of electricity that manifest themselves in either an 'on' or 'off' state, commonly referred to as the binaries 'one' and 'zero'. In bitmapping, each pixel of the computer screen is assigned to small units of the computer's memory, bits, which can also manifest themselves as 'on' or 'off' and be described as 'zero' or 'one'. The computer screen could thus be imagined as a grid of pixels that are either on or off, lit up or dark, and that create a two-dimensional space. The direct manipulation of this space by pointing or dragging was made possible by Engelbart's invention of the mouse, the extension of the user's hand into dataspace. The basic concepts of Engelbart and his colleague

Ivan Sutherland were further developed in the 1970s by Alan Kay and a team of researchers at Xerox PARC in Palo Alto, California, and resulted in the creation of the Graphic User Interface (GUI) and the 'desktop' metaphor with its layered 'windows' on the screen. The desktop metaphor would finally be popularized by Apple's Macintosh, 'the computer for the rest of us', as it was marketed by its creators in 1983.

Digital art did not develop in an art-historical vacuum either, but has strong connections to previous art movements, among them Dada, Fluxus, and conceptual art. The importance of these movements for digital art resides in their emphasis on formal instructions and in their focus on concept, event, and audience participation, as opposed to unified material objects. Dadaist poetry aestheticized the construction of poems out of random variations of words and lines, using formal instructions to create an artifice that resulted from an interplay of randomness and control. This idea of rules being a process for creating art has

4. **Marcel Duchamp**, *Rotary Glass Plates (Precision Optics [in motion])*, 1920. Duchamp's rotating device was an early example of interactive art. It requires the viewer to turn on the machine and stand at a distance of one metre.

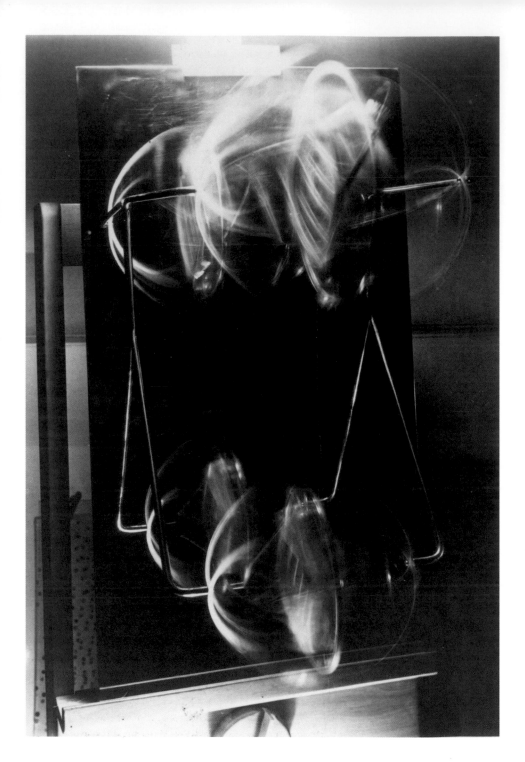

a clear connection with the algorithms that form the basis of all software and every computer operation: a procedure of formal instructions that accomplish a 'result' in a finite number of steps. Just as with Dadaist poetry, the basis of any form of computer art is the instruction as a conceptual element. The notions of interaction and 'virtuality' in art were also explored early on by artists such as Marcel Duchamp and László Moholy-Nagy in relation to objects and their optical effects. Duchamp's *Rotary Glass Plates (Precision Optics)* [4], created in 1920 with Man Ray, consisted of an optical machine and invited users to turn on the apparatus and stand at a certain distance from it in order to see the effect unfold, while the influence of Moholy-Nagy's kinetic light sculptures and his idea of virtual volumes – 'the outline or trajectory presented by an object in motion' – can be traced in numerous digital installations. Duchamp's work, in particular, has been extremely influential in the realm of digital art: the shift from object to concept embodied in many of his works can be seen as a predecessor of the 'virtual object' as a structure in process, and his readymades connect with the appropriation and manipulation of 'found' (copied) images that play a dominant role in many digital artworks. Duchamp himself described his work *L.H.O.O.Q.* (1919), a reproduction of the *Mona Lisa* on which he drew a moustache and goatee, as 'a combination readymade and iconoclastic dadaism'. The combinatorial and strict rule-based processes of Dadaist poetry also resurfaced in the works of OULIPO (Ouvroir de Littérature Potentielle), the French literary and artistic association founded in 1960 by Raymond Queneau and François Le Lionnais, who argued that all creative inspiration should be subject to calculation and become an intellectual game, and whose experimental concepts of combination compare to the reconfiguration of media elements in many later computer-generated environments.

The events and happenings of the international Fluxus group of artists, musicians, and performers in the 1960s were also often based on the execution of precise instructions. Their fusion of audience participation and event as the smallest unit of a situation in many ways anticipated the interactive, event-based nature of some computer artworks. The concepts of the 'found' element and instructions in relation to randomness also formed the basis of the musical compositions of vanguard American composer John Cage, whose work in the 1950s and '60s is most relevant to a history of digital art, and in many ways anticipated numerous experiments in interactive art. Cage described structure in

5. **László Moholy-Nagy,** *Kinetic sculpture moving, c.* 1933

6. **Nam June Paik**, *Random
Access*, 1963

music as 'its divisibility into successive parts', and often filled the predefined structural parts of his compositions with found, pre-existing sounds. Not surprisingly, Cage was an admirer of Duchamp's and paid homage to him in several of his pieces.

The element of a 'controlled randomness' that emerges in Dada, OULIPO, and the works of Duchamp and Cage points to one of the basic principles and most common paradigms of the digital medium: the concept of random access as a basis for processing and assembling information. American digital artist Grahame Weinbren has stated that 'the digital revolution is a revolution of random access' – a revolution based on the possibilities of instant access to media elements that can be reshuffled in seemingly infinite combinations. Korean artist Nam June Paik had anticipated this very idea in his 1963 installation *Random Access*, in which he stuck more than fifty strips of audio tape to a wall and asked users to 'play' the segments by means of a playback head that Paik had taken out of a reel-to-reel tape deck and wired to a pair of speakers.

Computers were used for the creation of artworks as early as the 1960s. Michael A. Noll, a researcher at Bell Laboratories in New Jersey, created some of the earliest computer-generated images – among them *Gaussian Quadratic* (1963) – which were exhibited in 1965 as part of the exhibition 'Computer-Generated Pictures' at the Howard Wise Gallery in New York. Bela Julesz, whose work was also included in the exhibition, and the Germans Georg Nees and Frieder Nake, were among the other early practitioners of the medium. Although their works resembled abstract drawings and seemingly replicated aesthetic forms of expression that were very familiar from traditional media, they captured essential aesthetics of the digital medium in outlining the basic mathematical functions that drive any process of 'digital drawing'. The works of John Whitney, Charles Csuri, and Vera Molnar in the 1960s remain influential today for their investigations of the computer-generated transformations of visuals through mathematical functions. Whitney (1917–96), widely considered 'the father of computer graphics', used old analogue military computing equipment to create his short film *Catalog* (1961) [8], a catalogue of the effects he had been working on for years. Whitney's later films *Permutations* (1967) and *Arabesque* (1975) secured his reputation as a pioneer of computer filmmaking. Whitney also collaborated with his brother James (1922–82), a painter, on several experimental films. Csuri, whose film *Hummingbird* (1967) [7] is a landmark of computer-generated

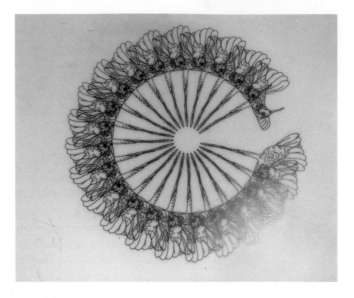

7. **Charles Csuri**, *Hummingbird*, 1967. This sequence, *22 Birds in a Circle*, was also produced as a print on plotter paper and silkscreened onto plexiglas.

8. (opposite, top) **John Whitney**, *Catalog*, 1961. Whitney's computer was a twelve-foot-high device that could process only pre-existing information. Images had to have been already drawn, photographed, and pasted together before the computer could perform its operations. The result was a seven-minute-long collection of computer graphic effects.

9. (opposite, bottom) **James Whitney**, *Yantra*, 1957. Influenced by psychologist Carl Jung's writings on alchemy, *Yantra*, which takes its name from a creation myth, was an attempt to depict visually a unity of cosmic and psychic states. The film consists of hand-drawn animation, rephotographed on an optical printer.

'animation', began creating his first digital images in 1964 with an IBM 7094 computer. The output of the IBM 7094 consisted of 4 × 7 inch 'punch cards' with holes, which contained information for driving a drum plotter, specifying when to pick the pen up, move it, and put it down, as well as when the end of a line had been reached, and so on.

As the industrial age made its transition into the electronic era, artists became increasingly interested in the intersections between art and technology. In 1966, Billy Klüver founded Experiments in Art and Technology (EAT), which – in Klüver's words – was formed out of a desire to 'develop an effective collaboration between engineer and artist'. The joint projects that were developed over a decade between Klüver and artists such as Andy Warhol, Robert Rauschenberg, Jean Tinguely, John Cage, and Jasper Johns were first seen in performances in New York and lastly at the Pepsi-Cola pavilion at the World Expo '70 in Osaka, Japan. EAT was a first instance of the complex collaboration between artists, engineers, programmers, researchers, and scientists that would become a characteristic of digital art. Notably, EAT also received creative support from Bell Labs, which became a greenhouse for artistic experimentation.

Predecessors of today's digital installations were also first exhibited in the 1960s. In 1968, the exhibition 'Cybernetic Serendipity' at the Institute of Contemporary Arts in London [10] presented works – ranging from plotter graphics to light

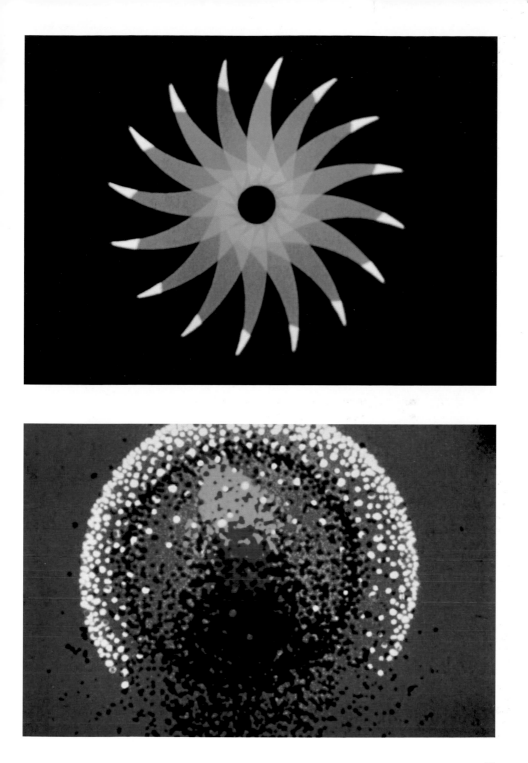

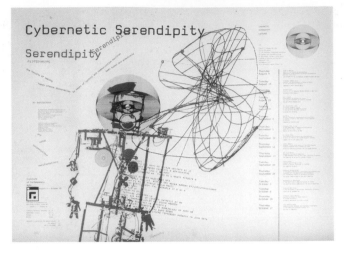

and sound 'environments' and sensing 'robots' – that now seem only like the humble origins of digital art (and could be criticized for their clunkiness and overly technical approaches), but which nonetheless anticipated many of the important characteristics of the medium today. Some works focused on the aesthetics of machines and transformation, such as painting machines and pattern or poetry generators. Others were dynamic and process-oriented, exploring possibilities of interaction and the 'open' system as a post-object. In his articles 'Systems Aesthetics' and 'Real Time Systems' (published in *Artforum* in 1968 and 1969, respectively), American art historian and critic Jack Burnham explored a 'systems approach' to art: 'A systems viewpoint is focused on the creation of stable, on-going relationships between organic and non-organic systems.' In modified form, this approach to art as a system still holds a noticeable position in today's critical discourse on digital art. In 1970, Burnham curated an exhibition called 'Software' at the Jewish Museum of New York, which included works such as the prototype of Theodor Nelson's hypertext system *Xanadu*.

Using 'new technology' such as video and satellites, artists in the 1970s also began to experiment with 'live performances' and networks that anticipated the interactions now taking place on the Internet and through the use of 'streaming media', the direct broadcast of video and audio. The focus of these projects ranged from the application of satellites for extending the mass dissemination of a television broadcast to the aesthetic potential of video teleconferencing and the exploration of a real-time

11. **Douglas Davis**, *The Last 9 Minutes*, 1977

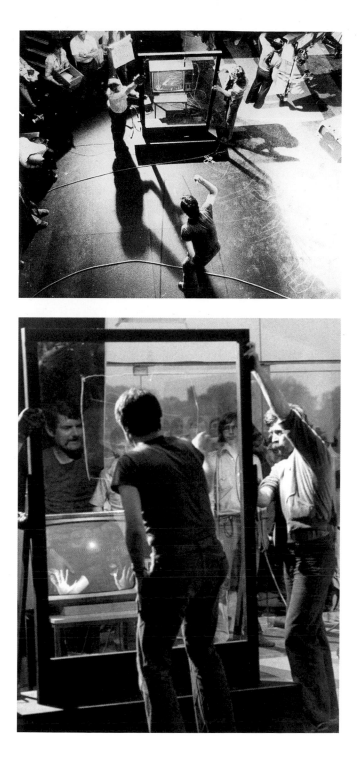

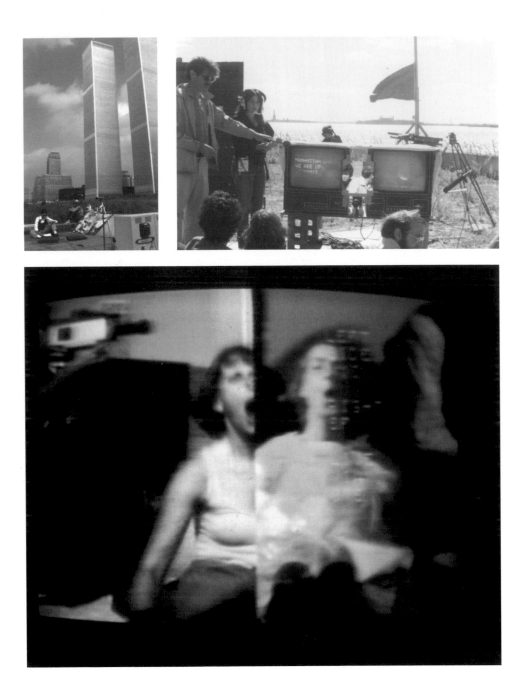

virtual space that collapsed geographic boundaries. At the Documenta VI art show in Kassel, Germany, in 1977, Douglas Davis organized a satellite telecast to more than twenty-five countries, which included performances by Davis himself, Nam June Paik, Fluxus artist and musician Charlotte Moorman, and German artist Joseph Beuys. In the same year, a collaboration between artists in New York and San Francisco resulted in *Send/Receive Satellite Network*, a fifteen-hour, two-way, interactive satellite transmission between the two cities. Also in 1977, what became known as 'the world's first interactive satellite dance performance' – a three-location, live-feed composite performance involving performers on the Atlantic and Pacific coasts of the United States – was organized by Kit Galloway and Sherrie Rabinowitz, in conjunction with NASA and the Educational Television Center in Menlo Park, California [13]. The project established what the creators called an 'image as place', a composite reality that immersed performers in remote places into a new form of 'virtual' space. In 1982, the Canadian artist Robert Adrian, who began working with communication technology in 1979 and created projects involving fax, slow-scan TV, and radio, organized the event *The World in 24 Hours*, in which artists in sixteen cities on three continents were connected for twenty-four hours by fax, computers, and videophone and created and exchanged 'multimedia' artworks. These performative events were early explorations of the connectivity that is an inherent characteristic of networked digital art.

Throughout the 1970s and '80s, painters, sculptors, architects, printmakers, photographers, and video and performance artists increasingly began to experiment with new computer imaging techniques. During this period, digital art evolved into multiple strands of practice, ranging from more object-oriented work to pieces that incorporated dynamic and interactive aspects and constituted a process-oriented virtual object. Expanding on the concepts of movements such as Fluxus and conceptual art, digital technologies and interactive media have challenged traditional notions of the artwork, audience, and artist. The artwork is often transformed into an open structure in process that relies on a constant flux of information and engages the viewer/participant in the way a performance might do. The public or audience becomes a participant in the work, reassembling the textual, visual, and aural components of the project. Rather than being the sole 'creator' of a work of art, the artist often plays the role of a mediator or facilitator for audiences' interaction with and

12. **Keith Sonnier and Liza Bear,** *Send/Receive Satellite Network: Phase II,* 1977

contribution to the artwork. The creation process of digital art itself frequently relies on complex collaborations between an artist and a team of programmers, engineers, scientists, and designers. (Several digital artists are also engineers by training.) Digital art has brought about work that collapses boundaries between disciplines – art, science, technology, and design – and that originates in various fields, including research-and-development labs and academia. From its history to its production and manifestation, digital art tends to defy easy categorization.

As has often been the case, concepts – and sometimes even specifics and aesthetics – of new technologies are partly shaped by science-fiction writers who create visions of a technologized world that are compelling enough to inspire their re-creation in reality. In 1984, William Gibson published his now-legendary novel *Neuromancer* and coined the term 'cyberspace' for a data world and network that people could experience as an organic informational matrix. Today's networked cyberspace is far away from Gibson's vision, but his *Neuromancer*, as well as Neal Stephenson's novel *Snow Crash*, for decades informed the dream and sensibilities of the virtual spaces that were built.

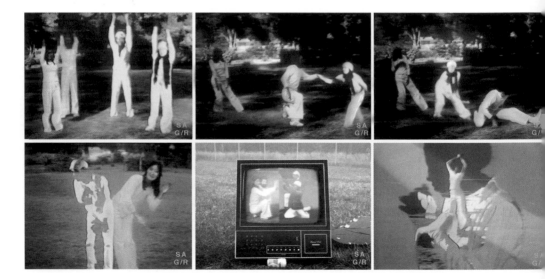

13. **Kit Galloway and Sherrie Rabinowitz**, *Satellite Arts*, 1977

The presentation, collection, and preservation of digital art

Digital art made its official entry into the art world only in the late 1990s, when museums and galleries began increasingly to incorporate the art form into their shows and dedicate entire exhibitions to it. Although there had been a number of digital and media art exhibitions over the decades, and some galleries had consistently presented this art, digital-art shows in an institutional context mostly took place at media centres and museums such as NTT's Intercommunication Center (ICC) in Tokyo or the Center for Culture and Media (ZKM) in Karlsruhe, Germany. For the previous two decades, the main exhibition forums for digital art were the Ars Electronica festival (in Linz, Austria), ISEA (Inter-Society for Electronic Arts, based in Canada) and festivals such as EMAF (European Media Arts Festival, Osnabrück, Germany), DEAF (Dutch Electronic Arts Festival), Next 5 Minutes (Amsterdam, Netherlands), Transmediale (Berlin, Germany), and VIPER (Switzerland). At the beginning of the twenty-first century, an increasing number of exhibition spaces devoted exclusively to 'new media art' developed worldwide, from Europe to South Korea, Australia, and the United States.

Because of its characteristics, the digital medium poses a number of challenges to the traditional art world, not least in its presentation, collection, and preservation. Digital prints, photography, and sculpture are the kinds of object-oriented work for which museums are equipped, but time-based, interactive digital artworks raise numerous issues. These issues are to a large extent not medium-specific but apply to any time-based and interactive work, be it a video, a performance, or Duchamp's *Rotary Glass Plates*. However, such pieces have always been an exception rather than the rule in the mostly object-based art world. Digital art projects often require audience engagement and do not reveal their content at a glance. They are also often expensive to show and ideally require consistent maintenance. Museum buildings are mostly based on the 'white cube' model rather than being completely wired and equipped with flexible presentation systems. The success of an exhibit and the audience's appreciation of the art is invariably dependent on the effort that an institution puts into the exhibition, both in technical and educational respects.

The presentation of art created for the Internet within a public physical space tends to complicate matters even more. Internet art has been created to be seen by anyone, anywhere, anytime (provided one has access to the Net) and does not

need a museum to be presented or introduced to the public. In the online world, the physical gallery/museum context does not necessarily work as a signifier of status any longer. However, physical art spaces could nonetheless play an important role when it comes to Internet art – providing a context for the work, chronicling its developments, assisting in its preservation, as well as expanding its audience. Various models for presenting net art in an institutional context have been widely debated. Some people have argued that it should be presented only online and that 'it belongs on the Internet' – which is where it resides in any case. The question rather seems to be, should Internet access be possible in public spaces or only from home computers in a private setting? With the more recent developments in wireless technologies and mobile devices, the Internet has become increasingly accessible from any location. However, this does not erase the fact that Internet art often requires a relatively private engagement over a longer period of time. To create an environment for the latter experience, net art has often been presented in a separate area of a public space, which in turn raises the criticism of 'ghettoization'. The set-up in a separate 'lounge area' has the advantage of inviting people to spend more time with a piece, but it prevents the art from being seen in the context of more traditional media and entering into a dialogue with them. Ultimately, the exhibition environment should be defined by what an artwork requires. As the technology keeps developing rapidly and is increasingly integrated into our daily lives, we are in all likelihood going to see new ways of interacting with and relating to digital art.

The collection (and therefore the sale) of digital art is yet another topic that has been hotly debated since the art form began to register on the radar of the art market. The value of art – at least when it comes to the traditional model – is inextricably linked to its economic value, but the 'scarcity equals value' model does not necessarily work when it comes to digital art. It is less problematic when it comes to digital installations, which ultimately are objects, or software art (which sometimes comes with its own unique custom hardware). The model of limited editions established by photography has been adopted by some digital artists whose work consists mostly of software, and this has allowed their art to enter the collections of major museums around the world. In the context of collecting, Internet art is the most problematic form since it is accessible to anyone with a network connection. Nevertheless, net art is increasingly

being commissioned and collected by museums, with the source code of the work being hosted on the respective museum's server. A major difference between this and the museum's other holdings is that the work stays on view permanently and not only when the museum decides to mount it in a gallery.

The process of collecting art also entails the responsibility of maintaining it, which may be one of the biggest challenges that digital art poses. Digital art is often referred to as ephemeral and unstable, a label that is only partially accurate. Any time-based art piece, such as a performance, is essentially ephemeral and often continues to exist after the event only in its documentation. Process-oriented digital artworks certainly are ephemeral, but digital technology also allows for enhanced possibilities of recording the process of a time-based digital artwork. Bits and bytes are in fact more stable than paint, film, or videotape. As long as one has the instructions to compile the code – for example as a print-out on paper – the work itself is not lost. What makes digital art unstable are the rapid developments in hardware and software, from changes in operating systems to increasing screen resolution and upgrades of Web browsers. Basic preservation strategies are storage, collecting the software and hardware as it continues to be developed; emulation, 'recreating' software, hardware and operating systems through so-called emulators that simulate the original; migration, an upgrade to the next version of hardware/software; and reinterpretation, a 're-staging' of the work in a contemporary context and environment. Initiatives aimed at preserving digital art have been developed by governments, national and international organizations, as well as institutions. Among them are the Variable Media Network consortium, which brought forth the Archiving the Avant-Garde and the Forging the Future initiatives; DOCAM (Documentation and Conservation of the Media Arts Heritage); as well as the Media Matters consortium.

Digital art has made enormous developments since the early 1990s and there is no doubt that it is here to stay. The expansion of digital technologies and their impact on our lives and cultures will induce the creation of even more artworks that reflect and critically engage with this cultural phenomenon. Whether digital art will find a permanent home in museums and art institutions or exist in different contexts – supported and presented by a growing number of art-and-technology centres and research-and-development labs – remains to be seen however.

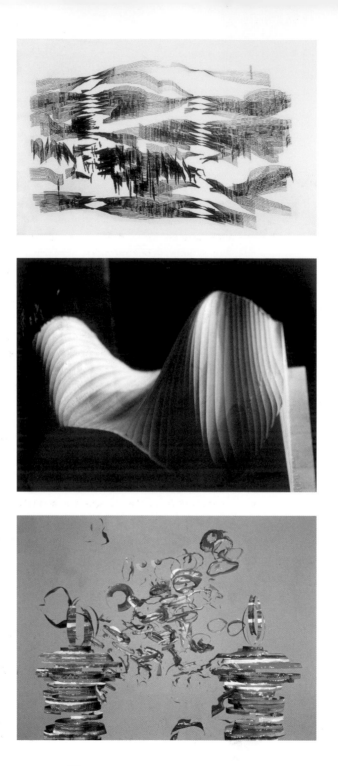

Chapter 1: Digital Technologies as a Tool

The use of digital technologies in almost every arena of daily life has vastly increased during the past two decades, leading to speculations that all forms of artistic media will eventually be absorbed into the digital medium, either through digitization or through the use of computers in a specific aspect of processing or production. It is certainly true that more and more artists working in different forms of media – from painting, drawing, and sculpture to photography and video – are making use of digital technologies as a tool of creation for aspects of their art. In some cases, their work displays distinctive characteristics of the digital medium and reflects on its language and aesthetics. In other cases, the use of the technology is so subtle that it is hard to determine whether the art has been created by means of digital or analogue processes. A work suggesting that it has been created through digital manipulation may have been created entirely by means of traditional techniques, while one appearing to be entirely handmade may have undergone digital processing. In both cases, however, these two kinds of work owe as much to the histories of photography, sculpture, painting, and video as to the use of digital technologies.

While not every work that makes use of digital technologies also reflects on those technologies' aesthetics and makes a statement about them, there are certain basic characteristics exhibited by the digital medium. One of the most basic of them is that this medium allows for multiple kinds of manipulation and a seamless combination of art forms, which can lead to a blurring of the distinctions between different media. Photography, film, and video have always entailed manipulation – for example, of time and place through montage – but in digital media, the potential for manipulation is always heightened to such a degree that the reality of 'what is' at any given point is constantly open to question. Recontextualization through appropriation or collaging, as well as the relationship between copy and original, are also prominent features of the digital medium. While appropriation and collaging, techniques originating with the Cubists, Dadaists, and Surrealists at the beginning of the twentieth century, have a long history in art, the digital medium has multiplied their

14. (opposite, top) **Charles Csuri**, *SineScape*, 1967

15. (opposite, centre) **Charles Csuri**, *Sculpture Graphic/Three Dimensional Surface*, 1968. Csuri used a mathematical function to generate the sculpture's surface. A punched tape contained the data, which was sent to a numerically controlled milling machine.

16. (opposite, bottom) **Charles Csuri**, *GOSSIP (Algorithmic painting)*, 1989. For this work, which won a prize at the Ars Electronica Festival in Linz in 1990, a painting of stripes was scanned and mapped onto three-dimensional models, which were then broken up through a function for fragmentation.

possibilities and taken them to new levels. Walter Benjamin's seminal 1936 essay 'The Work of Art in the Age of Mechanical Reproduction' discussed the impact of reproduction brought about by the then 'new' media of photography and film. For Benjamin, the presence of an artwork in time and space, 'its unique existence at the place where it happens to be', constituted the authenticity, authority, and 'aura' of the art object, all of which seemed to be jeopardized by the possibilities of mechanical reproduction and the creation of identical copies. The work of art in the age of digital reproduction, however, takes instant copying, without degradation of quality from the original, for granted. The digital platform also increases the accessibility of visual materials: images can be easily digitized through scanning and are readily available for copying or dissemination on the Internet. Whether the concepts of authenticity, authority, and aura are destroyed through these forms of instant reproducibility is debatable, but they have certainly undergone profound changes.

In this chapter, the use of digital technologies as a tool for the creation of art objects and their aesthetic impact will be discussed through the use of a few key examples. Since these technologies are now commonly used in art, an inclusive survey would probably have to comprise thousands of artworks. The works presented here are merely a selection that illustrates specific aspects of digital imaging and the digital production of art.

Digital imaging: photography and print

Digital imaging as it manifests itself in photography and print is a vast field, including works that have been created or manipulated digitally but then printed in the traditional way, as well as images that have been created without the use of digital technology but then printed using digital processes. In this section, these different techniques will be considered, with a special focus on the changes they have brought about in our understanding and reading of the visual image.

Early experiments with digital image creation and output, such as the works of American artist Charles Csuri, exhibit some of the essential characteristics of the computer medium, such as forms driven by mathematical functions and their repetition and reiteration. Csuri's *SineScape* (1967) [14] consisted of a digitized line drawing of a landscape that was then modified by a wave function in a procedure repeated about a dozen times. The original landscape thereby underwent a process of abstraction that made it appear as a notation of its own characteristics.

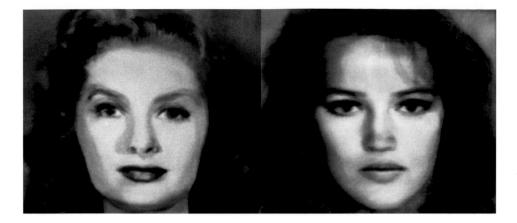

Abstract imagery consisting of formal variations driven by mathematical functions such as Csuri's constitutes one of the major strands of the early history of digital imaging. But computer technology has also been used for decades for the compositing of different forms of imagery, the overlaying or blending of visuals. Nancy Burson was among the pioneers in the field of computer-generated composite photographs, and made a major contribution to the development of the technique known as 'morphing' – the transformation of one image or object into another through composite imagery – which is now commonly used by law-enforcement agencies to age or alter the facial structure of missing persons or suspects. Burson's work has consistently addressed notions of beauty as defined by society and culture: her *Beauty Composites* (1982), which merge the faces of film stars Bette Davis, Audrey Hepburn, Grace Kelley, Sophia Loren, and Marilyn Monroe (*First Composite*) and Jane Fonda, Jacqueline Bisset, Diane Keaton, Brooke Shields, and Meryl Streep (*Second Composite*), are investigations into beauty that focus on the constituent elements of culturally defined ideals. The face literally becomes a topographical record of human aesthetics, a document and history of standards of beauty that at the same time suppresses individuality. The study and comparison of structural and compositional elements also played a major role in the work of Lillian Schwartz, who used the computer as a tool for the analysis of the works of artists such as Matisse and Picasso. Her famous image *Mona/Leo* (1987), a composite of the faces of Leonardo and the *Mona Lisa*, suggested a deceptively simple solution to the identity of the painter's subject while blurring the boundaries between the persona of the artist and his creation.

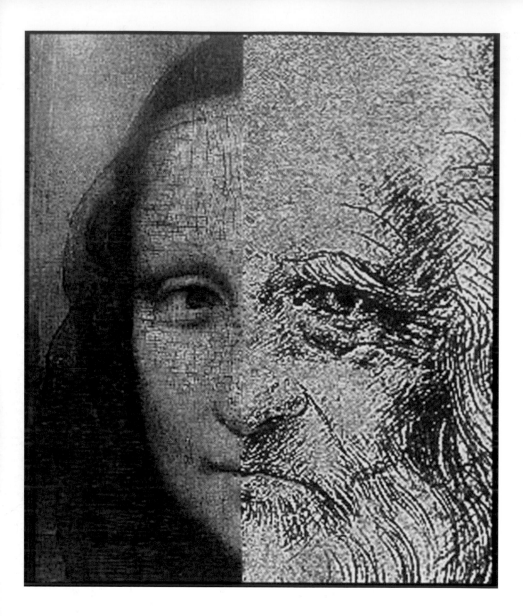

18. **Lillian Schwartz**, *Mona/
Leo*, 1987

19. **Robert Rauschenberg**, *Appointment*, 2000. The artist scanned a number of 35mm photographs, which had been printed using water-soluble pigments. After assembling the images in a collage, he applied water to their surfaces and separately transferred them to paper. The resulting copy was then photographed and processed as a traditional screenprint.

Digital technologies add an extra dimension to the composite and collage, for disparate elements can be blended more seamlessly, with the focus being on a 'new', simulated form of reality rather than on the juxtaposition of components with a distinct spatial or temporal history. Digital collages and composites often constitute a shift from the affirmation of boundaries to their erasure. American Robert Rauschenberg (1925–2008), the pioneer of collaged multimedia works, began to use computers to make his collages towards the end of his career. In his computer-generated images from collages of photographs, American artist Scott Griesbach (1967–2010) took collage's process of recontextualization to a further level by revisiting prominent players and moments of art history, often in the context of technology's absorption of art and ideas. His 1995 piece *Dark Horse of Abstraction* [20] depicts the four horsemen of the Apocalypse in

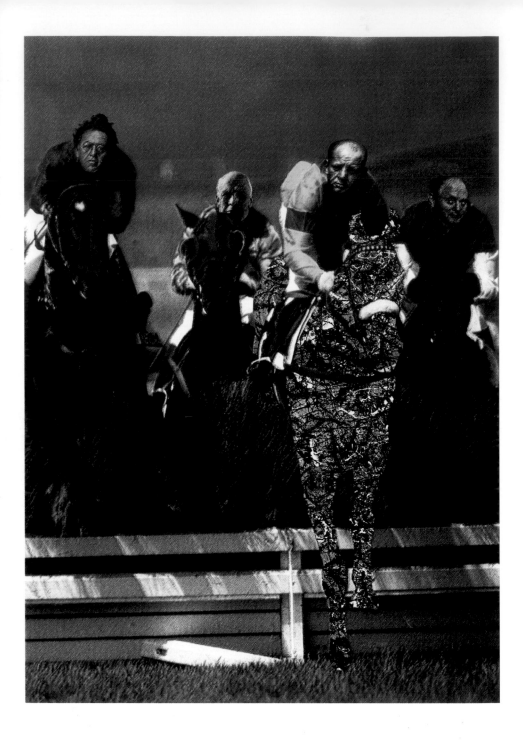

a steeplechase in which Jackson Pollock's abstract-expressionist horse is chased by artists such as Edward Hopper along 'the path of formalist evolution'. In a humorous way, Griesbach alludes to the pursuit of pure form in art and the opposing movements that both foreshadow and challenge it. The subtext of the assimilation of artistic ideas (through technology) is also present in Griesbach's digital photocollage *Homage to Jenny Holzer and Barbara Kruger* (1995). The image shows the two artists, both of whom played a major role in the artistic exploration of text and typography – particularly in relation to the strategies and politics of advertising – behind the wheel of a large vintage automobile.

The language of advertising is obviously closely connected to the history of image manipulation and the proliferation of imagery in a media society – which has increased with digital media and the Internet. In the aesthetics of advertising, the 'image' makes the fluent transition from mere representation to branding, in which is it is inscribed with a concept or value. This 'image consumer culture' has been taken to new levels by the possibilities of manipulation, compositing, and collaging enabled by digital processing, a fact that is frequently referenced in art. The

21. **Scott Griesbach**, *Homage to Jenny Holzer and Barbara Kruger*, 1995. In this work, Griesbach alludes to the impact of Kruger's and Holzer's artistic style, the 'head-on' provocation of questions about power as a motor of the human condition. For him, their art 'hits you like a truck'.

works of the team KIDing® – Angolan-born artist João António Fernándes (b. 1969) and Portuguese graphic designer Edgar Coelho Silva (b. 1975) – cross the boundaries between art and advertising with their concept of an 'art agency' and frequently satirize the aesthetics of advertising and branding. Their series *I Love Calpe* (1999) consists of out-of-focus images that, through colour and form (and the series' title), suggest 'holiday', in this case the tourist resort Calpe on the Spanish Costa Blanca. While the blurry images themselves can function only as vague carriers of meaning, their signification is immediately defined by the small corporate and advertising logos that are overlaid as thumbnails. The creation of meaning in these works reverses the language of advertising by erasing the suggestive power of the image and foregrounding the 'label'. The overlaid and inserted information does not seamlessly blend but deliberately disrupts the creation of the perfectly constructed image and its message. The language of advertising and mass entertainment also surfaces in the *Bollywood Satirized* series by British-born and US-based Annu Palakunnathu Matthew (b. 1964) whose work focuses on the politics of gender and race. Matthew's *Bomb* (1999) and *What Will People Think?* (1999) are 'Bollywood' posters that use the traditional visual language of the movie industry's 'dream factory'. Inscribed with text that draws attention to gender and cultural stereotypes as well as nuclear politics, Matthew's posters deconstruct the creation of message and context through visual images.

22. **KIDing®**, *I Love Calpe 5*, 1999

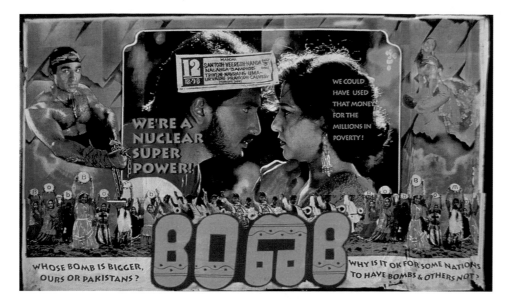

23. (top) **Annu Palakunnathu Matthew**, *Bollywood Satirized: Bomb*, 1999

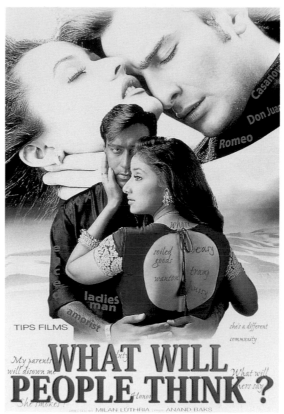

24. (right) **Annu Palakunnathu Matthew**, *Bollywood Satirized: What Will People Think?*, 1999

Apart from the shifts that digital technologies have brought about in the realms of collage, montage, and compositing, they also challenge traditional notions of realism by facilitating the creation of alternative or simulated forms of reality, or a sense of the 'hyperreal'. The concept of artistic realism has been inextricably interconnected with the history of photography. The idea that the photograph records and represents reality 'as it is' is both an important aspect of the medium and an arguable historical convention. The subjectivity of the photographer – for example, in the choice of angle, placement, and lighting – is obviously inscribed into any photographic record. And the 'staging' and the manipulation of photographs are as old as the history of photography itself: manipulated photographs of 'seances' were used to prove the existence of ghosts; historical photos have frequently been altered for propaganda purposes, sometimes simply erasing a person with unpopular political beliefs from the scene. The fact that the digital medium allows for a seamless reconstruction and manipulation of reality seems to have heightened an awareness of the questionable nature of the authenticity of all images.

Digital technologies are frequently used to alter and question the qualities of representation, be it in a historical or predominantly aesthetic context. In his series of digital prints *The Bone Grass Boy: The Secret Banks of the Conejos River*, Los Angeles-based artist Ken Gonzales-Day (b. 1964) questions stereotypical representations of Native and Latino inhabitants in the frontier novel of the late nineteenth century by inserting himself into

25. **Ken Gonzales-Day**, *Untitled #36 (Ramoncita at the Cantina)*, 1996

26. **Patricia Piccinini**, *Last Day of the Holidays*, 2001

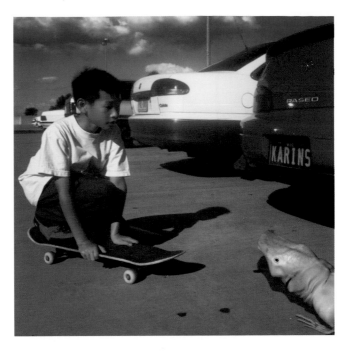

'historical documents'. The work is set during the Mexican–American War (1846–8), and the digitally (re)constructed image becomes a stand-in for the absence of an authentic history. In *Untitled #36 (Ramoncita at the Cantina)* (1996), the protagonist Ramoncita represents the figure of the Native/Latina *berdache* (a term created by Europeans from the Persian *bardaj*, originally a derogatory word for a passive homosexual partner, usually a feminine boy). Gonzales-Day describes his series as 'fictitious readymade', an object that was never made but appears to be a historical record. *The Bone Grass Boy* series challenges differences and boundaries between cultures, race, and class, as well as those between the photographic and digital media, both of which raise questions about their relationship to representation. A different kind of constructed reality is presented in *Last Day of the Holidays* (2001) by Sierra Leone-born, Australian-based artist Patricia Piccinini (b. 1965), whose work frequently creates a form of synthetic realism. The scene of a skateboarding boy in a parking lot encountering an alien creature appears at the same time artificial and familiar. Referencing cartoons and animation (particularly in its combination with 'live action' film), Piccinini plays with the 'cutesy' aesthetics of pop culture in creating a reality that seamlessly incorporates its fantasy products.

27. (above left) **Charles Cohen**, *12b*, 2001

28. (above right) **Charles Cohen**, *Andie 04*, 2001. The negative space in Cohen's images questions and reverses the dichotomy of foreground and background, as well as that of the subject and observer, who mentally 'fills in' what the image itself does not actually represent.

A diametrically opposed approach to the alteration of the image unfolds in American artist Charles Cohen's (b. 1968) archival digital inkjet prints *12b* (2001) and *Andie 04* (2001), which explore representational qualities in the context of abstraction through erasure. Cohen's work, which eradicates the human figure from pornographic scenes, subverts the images' original function and creates a void where absence becomes a presence in its own right. Erasure also becomes the key element in Venezuelan artist Alexander Apóstol's (b. 1969) series *Residente Pulido* (Polished Tenant). Apóstol's *Royal Copenhague* (2001) and *Rosenthal* (2001) depict landmark modernist buildings without doors or windows. The buildings create a desolate city landscape where architecture functions as an inaccessible monolithic monument and artefact – an emptiness resulting from a belief in the perfection of form. The images derive their names from famous china collections, an allusion to both their texture and a certain fetishization in consumer society where everyday objects become collectibles disassociated from their original functions.

The alternative realities created through digital manipulation are complemented by works that have an air of the 'hyperreal', creating a heightened reality that seems to be neither artificial nor an authentic representation. While temporal and spatial

29. **Alexander Apóstol,**
Residente Pulido: Royal Copenhague,
2001

30. **Alexander Apóstol,**
Residente Pulido: Rosenthal, 2001

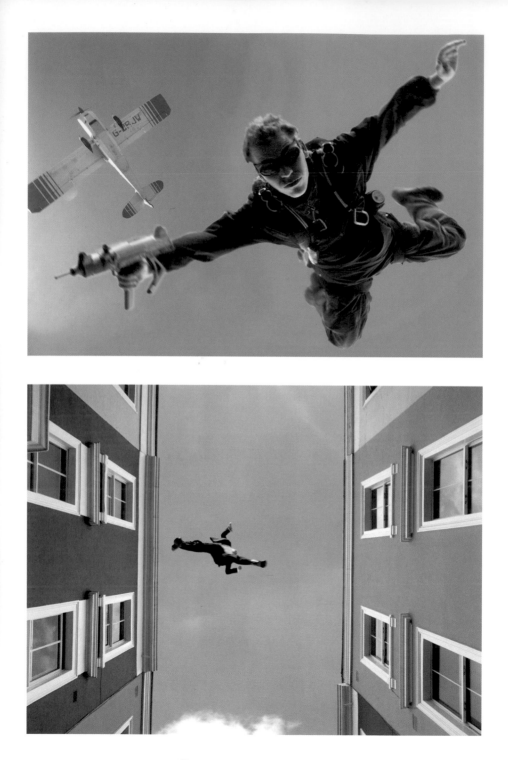

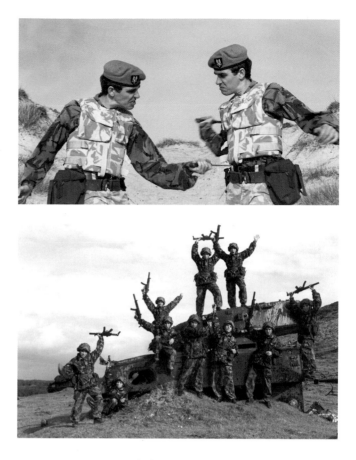

31. (opposite, top) **Paul Smith**, from the series *Action*, 2000

32. (opposite, bottom) **Paul Smith**, from the series *Action*, 2000

33. (this page) **Paul Smith**, from the series *Artists Rifles*, 1997. In *Artists Rifles*, Smith literally becomes every soldier in scenarios of army life, hinting at the loss of individuality in the army and the anonymity of military force.

continuity are maintained, the concept of reality still remains questionable. In his series *Artists Rifles* and *Action*, British artist Paul Smith (b. 1969) inserts himself as the protagonist of his own works, deconstructing myths of masculine stereotypes and glorification. The *Action* series depicts Smith as the omnipotent superhero of action films – jumping from one building to the next or in free fall, parachuting from a plane. The heroic fantasies propagated by the movie industry become the reality of the artist (and everyman). In a gallery environment, the works are installed as light boxes under the ceiling, enhancing the illusion and forcing the viewer to look up to the hero. The polished 'hyperreality' of Dutch artist Gerald van der Kaap's (b. 1959) *12th of Never* (1999) [34] equally comprises the subtext of a levelling of individuality, both in the context of mass transportation and mass media with its stylized language of perfection and beautification. This abstraction produced by perfection becomes a focus of American

34. **Gerald van der Kaap**, *12th of Never, c. 1999*

Craig Kalpakjian's (b. 1961) work, which frequently depicts 'landscapes' of the everyday, such as office buildings and details of interiors, that seem eerily real yet are completely computer-generated. In Kalpakjian's digital video *Corridor* (1997), viewers follow a seemingly endless hallway that, in its even structure and lighting, invokes both emptiness and formal perfection. The synthetic nature of *Corridor*'s computer-generated world alludes to the artificiality of many of the environments and office buildings we inhabit on a daily basis and the alienating effects induced by modern architecture.

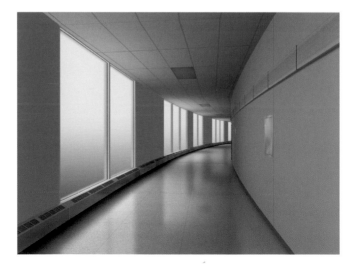

35. **Craig Kalpakjian**, *Corridor*, 1997

The refined possibilities of manipulating images also lead to a certain 'dematerialization' of the naturalistic aspects of representation, or at least to a redefinition of the relationship between the viewer, nature, and its representation. Numerous digital art works address the notion of an enhanced nature or explore issues of artificial life and organisms. An example of this redefined relationship between nature and representation are the high-resolution scans of moths – *Great Tiger Moth*, *Ctenucha Moth*, *Leopard Moth* (2001) – by Joseph Scheer (b. 1958). The images are created by passing a scanner over the body of the moth and provide a far more detailed view than could ever be

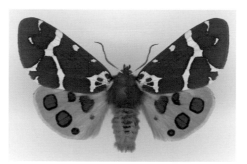

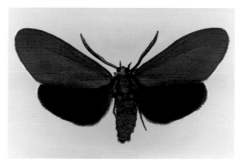

36. (top) **Joseph Scheer**, *Arctia Caja Americana (Great Tiger Moth)*, 2001.

37. (centre) **Joseph Scheer**, *Ctenucha Virginica (Ctenucha Moth)*, 2001.

38. (right) **Joseph Scheer**, *Zeuzera Pyrina (Leopard Moth)*, 2001. While the prints seem to suggest a form of photorealism, their visual qualities also radically differ from those of photography. The evenness of the scan replaces the single focal point of a camera and leads to an almost supernatural level of detail, a heightened physical presence of nature.

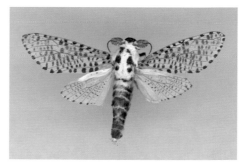

achieved with a camera. The surface texture of the moths' bodies becomes an almost tangible reality. The concept of an enhanced nature also manifests itself in *Mere* (1994) by Peter Campus (b. 1937), a seminal figure in video art, and *Untitled #339* (1996), a C-print from a digital image by Oliver Wasow (b. 1960). Both Campus's insect and Wasow's landscape suggest an 'otherworldliness' and at the same time a believable reality that might exist in an unknown place. *Mere* and Wasow's landscape are neither 'here' nor 'there', depicting a stylized or dramatic, painterly view while maintaining basic spatial and temporal referents to create a seamless, unified image.

39. **Peter Campus**, *Mere*, 1994

40. **Oliver Wasow**, *Untitled #339*, 1996. Wasow has created a body of work consisting of landscapes that verge on the fantastic, and is particularly interested in a synthesis of fiction and reality, or culture and nature, and the ways they inform our view of the world around us.

In his series *Horror Vacui* and *Digital Hide*, Spanish artist Daniel Canogar (b. 1964) creates composite collages that reflect on relationships between the body and its image by merging body parts into structures and patterns that suggest and transcend naturalism. The interlocked hands in *Horror Vacui* (1999) suggest both dismemberment and the creation of an 'other' as an organic whole processed by technology. Canogar's *Digital Hide 2* (2000), in particular, seems to create a new form of anatomy, inscribed by human fingerprints but unrecognizable as existing biological form. Canogar's rewriting of the body operates on the border of fear and fascination with technologically formed organisms.

41. **Daniel Canogar**, *Horror Vacui*, 1999

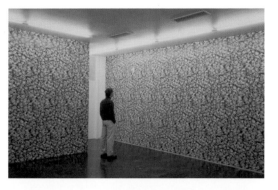

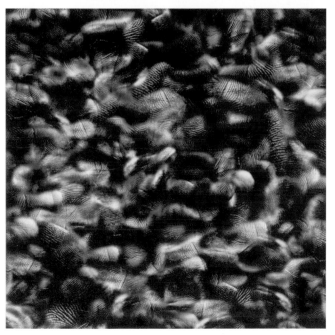

42. **Daniel Canogar**, *Digital Hide 2*, 2000

The concept of technologized, artificial life-forms is also at the core of the *Klone* series by Austrian artist Dieter Huber (b. 1962), which depicts technologically transformed plants, humans, and landscapes. Huber's work explicitly establishes a connection to genetic engineering, biotechnology, and changing notions of the organism in the age of new technologies. Huber's *Klone #100* (1997) and *Klone # 76* (1997) show mutated plants that appear at the same time real and unfamiliar, a fictitious result of an engineering of nature. The deceptively sober and scientific nature of Huber's photographs enhances the perception of the images

43. (below left) **Dieter Huber**, *Klone #100*, 1997

44. (below right) **Dieter Huber**, *Klone #76*, 1997

45. (bottom) **Dieter Huber**, *Klone #117*, 1998–9

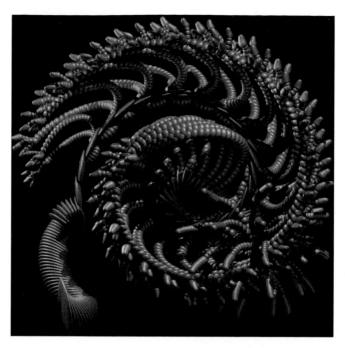

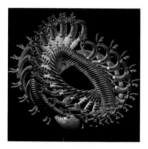

46. (above left) **William Latham**, *HOOD2*, 1995

47. (above right) **William Latham**, *SERIOA2A*, 1995
Latham's work results in a computer-generated nature that crosses the boundary between animated sequences and virtual sculptures implying unlimited possibilities. Latham's images do not represent natural form but highlight the aesthetics of computer-generated morphology, an artificial nature that is reminiscent of, and yet distinctly different from, living organisms.

as a reality. The artist combines analogue and digital technologies in the creation of his work, starting from analogue images that are then digitized and digitally manipulated but finally presented as a photograph. Huber's landscapes equally seem deceptively real while their flawless composition and arrangement hints at an artificial, beautified nature. An entirely different form of computer-generated 'nature' is represented by the works of British sculptor William Latham. Working as a research fellow in the IBM Scientific Centre at Winchester in southern England, Latham (in collaboration with Stephen Todd) developed programs that allow users to shape sculptural three-dimensional (3D) forms according to 'genetic' properties. Through algorithms generating fractal and spiral mutations, Latham simulates the geometry of natural forms to produce artificial 'organisms'. His programs, which have been developed into commercial software, use elements of random mutation and rules of 'natural selection' to create an evolution of forms – genetic variations based on aesthetic choices. The use of evolutionary and behavioural algorithms has become a broad field of artistic creation, which will be further discussed later in the section on artificial life.

It has frequently been argued that the digital image is not representational because it is encoded and does not record or

48. Andreas Müller-Pohle, *Digital Scores III (after Nicéphore Niépce)*, 1998. Müller-Pohle translated the oldest preserved photograph, Niépce's view from his study, into digital form. He digitized the image and converted the seven million bytes into alphanumeric code. The result, transcribed onto eight square panels, is indecipherable, yet contains an accurate binary description of the original. *Digital Scores* points both to the fluid transition of information in the digital realm and to the different forms of encoding inherent to the digital and photographic media.

reproduce physical reality. While this is debatable on the level of the 'content' of the image, which often simulates and represents a physical reality, it is true from the perspective of its production. The digital image consists of discrete, modular elements, pixels that are based on algorithms, mathematical formulas. While bits are still essentially threads of lights, they do not by nature require a physical object to 'represent' and are not based on a principle of continuity with a real world. Many digital images make this fact the focus of artistic exploration – often in relation and contrast to other media such as photography. They also sometimes visualize a process that otherwise would remain unseen, by translating and 'encoding' visual information. German artist Andreas Müller-Pohle's (b. 1951) series *Face Codes* (1998–9) unites analogue

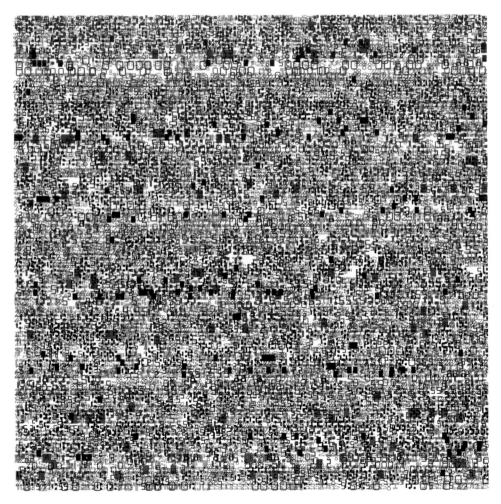

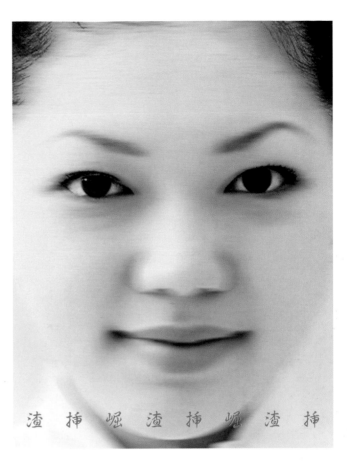

49. **Andreas Müller-Pohle**, *Face Code 2134 (Kyoto)*, 1998–9

and digital representation on the level of the image itself. The *Face Codes* are selections from several hundred video portraits recorded in Kyoto and Tokyo in 1998. The portrait images were digitally manipulated by first creating a standardized template and then adjusting the position of the heads, as well as the height of the eyes, lips, and chins, according to it. The individual faces were thus transformed into a unified structure. The artist then opened the image files as ASCII text files (ASCII stands for American Standard Code for Information Interchange, a common format for text files in computers and on the Internet that represents alphabetic and numeric characters as binary numbers). With software capable of processing both Western and Asian sign systems, the ASCII code was then translated into Japanese writing, which is a mixture of the sign systems Kanji, Hiragana, Katakana, and Romaji. A string of eight consecutive Kanji signs selected from

the translated alphanumeric code appears under the portraits, inscribing the 'genetic' makeup of the image itself onto its surface. The initial 'erasure' of the individuality of people's faces by means of a template points to the process of equalizing that occurs in the digital image, where any visual information ultimately is a calculable quantity. The concept of the human face as the sum of its data is further enhanced by the 'subtitles' that represent these data as a sign system. Genetic code in the literal sense becomes the focus of Müller-Pohle's Blind Genes (2002), for which he searched a genetic database on the Internet for the keyword 'blindness'. The gene sequences returned by the search were used regardless of their quality or completeness – partial results or sequences that were merely postulated were accepted as valid returns, pointing to the state of research at the time and the metaphorical element of the artistic process. The DNA bases CGAT (Cytosine, Guanine, Adenine, Thymine) were then positioned in blocks of ten, translated into Braille and coloured – A: yellow, G: blue, C: red, T: green. The height of the single pieces is produced by the different lengths of the sequences. Through a process of data translation, the genetic, organic 'code' for blindness manifests itself as Braille, the code and sign system that establishes an 'interface' with the seeing world.

The visualization of sign systems is also explored in American artist Warren Neidich's (b. 1956) 'conversation maps' – among them I worked on my film today. Are you dating someone now? (2002) [51] and I am in love with him, Kevin Spacey (2002) [52]. At first glance, these maps are reminiscent of abstract paintings of wave forms. But the images in fact represent everyday conversations that were conducted in sign language, with lights being attached to the participants' fingers and arms. Neidich photographed these conversations with very long exposures, creating black-and-white photo documentations, which were then digitized and subsequently superimposed and coloured by means of imaging software. The maps contain from five to thirty layered conversations and are exhibited as light boxes. Through the use of digital technology, Neidich's conversation maps not only document and visually translate a process but also represent it as comparative conversational patterns. The original photograph is transformed into a seemingly painterly abstraction. A notable characteristic of digital images that focus on aspects of encoding and visualization is that the process and meaning of an image do not always reveal themselves on the visual level but often rely on external contextual information to help 'explain' the work.

50. **Andreas Müller-Pohle**, Blind Genes, IV_28_AF254868, 2002

The multiple possibilities for constructing a digital image by combining qualities inherent to or associated with different art forms frequently erode the boundaries between diverse media, such as painting and photography. In Casey Williams' (b. 1947) *Tokyogaze III* (2000) and *Opal Sun I* (2000), for example, photography merges with a type of painterly colour-field abstraction. Informed by the aesthetics of industrialism, Williams' images developed out of numerous boat rides in the port of Houston, Texas. The less textured and nuanced quality of inkjet prints is counterbalanced by the fact that the images

53. (right) **Casey Williams**, *Tokyogaze III*, 2000

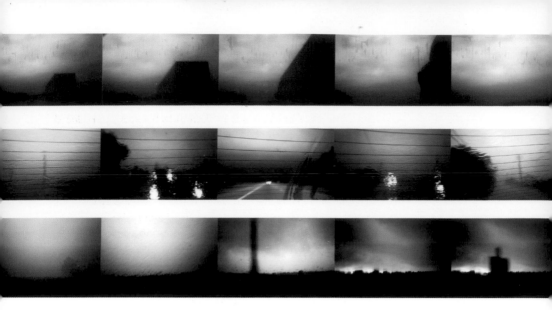

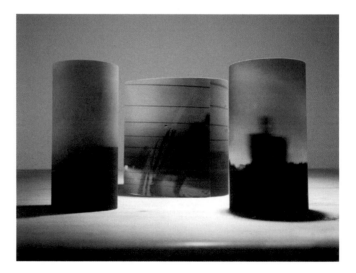

54. **Ana Marton**, *3×5*, 2000

are printed on canvas, which contributes to enhancing the painterly attributes. A very different fusion of media occurs in Romanian-born artist Ana Marton's series of digitally printed photographic rolls. Her work *3×5* (2000) layers different 'spaces' of photographic representation, from the original photographic roll to the two-dimensional 'record of reality'.

While digital media and traditional painting or drawing, in particular, seem to occupy opposite ends of the scale in their

inherent languages, these media are now frequently merged into new unities by artists who employ digital technologies as a step in the creation of a painting, drawing, or print. For his *Rhapsody Spray* series (2000), London-born artist Carl Fudge (b. 1962) digitally manipulated the scanned image of the Japanese anime (cartoon) character Sailor Chibi-Moon, which was then produced as a series of screenprints. While the physicality of the print is traditional, the abstraction of the composition, in its stretching and copying of elements, has a distinctly digital feel. Despite the digital manipulation, the images do not lose the context of their original but maintain discrete attributes of an anime character in colour scheme and forms (a distinctive feature of anime characters is that they are capable of shifting shape and turning into different personalities). Anime as a pop-cultural form has developed a cult following outside of Japan, and its aesthetic influences can be traced in many digital artworks, in particular animations, which will be discussed later.

55. **Carl Fudge**, *Rhapsody Spray I*, 2000

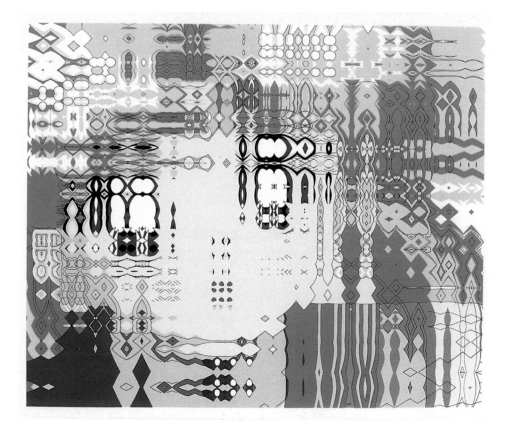

The aesthetics of digital composition also play a prominent role in the work of Chris Finley (b. 1971), who frequently creates digital templates for his paintings. Finley's work process mirrors the limitations that are inherent to the restricted menu of imaging software: working within the restraints of a set of options determining colour, shape, and form, Finley combines elements that are digitally manipulated through rotation or copying. The artist then re-creates the composition on canvas and mixes the colours to conform to the digital palette. The result are paintings where traditional craft blends with the clearcut shapes and colour fields of computer-generated painting. A completely different form of digital process is employed by Joseph Nechvatal (b. 1951) whose 'computer-robotic assisted' paintings are created by means of a

56. **Chris Finley**, *Goo Goo Pow Wow 2*, 2001

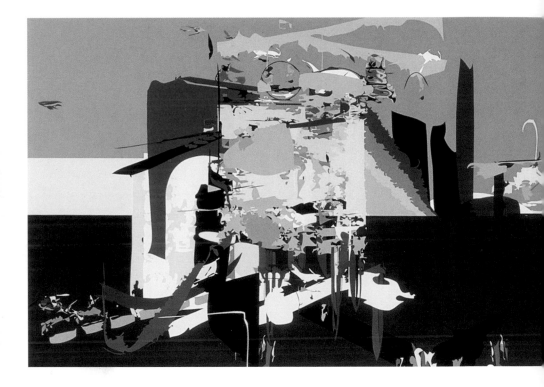

virus-like program that performs a degradation and transformation of the image. After digitally composing and manipulating image elements, most notably through the transformations induced by the virus, Nechvatal transfers his files over the Internet to a remote computer-driven robotic painting machine, which executes the painting. The artist himself is not involved in the process of painting itself, which ultimately takes place as an act of 'telepresence'. In paintings such as *vOluptuary drOid décOlletage* (2002) and *the birth Of the viractual* (2001), parts of the (intimate) human body are intermixed with flower or fruit ornaments into a virally created collage. The hybrid image suggests an androgyny that Nechvatal traces to Roman poet Ovid's *Metamorphoses*, which depicts transmutation as a universal principle driving the

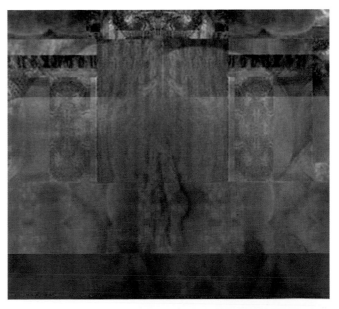

57. (right, top) **Joseph Nechvatal**, *the birth Of the viractual*, 2001

58. (right) **Joseph Nechvatal**, *vOluptuary drOid décOlletage*, 2002

59. (below) **Jochem Hendricks**, *EYE*, 2001

60. (opposite, top) **Jochem Hendricks**, *Blinzeln*, 1992

61. (opposite, bottom) **Jochem Hendricks**, *Fernsehen*, 1992

nature of the world. Nechvatal's paintings strive to create an interface between the biological and technological, the viral, virtual, and actual or 'viractual', as the artist refers to it. While Nechvatal's interface manifests itself within the painting, German artist Jochem Hendricks (b. 1957) uses digital technology as an interface that enables a direct representation of the artist's gaze. For his 'eye drawings', Hendricks uses goggle-like equipment to scan the motion of the eye and send the data to a printer, which translates the process of looking into physical drawings. In works such as *Fernsehen* (TV, 1992) and *Blinzeln* (Blinking, 1992), the artist's 'view of the world' is literally transcribed as an artwork. Hendricks's drawing *EYE* (2001) is a graph of the artist's reading of the 'Eye' entertainment section of the *San Jose Mercury News*. A previous work, *Zeitung* (Newspaper, 1994), charted the reading of an entire issue of the German newspaper *Frankfurter Allgemeine Zeitung*. While Hendricks's eye drawings are reminiscent of early plotter drawings in their rawness, at the same time they offer a precise record of the root of artistic process and visual perception, the process of 'seeing' itself.

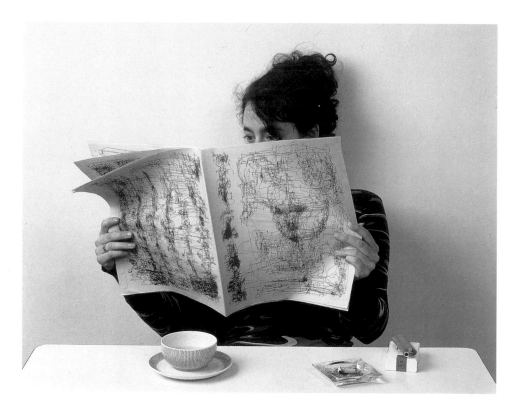

It has been suggested that the creation of artworks such as paintings or drawings on a computer implies a loss of relationship with the 'mark' – that is, that there is a significant lack of personality in the mark one produces on a computer screen as opposed to one on paper or canvas. While this is certainly true, the comparison with painting and drawing itself is slightly problematic. Art created by means of computer technologies is more comparable with other technologically mediated art forms such as film, video, and photography, where the individuality and voice of an artist does not manifest itself in a direct physical intervention. Concept, all elements of the composition process, the writing of software, and many other aspects of digital art's creation are still highly individual forms of expression that carry the aesthetic signature of an artist.

Sculpture
Digital technologies are also increasingly employed in various stages of the creation and production of sculptural objects, ranging from modelling software to manufacturing machines. While some sculptors make use of the technologies both in the initial design process and in the output of the physical objects, others create sculptures that exist only exclusively in the virtual realm and can take the form of a CAD (computer-aided design) model or a digital animation.

There are different types of computer-controlled manufacturing machines that allow for the production of physical objects and three-dimensional prints. Three-dimensional objects are created by what is commonly known as rapid prototyping technology, which automates the fabrication of a prototype from a CAD model (for example, by carving the object out of a block of material or by building it through layer-by-layer fabrication). Rapid prototyping is also often used for the creation of a mould for the casting of a sculpture. New tools for modelling and output have changed the construction and perception of three-dimensional experience and broadened the creative possibilities of sculptors. Digital media translate the notion of three-dimensional space into the virtual realm and thus open up new dimensions for the relationship between form, volume, and space. Tangibility, which has been a major characteristic of sculpture, is not necessarily a defining quality any more. The transphysical aspect of the virtual environment changes traditional modes of experience that were defined by gravity, scale, material, and so on. Scaling operations, proportional shifts, eccentric

vantage points, morphing processes, and 3D montage are some of the techniques employed in the realm of digital sculpture.

While some digitally produced objects do not exhibit distinctive features of the medium and could have been created by traditional means, others immediately point to the process of their creation. Robert Lazzarini's (b. 1965) sculptures *skulls* (2000), for example, could not have been created without digital technologies, a fact that is immediately obvious to the viewer's eye. Based on 3D CAD files that were distorted and then produced as sculptures, the skulls achieve a perspectival distortion that never resolves itself into a three-dimensional object as we know it (looking at these objects can in fact induce nausea). At the same time, the skulls are firmly embedded in the history of art, recalling Hans Holbein's anamorphic skull in the

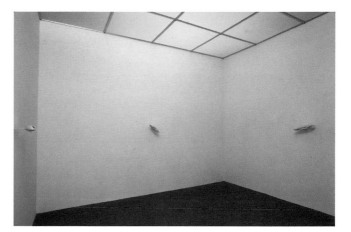

62. **Robert Lazzarini**,
skulls, 2000

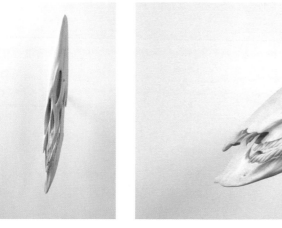
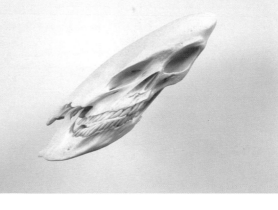

foreground of his well-known painting *The Ambassadors* (1533) in the National Gallery, London, and various other distortions that have been explored in painting through the ages.

Sculptor Michael Rees (b. 1958) uses rapid prototyping to create objects that borrow from medical anatomy for an exploration of what he refers to as 'spiritual/psychological anatomy'. In Rees's *Anja Spine* series (1998), anatomical elements and organic forms, such as a spine with ears protruding from it, are woven into complex sculptural structures, which raise questions about the scientific validation of a sensuality that

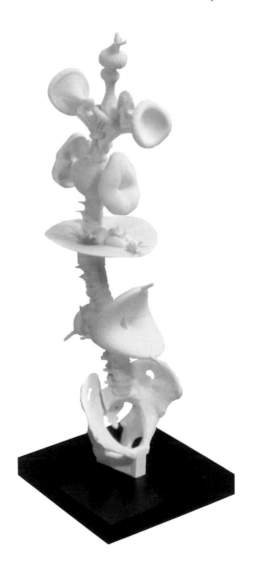

63. **Michael Rees,** *Anja Spine Series 5,* 1998

64. (right) **Michael Rees**, *A Life Series 002*, 2002. Joining body parts without paying attention to the functionality of the result, Rees represents the physical body as mutable and clonable. The use of limbs as modular elements implies that body parts are components that can be reconfigured at will, and hints at the objectification of our bodies. The artist also created animations, such as *A Life movie (monster Series)* from 2002 (below), in which the artificial sculptural bodies come to life and perform their permutations.

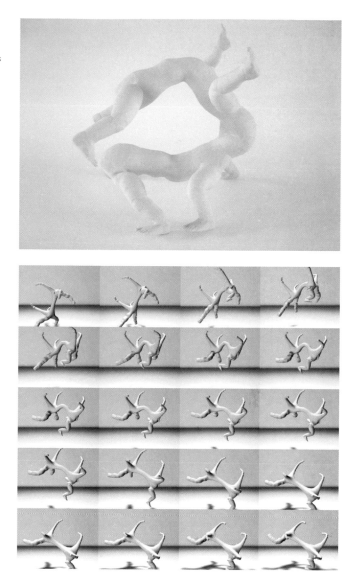

transcends the known structure of the body. Rees uses science and its imagery as a way of weaving systems, both analytical and intuitive. 'Anja' is the Hindu term for the sixth of the Chakras, energy centres that are openings for life energy and vitalize the physical body to bring about the development of our self-consciousness. The word 'Anja' means 'command', in the sense of spiritual guidance and, while still part of embodied existence, is associated with the most subtle elements. Rees's *A Life* series

(2002) continued his interest in the permutations of the human body in the context of artificial life.

Questions surrounding new relationships between the body and representation are raised by German artist Karin Sander's (b. 1957) work *1:10* (1999–2000), which presents itself as sculptural miniature portraits of people on a scale of 1 to 10. The miniatures are created by taking a 360-degree scan of the subject's body. The resulting file is then fabricated as a three-dimensional plastic object and finally airbrushed, using a photo of the person as a reference for accurate colouring. Sander herself is not involved in the actual creation of the object, which is entirely machine-produced, and she also makes a point of not affecting the appearance of the subject by 'directing' their posture or choice of clothes. While the final object appears to be a traditional sculpture, it simultaneously questions the notion of sculpture itself. The artist does not work with physical materials at any point, and the final object does not bear her 'mark'. It is in fact less a physical 'representation' than an accurate miniature copy of a person that suggests an unfiltered purity. At its very basis, Sander's work remains conceptual, an idea that is executed by various kinds of technology.

Sander's working process exemplifies the concept of 'telemanufacturing', the possibilities of digitally 'teleporting' forms, which can then be created at a specific site on an 'as needed, where needed' basis. Through telemanufacturing, virtual 3D forms can be remotely translated into a haptic experience – an idea and form, conceived anywhere, can literally be at your fingertips. Affordable 3D printers will probably be introduced to the mass market in the not too distant future, establishing another level of physicality for digitally transmitted information. In its 2013 exhibition 'Out of Hand – Materializing the Postdigital', the Museum of Art and Design in New York City specifically addressed the different concepts explored by sculptural work produced through digital fabrication, showcasing work by artists from Michael Rees (b. 1960) and Roxy Paine (b. 1966) to Anish Kapoor (b. 1954) and Frank Stella (b. 1936).

65. **Karin Sander,** *Bernhard J. Deubig 1:10,* 1999

Chapter 2: Digital Technologies as a Medium

The employment of digital technologies as an artistic medium implies that the work exclusively uses the digital platform from production to presentation, and that it exhibits and explores that platform's inherent possibilities. The digital medium's distinguishing features certainly constitute a distinct form of aesthetics: it is interactive, participatory, dynamic, and customizable, to name just a few of its key characteristics. However, the art itself has multiple manifestations and is extremely hybrid. It can present itself as anything ranging from an interactive installation with or without network components, virtual reality, software written by the artist, purely Internet-based art, or any combination thereof. These forms will be surveyed in this book, with an emphasis on the formal language that is specific to them.

Technologies often tend to develop faster than the rhetoric evaluating them, and we constantly have to develop vocabulary for art using digital technologies as a medium – in social, economic, and aesthetic respects. The characteristics commonly assigned to the digital medium need some further clarification since they are often used in such a general way that they hardly carry any meaning. The term *interactive*, for instance, has become almost meaningless due to its inflationary use for numerous levels of exchange. Ultimately, any experience of an artwork is interactive, relying on a complex interplay between contexts and productions of meaning at the recipient's end. Yet, this interaction remains a mental event in the viewer's mind when it comes to experiencing traditional art forms: the physicality of the painting or sculpture does not change in front of his or her eyes. With regard to digital art, however, interactivity allows different forms of navigating, assembling, or contributing to an artwork that go beyond this purely mental event. While the user's or participant's involvement with a work has been explored in performance art, happenings, and video art, we are now confronted with complex possibilities of remote and immediate intervention that are unique to the digital medium.

The possibilities of complex interaction in digital art go far beyond the simple 'pointing and clicking' that offers nothing more

66. **Jim Campbell**,
5th Avenue Cutaway #2, 2001

than a sophisticated form of looking at a work, or the type of interactivity where a user's act triggers one specific response. Far more fundamental changes take place with virtual art objects that are open-ended 'information narratives' with a fluctuating structure, logic, and closure, where control over content, context, and time is shifted to the respective recipient through interaction. These types of works can take numerous forms with varying degrees of control over their visual appearance by the artist or the audience. Digital art is not always collaborative in the original sense of the word but often *participatory*, relying on multi-user input. In some artworks, viewers interact within the parameters that have been set by the artist; in others, they set the parameters themselves, or become remote participants in time-based, live performances. In some cases, the visual manifestation of an artwork is ultimately created by the viewer: without input, a work of art may literally consist of a blank screen.

The digital medium is also *dynamic* and can respond to a changing data flow and the real-time transmission of data. A variety of artworks, some of which will be discussed later, have used 'live' stock market and financial data as a source for different kinds of visualizations. It is important to point out that the digital medium is not by nature visual but always consists of a 'back end' of code or scripting languages that mostly remain hidden and a visible 'front end' that is experienced by the viewer/user, the latter being produced by the former. The results can range from complex visuals to very abstract communication processes. Some digital art is predominantly visual; other works are more focused on raw data or databases. Another prominent feature of the medium is that it is *customizable*, adaptable to a single user's needs or intervention, for example in artworks where the user's individual profile becomes the basis for the development of and changes in the work.

These distinguishing features of the digital medium do not necessarily all surface in one work but are used in varying combinations. Jim Campbell's (b. 1956) *5th Avenue Cutaway* series (2001) [66] is a prime example of a digital work that displays only a few of its characteristics – it is a dynamic art object, yet is neither interactive nor participatory nor customizable. The work consists of scenes displayed on panels created out of computer-controlled red light-emitting diode (LED) lights, which show video-derived imagery of people walking down 5th Avenue in Manhattan. Placed in front of the panels are panes of treated plexiglas. Since the plexiglas is placed at an angle – with varying distance to the

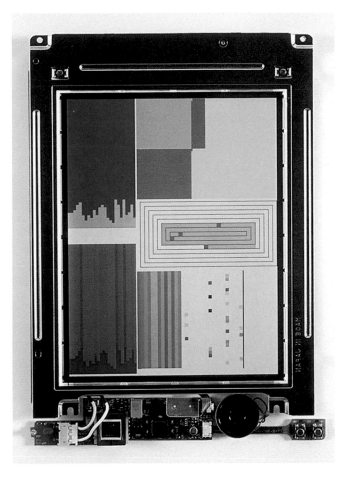

67. **John F. Simon, Jr**, *Color Panel v 1.0*, 1999. This work is a time-based study of colour theory, in which artist-written software explores different possibilities and 'rules' for colour (as proposed by early twentieth-century painters such as Paul Klee and Wassily Kandinsky) in relation to time and motion. The electronics consist of the recycled remains of a laptop computer (screen, processor, memory, hard disk), while the display housing is custom-made from acrylic.

LEDs – the scene goes through various stages of pixelation (from strong to hardly visible) and thus seems to make a transition from a digital to an analogue image, in the process reflecting not only on abstraction but also the aesthetics of these different media types. Another example of a dynamic digital art object is John F. Simon, Jr.'s (b. 1963) colour panel series, which consists of custom hardware, software, and liquid crystal display (LCD) screens. The panels show dynamic compositions unfolding according to the software written by the artist. Viewers can literally see the algorithms driving the visuals on the screen in never-repeating variations. Both Campbell's and Simon's works expand the notion of the art object in the digital age, maintaining aspects of the object and at the same time transforming it into a changing, time-based structure.

One of the pragmatic aspects of digital practice is the fact that information can be infinitely developed, recycled, and reproduced in various contexts – it can breed new ideas through recombination. The recontextualization of information in various relational combinations is inherently connected to the logic of the database, which ultimately lies at the core of any digital art project. As media theorist Lev Manovich has put it, a digital art object can be described as one or more interfaces to a database of multimedia material. Manovich's definition points to the fact that the virtual object is bound to the concept of an interface that allows the user or viewer to experience it. The word interface has become almost synonymous with the navigational methods and devices that allow users to interact with the virtual three-dimensional space of a computer program. Yet, the term has existed for over a century, describing the place at which independent 'systems' (such as human/machine) meet and the navigational tool that allows one system to communicate with the other. The interface serves as a navigational device and as translator between two parties, making each of them perceptible to the other. We have been surrounded by interfaces for such a long time that we hardly notice them any more. From the 'control panels' of our television, video recorders, and audio remote controls, stereos, microwaves, and elevators to telephones and fax machines, we constantly rely on them to communicate with machines and the world outside ourselves. Interfaces always subtly change the paradigms of communication, and the design and culture of digital interfaces, with their conventions, structural peculiarities, as well as promises and limitations are deeply interconnected with the way we perceive digital art.

Forms of digital art
It is problematic to claim that all digital artworks can be neatly categorized according to different forms: most of the time, these works combine various elements (such as a physical installation with a sound and Internet component) and defy a purely formal classification. Nevertheless, it is important to be aware of the formal aspects upon which the art is based. Ultimately, every object – even the virtual one – is about its own materiality, which informs the ways in which it creates meaning. Among the forms that a digital artwork can take are installation; film, video, and animation; Internet art, networked art and software art; and virtual reality and musical environments. While the formal aspects of a work are always inextricably interconnected with

its content (the medium also being the message), classifications based on form are not necessarily helpful in consistently outlining the themes developed in a given art. In this chapter, different formal categories of digital art will be outlined through the use of examples. In a later chapter, artworks across all these categories will be discussed in the context of prominent themes and issues they are exploring. Occasionally the categories of form and theme overlap: locative and social media or augmented reality are as much technological forms as they are concepts addressed in the art. Many of the works mentioned in the following pages have been shown at venues that have been devoted to the digital medium for quite some time – such as the ZKM in Karlsruhe, Germany, the ICC in Tokyo or the Ars Electronica Festival in Linz, Austria – and have been produced with support from research labs of educational institutions or organizations such as the Banff New Media Center in Canada, Canon Artlab in Japan, or V2 in the Netherlands.

Installation
Digital art installations are in and of themselves a broad field and come in myriad forms. Some are reminiscent of the large-scale video installations that include multiple projections, or of video works that incorporate the viewer in the imagery through live captures. Many are aimed at creating 'environments' that can entail varying degrees of immersion, ranging from pieces that strive to envelop the audience in a projected environment to those that immerse them in a virtual world. Immersion has a long history and is inextricably connected with art, architecture, and symbolic systems: cave paintings can be considered early immersive environments, and medieval churches are equally aimed at creating a transformative enclosure for their visitors through a combination of architecture, light, and symbolism. Just like their video counterparts, digital installations are often site-specific and scalable and do not necessarily come with pre-established dimensions. Since they exist in and establish a connection to physical space (be it an enclosed space or a public one), they always incorporate an underlying spatial and architectonic element, which may be of varying importance to the piece itself. Some of the common formal aspects of large-scale digital environments are: architectural models; navigational models that explore interfaces or movements; explorations of the construction of virtual worlds; and distributed, networked models that allow users to participate remotely in the work. In

one way or another, all are concerned with possible relationships between the physical space and the virtual, and what distinguishes them are the balance between these two realms and the methods employed to translate one space into the other. Some artworks try to translate qualities of the virtual world into the physical environment; others strive to map the physical in the virtual; and yet others are aimed at fusing the two spaces.

Australian artist Jeffrey Shaw (b. 1944), who has created a variety of influential projects in the field of digital installation art, addressed issues of navigation in connection to architecture in his landmark piece *The Legible City* (1988–91). The project allows visitors to navigate a simulated city – consisting of computer-generated three-dimensional letters that form words and sentences – by riding a stationary bicycle. The architecture, which is based on maps of actual cities, thus entirely consists of texts, which are projected onto a large screen in front of the viewer. In the *Amsterdam* (1990) and *Karlsruhe* (1991) versions, the scale of the letters actually corresponds to the proportion of the buildings they replace, and the texts are assembled from archive documents describing historical events. In the *Manhattan* version (1989), the texts consist of eight differently coloured stories presented in the form of fictional monologues by Manhattanites, among them ex-Mayor Koch, Donald Trump, and a taxi driver. *The Legible City* establishes a direct connection between the physical and virtual realm by allowing users to control the speed and direction of navigation by using the bicycle's pedals and steering handle, which are connected to a computer that translates the physical actions into changes of the landscape on the screen. Shaw's piece touches upon numerous issues that are crucial to the construction of virtual environments: the textual component of the city literally translates characteristics of hypertext and hypermedia into an architecture where 'readers' construct their own narrative by choosing paths through the non-hierarchical textual labyrinth; in other words, the city becomes an 'information architecture' where buildings consist of stories that are site-specific, related to and enhancing the location visited and thus pointing to the history of immaterial experiences that are not immediately accessible through the tangible form of the building itself.

The augmentation of a physical architecture with a virtual memory and narrative is what Mexican-Canadian artist Rafael Lozano-Hemmer (b. 1967) has referred to as 'relational architecture', which he defines as 'the technological actualization of buildings and public spaces with artificial memory'. Lozano-

68. (opposite, top) **Jeffrey Shaw**, *The Legible City (Manhattan)*, 1989

69. (below) **Jeffrey Shaw**, *The Distributed Legible City*, 1998. Shaw extended his project by allowing several cyclists at remote locations to navigate the same virtual environment simultaneously. The cyclists can see virtual representations of themselves and each other in the projection (opposite, bottom), and can verbally communicate if they come close enough.

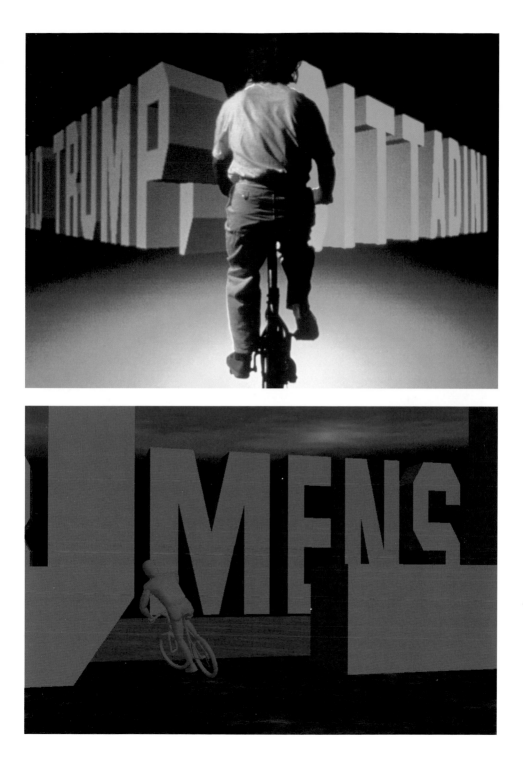

Hemmer has created a whole series of relational architecture projects in which he augments buildings and sites; these will be discussed in the context of public interactives later in this book. While Lozano-Hemmer's projects are distinctly different from *The Legible City*'s purely virtual architecture in that they expand a physical building into an artificial construct, they equally experiment with the tension between physical and virtual architecture. In his project *Displaced Emperors (Relational Architecture #2)*, which was shown in Linz in 1997, Lozano-Hemmer established a link between Mexico and Austria through seemingly unrelated historical oddities: the Mexican empire of the Austrian Maximilian of Habsburg (1864–7) and the feather crown ('Penacho de Moctezuma') of one of the last Aztec emperors, which was in the possession of the Ethnological Museum of

70. **Rafael Lozano-Hemmer, with Will Bauer and Susie Ramsay**, *Displaced Emperors (Relational Architecture #2)*, 1997

Vienna. The actual intervention transformed the outside of the Habsburg Castle in Linz: by pointing to places on the façade, the audience (whose movements were tracked by wireless sensors) triggered the projection of a large animated hand that appeared at the location to which they pointed. Moving their hand over the building, participants could seemingly unveil its interiors, which appeared as a projection on the building. However, these interiors did not represent the actual inside of the castle but that of Chapultepec Castle, the Habsburg residence in Mexico City. The audience could also make the feather headdress appear as a projection by pressing a 'Moctezuma button' at various stations. *Displaced Emperors* thus literally displaced and replaced strands of colonial history, endowing a familiar physical site with a context that was far from well known, and implicating the public in

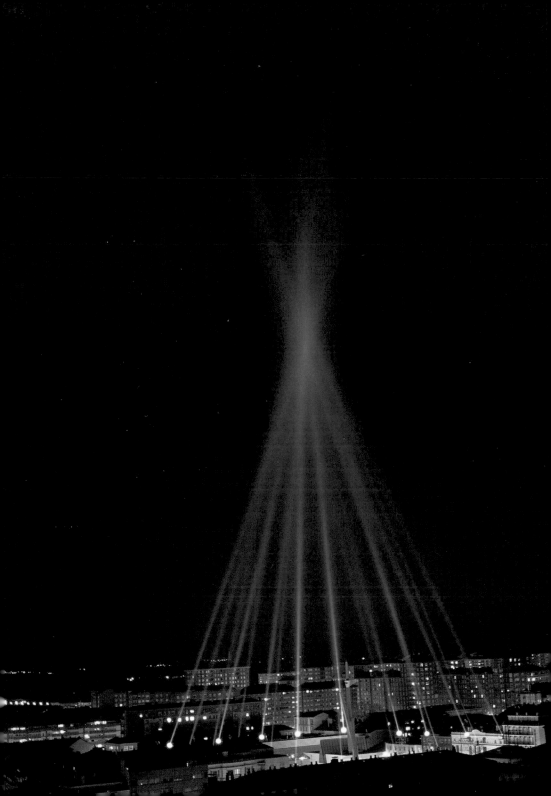

71. **Rafael Lozano-Hemmer**, *Vectorial Elevation (Relational Architecture #4)*, 2002.
In this work, which was shown in Mexico (1999) and then in the Basque region (2002), the robotically controlled searchlights could be manipulated by visitors over the Internet. *Vectorial Elevation* stands in the tradition of early computer-controlled outdoor light installations such as Otto Piene's (b. 1928) *Olympic Rainbow* (1972) and the laser sculptures of Norman Ballard (b.1950) and Joy Wulke (b. 1948).

72. **Erwin Redl**, *Shifting, Very Slowly*, 1998–9

historical power relations. The artist continued his architectural intervention in his project *Vectorial Elevation* (since 1999), which transformed the urban landscape by means of more than a dozen robotically controlled gigantic searchlights.

A very different approach to an architectural exploration of space in its connection to light as a structural element, are the installations of Austrian-born artist Erwin Redl (b. 1963). Redl's light projects are yet another example of work that uses the digital medium in a very minimal way and makes the subtlety of this use the focus of the work itself. For several years, Redl has created large-scale, site-specific installations from LED lights. These installations often present themselves as enormous 'curtains' consisting of a vast number of strings of the small LEDs. At times, the lights have been programmed to change colour slowly, adding yet another layer to the construction of space. Redl's *Matrix* series (since 2000) [73], in particular, seems to translate virtual space into a physical one: virtual space would not be visible and accessible without the screen's grid of light, which is an essential element of this space's construction. *Matrix* transposes the grids and planes of virtual space into physical environments, allowing users a direct visceral

73. (opposite) **Erwin Redl**, *Matrix IV*, 2001

experience of an essentially immaterial space. The interplay between virtual and physical structures and architectures has also been the focus of the works created by Asymptote, a New York–based architectural office founded by Hani Rashid and Lise-Anne Couture in 1987. Asymptote's *Fluxspace* series is a study in different forms of intersections between the virtual and actual, striving to fuse the different qualities of both realms and translating features of the digital medium into actual space.

74. (right) **Asymptote**, *Fluxspace 3.0*, 2002. In this work, as in the group's earlier *Fluxspace 1.0* (2000) and *Fluxspace 2.0* (2001), the fluidity of virtual space becomes part of the physical environment of the installation. A distorted and seemingly inverted urban landscape is projected onto an amorphous shape hanging in the middle of a room with mirror-covered walls. The resulting reflections seem to create a virtual 3D architecture that surrounds the viewer.

75. Masaki Fujihata, *Global Interior Project,* 1996.
Participants enter and interact with the world through a 'Cubical Terminal', which contains a computer and trackball. Using the ball, participants travel through a maze of interconnected virtual cubic rooms that resemble the physical terminal and are distinguished by the objects they contain (such as an apple or a hat). In the virtual space, each participant is represented by a character – a cubic form with a video image of the participant's face mapped onto it – and people can talk to each other as they meet in rooms. The activity in the cubicals of the virtual space is in turn mapped in 'Matrix Cubes', stacks of boxes with doors, each of which corresponds to a particular virtual room. If someone accesses a room, the door of its box opens.

Both Redl's and Asymptote's work have an underlying focus on transporting characteristics of the virtual into the actual realm, augmenting notions of physical space. The attempt to blend the virtual and actual and fuse them in a world where one mirrors the other was undertaken in Japanese artist Masaki Fujihata's (b. 1956) *Global Interior Project* (1996), a networked multi-user environment that creates a mirror world, in which the physical installation seems to become a map of a virtual world: the installation itself represents the architecture and construction of the virtual space. As its title suggests, *Global Interior Project* blurs the boundaries between exterior and interior, creating corresponding worlds of the virtual and actual that seamlessly blend.

Architect Marcos Novak has described cyberspace as a 'liquid architecture' where all structures are programmable and thus fluid, capable of transcending the laws of the physical world and reacting to the viewer in an intelligent way. The endeavour to create this form of responsive 'intelligent environment' in actuality has played an increasingly important role in art and architectural projects, where models of the fluidity and transparency of a dataspace inform an understanding of physicality. The ultimate intelligent environment was envisioned in Stanislaw Lem's novel *Solaris* (1961) – adapted for film by Andrei Tarkovsky

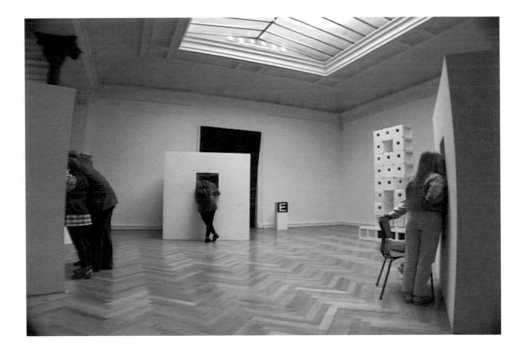

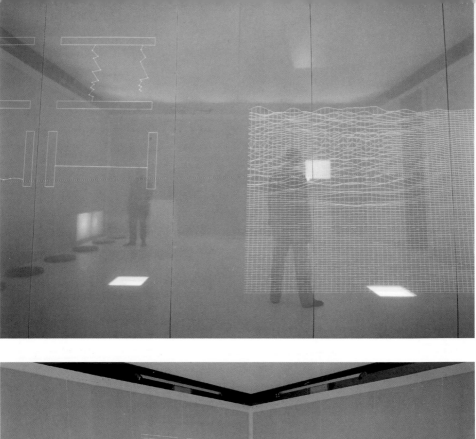

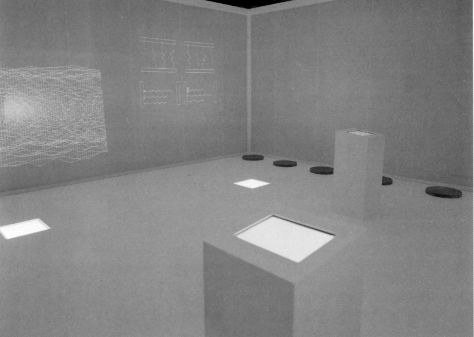

76. Marko Peljhan in collaboration with Carsten Nicolai, *Polar*, Artlab 10, Hillside Plaza, Tokyo, 2000. The data collected by visitors through a recording device is analysed and translated into seven keywords that appear on the two monitors in the space. By choosing one of the keywords, participants trigger a search system that compiles a 'dictionary' of related concepts from databases and websites on the Internet. Interacting with the dictionary, users customize and develop it, using the parameters set by the original knowledge database as a basis for their own transformation of the dataspace. The installation also includes real-time projections of wave shapes, which are processed corresponding to the information collected by the visitors. The space itself thus becomes a kind of living matrix that responds to the participants.

and, recently, Stephen Soderbergh – where the whole fictitious planet Solaris is an intelligent system and organism capable of reflecting human emotions and thoughts. Lem's novel was a direct inspiration for the project *Polar* (2000) – a collaboration between Slovenian artist Marko Peljhan, German sound artist Carsten Nicolai (b. 1965), and Canon Artlab – which strives to re-create an intelligent dataspace in a physical environment. Suggesting antagonisms, the project explores the concept of different poles in dataspace and the ways in which various forms of information can materialize in a dynamic matrix. The space of the installation is entered by two people at a time, each equipped with a device that allows them to record and collect sensory information – such as images, sounds, temperature, and cultures of microorganisms that respond to the temperature and light conditions in the space. Each pair of visitors changes the space and creates a new starting position for the next couple.

The inversion of installations such as *Polar* forms another strand of installation work that investigates the representation of physical space and architecture in the virtual realm. The performative element of this process is emphasized in *Adrift* (1997–2001), a collaborative project by Jesse Gilbert, Helen Thorington, Marek Walczak, and other contributors, which has been presented in different configurations over the years. The multi-location project establishes a connection between virtual and real geographies by mixing imagery recorded by cameras in public spaces with virtual 3D spaces, text, and sound, which are projected onto a semicircular screen in a physical location. *Adrift* depicts journeys that collapse dataspace and physical, mediated environments, creating a collage in which the distinctively different elements reflect on the spatial characteristics of the language of different media (video, text, sound, 3D). The multimedia research team Knowbotic Research (Yvonne Wilhelm, Christian Hübler, and Alexander Tuchacek) also created various installations that investigate the depiction of actual locations in a data world, both in the context of natural and urban environments. Knowbotic Research's interdisciplinary project *Dialogue with the Knowbotic South* (*DWTKS*; 1994–7), in particular, focused on issues of representation and simulation in the realms of art and science, where navigation of virtual environments and the interface have become primary concerns. Science increasingly relies on simulation in its use of 3D worlds, virtual reality, and immersive environments. Art is exploring the same environments – sometimes using scientific data – in an attempt to construct

77. (overleaf) **Jesse Gilbert, Helen Thorington, and Marek Walczak, with Hal Eager, Jonathan Feinberg, Mark James and Martin Wattenberg**, *Adrift*, 1997–2001

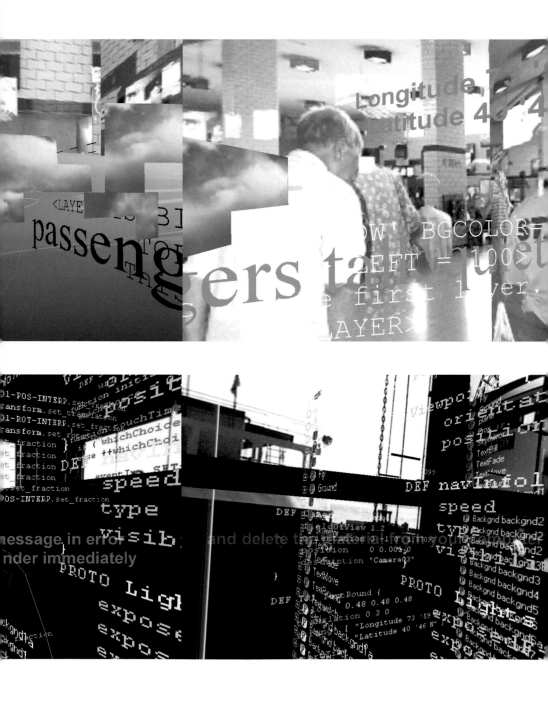

realities and ways of communicating. An underlying concern for both art and science are the spaces in between the actual and the virtual worlds and realities, the gaps and overlaps between these different areas and states, including subjectivity and objectivity. *Dialogue with the Knowbotic South* made it possible for users to trace how science and technology transform nature – in this case Antarctica – into computer-aided nature. The installation of *DWTKS* allows an interaction with a dynamic data-landscape. The information landscape incorporates data sets, models, and simulations of Antarctic research which symbolize links to natural events at the South Pole. Visitors were able to navigate through a Web environment as well as through a local, real-time computed model of the *DWTKS* environment.

One of the crucial issues raised by *DWTKS* is that of the relation between representation and simulation. The issue of representation plays an important role in the arguments of theorists such as Friedrich Kittler, William Mitchell, and Edmond Couchot who understand the digital image as simulation. Mitchell makes a distinction between the cinematic and electronic image as *representational* and the simulated, digital image as *presentational*. One could certainly claim that everything created and presented by means of a computer ultimately is a simulation but the

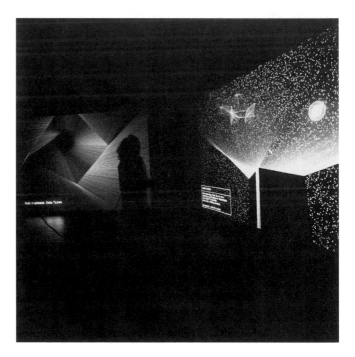

78. **Knowbotic Research**,
Dialogue with the Knowbotic South,
1994–7

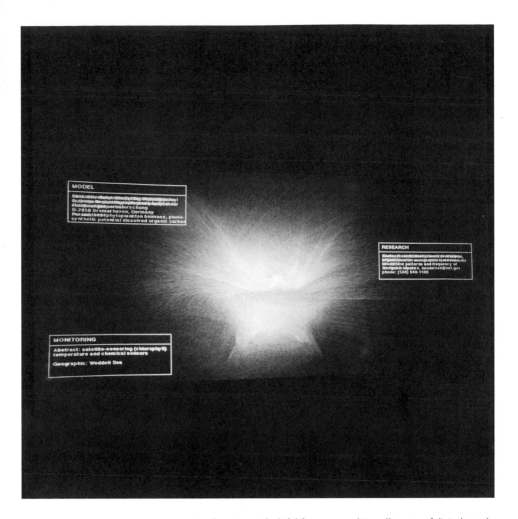

terminology is not helpful for approaching all types of digital work. It is also problematic to construct representation and simulation as a dichotomy. Simulation can be defined as the imitative representation of one system or process by another. In a flight simulator, for example, the reality of navigating a plane is replaced by the digital simulation of this process. However, the simulation is geared towards being as 'representational' and as close to reality as possible. This representational quality has become a major goal in science, as well as the gaming and entertainment industries, which strive to imitate the look of actual, physical objects or live beings. *Dialogue with the Knowbotic South* posed the (open) question of whether scientific knowledge can be translated into aesthetics, and whether there are possibilities for new visuals

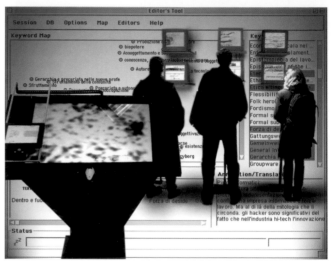

79. Knowbotic Research,
10_DENCIES, 1997–9.
This project created hypothetical interfaces for mapping and intervening with the 'tendential' forces that influence the dynamics of cities. In collaboration with architects, urban planners, and inhabitants of the cities, Knowbotic Research developed profiles of the activities and growth factors of Tokyo, São Paolo, and Berlin. Urban data layers were translated into 'electronic fields' that were open to interventions and collaborations, and an interface on the Internet offered users worldwide an opportunity to join the dialogue. *10_DENCIES* was aimed at creating an interdisciplinary discourse on city development, and by its very nature fused the local and the global: discussions about the construction of these public spaces took place both locally and in the new public space of the network.

without simple visualization. Knowbotic Research continued their investigations into possible interactions between the actual, the virtual, and the hypothetical in their project *10_DENCIES* (pronounced 'tendencies'; 1997–9), which focused on the development of cities and urban process.

The navigation of any kind of virtual space is always dependent on layers of interfaces. One of these layers is constituted by the input device, be it a bicycle, a mouse, or a joystick; a screen of some kind constitutes another level of interface; and the virtual structure that represents the information – the world of letters in Jeffrey Shaw's *The Legible City* or the cubicles in *Global Interior Project* – adds yet another layer. Interfaces make a work open to

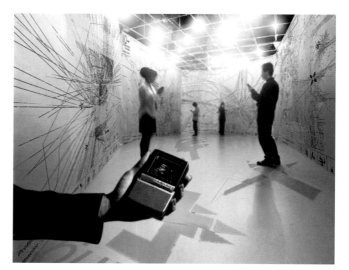

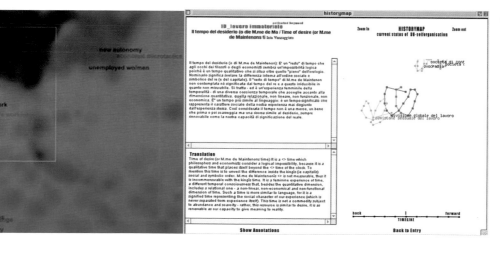

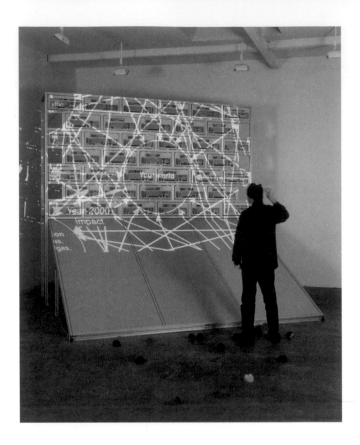

80. **Perry Hoberman**, *Cathartic User Interface*, 1995/2000. Hoberman's installation allowed users to vent their frustration with new technologies: the audience was invited to throw mouse-like balls at a wall created out of obsolete PC keyboards (top right), triggering projections that are modified versions of the familiar pop-up windows and control panels that appear on computer screens and so often become obstacles for productive interaction (bottom right). A menu might ask users for a password, which they obviously do not possess, while the buttons on the menu offered them the possibility to 'Give Up'.

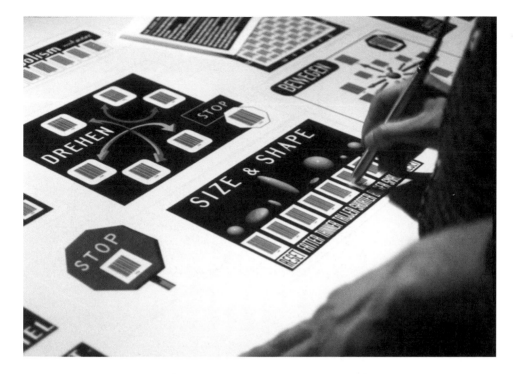

81. **Perry Hoberman**, *Bar Code Hotel*, 1994. In this project, the ubiquitous bar code symbol becomes an interface to a virtual environment. Guests to the 'hotel' receive a unique wand that allows them to scan and transmit bar codes printed throughout the room and instantaneously transmit them to a computer system, which generates objects in a projected virtual environment. Each object in the projection corresponds to a different guest but is only partially under the control of its creator. The objects have their own distinct 'personalities' and behaviours and interact with each other and their environment.

interaction and in themselves constitute a level of content that warrants investigation. American Perry Hoberman (b. 1954) is among the artists whose work focuses on the critical examination of interfaces in their various forms: in projects such as *Timetable* (1999) [82], *Cathartic User Interface* (1995/2000) and *Bar Code Hotel* (1994), he has explored the signification and connotations of different types of interface. *Timetable* consists of twelve dials that are positioned around the perimeter of a large circular table with an image projected from above onto its centre. The dials' functions change and mutate – they can become clocks, gauges, speedometers, switches, steering wheels, etc. – depending on what is projected onto them at any given moment. The real-time 3D scene at the centre of the table is controlled and influenced by the movements of the dials. The space of *Timetable* undergoes constant transformations and becomes more complex and multi-dimensional as it is used. Perspectives split off from each other, creating an awareness of the 'timeframes' suggested by different interfaces and underlining the different expectations and associations they evoke.

The connections between physical and virtual architecture and space established by many of the previous projects find their counterpart in a body of installation work that focuses primarily

82. **Perry Hoberman**, *Timetable*,
1999

83. Bill Seaman with Gideon May, *The World Generator/ The Engine of Desire*, c. 1995– present. Users construct a virtual world by selecting media elements such as 3D objects, pictures, digital movies, poetic phrases, and sound objects, which are then projected onto a fifteen-foot-wide screen. Once the elements have been selected and placed onto the space, users can navigate through them and observe them from all sides. Users can also alter an object's surface and create 'textures' by projecting an image or movie onto it; they may also present a movie on a nested screen in the space, which plays when they (virtually) approach it.

on the construction of virtual environments. One of the artists who has consistently explored this field is American Bill Seaman (b. 1956). He has created a series of 'Engines' works that create spaces of combination generating an ever-increasing complexity of meaning. Among them are *The World Generator/The Engine of Desire* (c. 1995–present) – a virtual environment created in collaboration with programmer Gideon May – which allows participants to build and explore virtual worlds, as well as *The Engine of Engines* (2011–present) and *An Engine of Many Senses* (2013). In 1995, he coined the term 'Recombinant Poetics' for an approach to computer-based works enabling the exploration of media elements in different orders and combinations, explicitly establishing connections between his project and the literary experiments of OULIPO. Seaman also investigated the navigable combination of text and images in earlier projects such as *Passage Sets/One Pulls Pivots at the Tip of the Tongue*, which allowed users to create a multimedia poem of words, images,

84. **Bill Seaman with Todd Berreth**, *An Engine of Many Senses*, 2013. This generative software project uses 2D and 3D imagery, video, text, and audio to explore the history and potential future of the computer. The internal rules of the software generate combinations of texts and collaged images relating to computational history, as well as diagrams of systems that have never been built. It is shown on high-definition screens or as projections on architectures.

and media clips, and continued this investigation in his work *The Hybrid Invention Generator*.

In distinct ways, all of the installations discussed here raise fundamental questions about the construction and perception of space. Edmond Couchot has argued that the digital does not represent the parameters of space as we know it in other media forms. According to Couchot, dataspace, although accessible through hardware that is part of our physical reality, is an exclusively symbolic space, purely made up of information. As a space constructed out of calculations, it certainly differs from the spaces of our physical reality in many ways; it is the

spatial reference system used in digital media. Any discussion of differences between physical and virtual space requires a clarification of what we understand as space in the first place. In his essay 'Anthropic Cyberspace', architect Peter Anders, whose publications include the book *Envisioning Cyberspace*, argued that what we experience as space is actually the product of complex mental processes and that cyberspace is an extension of consciousness. As Anders puts it, distinguishing a brick from its image is a matter of perception and cognition rather than a polarization of reality and simulation. Issues of perception and cognition are in fact a basic element in examining the characteristics of virtual space and play a key role when it comes to the degree at which the physical and symbolic differ or blend. This form of blending is epitomized in Jeffrey Shaw's project *The Golden Calf* (1994), which addresses notions of the virtual 'post-object' by blurring and questioning the boundaries and intrinsic characteristics of the virtual and physical object.

Virtual space has become a broad term that is applied to everything accessible through a computer screen, but as the

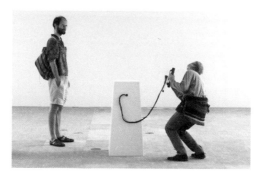

85. **Jeffrey Shaw**, *The Golden Calf*, 1994. The piece consists of a pedestal and a colour screen on which is displayed a virtual sculpture of a golden calf. Visitors can look at the calf from all sides by moving the monitor around the pedestal. The installation is highly site-specific: reflections of the actual physical environment are mapped onto the surface of the calf by using photographs of the room, so that users see their surroundings mirrored on the calf's body. Depending on the lighting and angle, users may also see their own image reflected on the screen, which adds a doubling of the mirror effect and thereby blurs the boundary between real and virtual worlds.

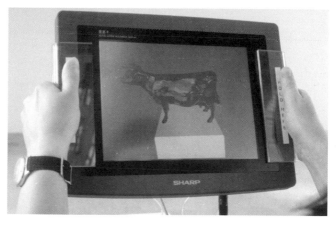

projects above show, the spaces we access are in fact radically different and defy easy categorization. Some of these spaces are 3D worlds (representational or non-representational) that exist in the two-dimensional format of the screen. Many strive to replicate the physical world and its laws: for example, streets and buildings pass in a way that suggests the speed of riding a bicycle. Others defy laws of gravity and allow users to hover above spaces and experience them from a bird's point of view. The virtual world that users experience may not physically exist and only part of it may be visible on the screen, but at the same time it always exists as a (mathematical) construct. The creation of a believable world requires continuity: the environment needs to develop in a continuous way; the reflection of light on an object cannot change its source in the next scene without creating the impression that one is looking at a sequence of still images rather than a scene or 'world'. At the same time, psychological effects do not only rely on the construction of an environment. The adrenaline rush induced by computer games often relies on the psychological perception of speed rather than the realism of graphics. The increasing intersections between virtual and physical space will be further discussed in the context of locative media and public interactives. While virtual space creates new forms of 'worlds' that unfold before our eyes, it is also connected to the history of the moving image, which has affected our assumptions about the mediated representation of the world.

Film, video, and animation
The concept of the digital moving image and 'digital cinema' is a particularly broad area that is informed by several media histories. As theorist Lev Manovich has pointed out, digital media in many ways have redefined the very identity of cinema as we know it. When it comes to the movie industry, cinema will in all likelihood continue to become an increasingly hybrid form that combines film footage with digital effects and 3D modelling, erasing the history of film that is grounded in the concept of 'recording reality'.

The digital medium has affected and reconfigured the moving image in various ways and areas. Digital technologies offer multiple possibilities for an enhanced cinematic representation in installations, a continuation of the spatialization of the image in a physical environment that theorist Gene Youngblood outlined in his book *Expanded Cinema* (1970). Interactivity is another aspect of the digital medium that has a profound impact on narrative and

non-narrative film, and is inextricably connected to the concept of databases, the possibility of assembling and reconfiguring elements from a compilation of image sequences.

A crucial aspect of the history of film and video is the notion of realism, the recording of 'real events'. The very idea of 'realism' gained new dimensions with Web cameras (webcams) in the 90s and the now ubiquitous built-in cameras of computers and smart phones that can transmit live imagery from anywhere in the world over the Internet. Video artists had previously explored live aspects in closed-circuit installations. Although television has been presenting live events for quite some time now, there still is a fair amount of control and filtering involved in this type of

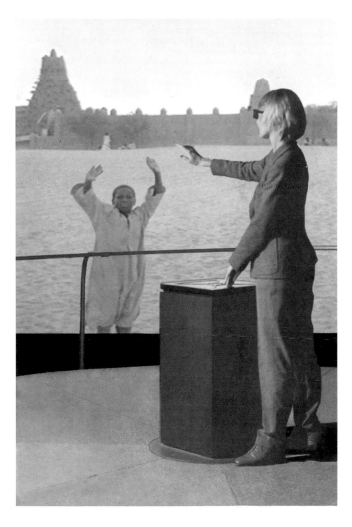

86. **Michael Naimark**, *Be Now Here*, 1995–7. This immersive virtual environment consists of a stereoscopic projection screen and a rotating floor, from which the audience experiences the work. The imagery surrounding the viewer shows public plazas on the UNESCO World Heritage Center's list of endangered places (among them Jerusalem, Dubrovnik, Timbuktu, and Angkor, Cambodia). Wearing 3D glasses, users choose a specific time and place by means of an input interface on a pedestal.

one-to-many broadcasting system. Events that are 'streamed' live in a many-to-many broadcasting system such as the Internet challenge and relinquish this form of control.

The early moving images of the nineteenth century created by pre-cinematic devices were mostly based on hand-drawn images. This strand of the history of cinema developed into animation, a medium that has also gained new momentum and popularity through the possibilities of the digital platform. We now associate cinema and the moving image mostly with live action, which in fact is only one strand of its history. The 3D worlds commonly created in digital art constitute yet another form of the moving image that exists in a category of its own.

Among the artists who have addressed issues surrounding the spatialization of the moving image are Michael Naimark, who has done numerous studies in the field of 'dimensionalized

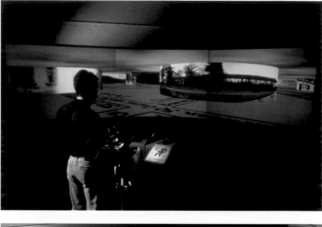

87. **Jeffrey Shaw**, *Place, a user's manual*, 1995. Shaw's installation makes use of a cylindrical projection screen and a round, motorized platform at its centre. The projected computer-generated scenery consists of landscape photographs taken with a panoramic camera. The scenes are projected onto a 120-degree portion of the screen, and users can travel through them by using a modified video camera as an interface. By rotating the camera and using its zoom and play buttons, the viewer controls his forward, backward, and rotational movements, as well as the movement of the platform. In addition, the screens are inscribed with the Sephirothic 'Tree of Life' – a Hebrew diagram of symbols that represent the spiritual realm – so that each real place is linked to a symbolic location. Sounds made by the viewer trigger three-dimensional texts within the projected scene that comment on place and language and temporarily inscribe the viewer into the scene.

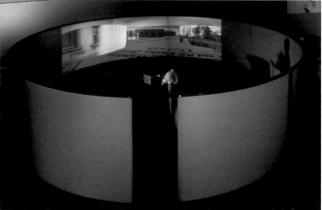

movies' and played an instrumental role in the creation of the first interactive videodiscs, and Jeffrey Shaw. Both Naimark's *Be Now Here* (1995) [86] and Shaw's installation *Place, a user's manual* (1995) combine various media forms, from landscape photography to panorama and immersive cinema, and redefine the basic spatial characteristics of cinema as a projection onto a flat screen in a darkened room. A more intimate panoramic insertion of the viewer into a cinematic environment takes place in *The Visitor – Living by Numbers* (2001) by Canadian Luc Courchesne (b. 1952), who has done various forms of interactive films, among them interactive portraits of people. In the installation, visitors step under a small projection dome that can be adjusted to their height, so that their head is encircled by the enclosure. The projected environment first places viewers in the Japanese countryside and they can then begin to navigate the video –

88. Luc Courchesne, *The Visitor – Living by Numbers*, 2001. Courchesne's installation was inspired by Pier Paolo Pasolini's film *Theorema* (1969) and by a dream his daughter had at the age of ten. The visitor's journey through the countryside that is projected on the inside of the inverted dome leads to encounters with local people, and choices he or she makes when navigating – such as staying with or leaving the inhabitants (as in Pasolini's film) – lead to an increasingly personal engagement and a sense of community.

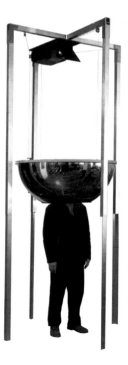

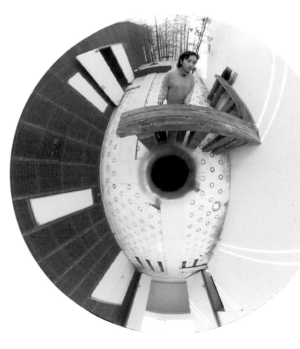

recorded by means of a panoramic lens – by saying a number between one and twelve, which respectively changes the route they are travelling through the film. Courchesne's project is a reflection on narrative pace and the time that the camera and viewer need to spend with a location or person in order to unveil personal stories and histories.

An exploration of interactive portraits in a public space unfolds in Rafael Lozano-Hemmer's *Body Movies* (2001), which combines techniques of *trompe l'oeil* and shadow play. Presented in Rotterdam in 2001, the project transformed the Schouwburgplein square into a 1,200-square-metre interactive projection environment. By means of robotically controlled projectors located around the square, portraits of people from cities around the world were projected onto walls. However, the portraits were faded out by powerful lights placed on the floor of the square and became visible only if passers-by threw shadows onto the walls, which made the portraits appear inside their silhouettes. While the project in itself has a distinctly performative aspect, it gained new dimensions when people repeatedly returned to the site to stage their own gigantic shadow plays.

Spatialization of the moving image does not necessarily have to take the form of immersive environments or large-scale

89. **Rafael Lozano-Hemmer**, *Body Movies: Relational Architecture #6*, 2001. The piece reversed the traditional roles of light and darkness – the basic elements of cinema – in the production of projected images, for shadows were necessary for the projections to become visible. Depending on how close the pedestrians came to the lights in the square, their shadows would be between two and twenty-two metres high. A camera-based tracking system monitored the shadows and, once they had revealed all the portraits in a given scene, a computer changed the scene to a different set of portraits.

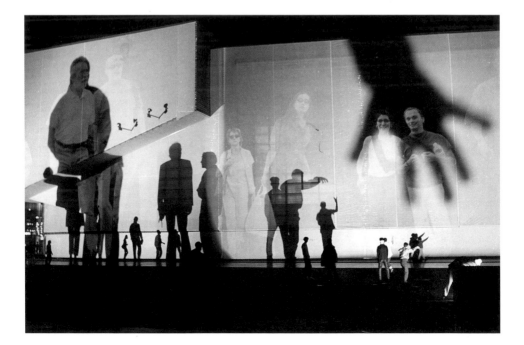

projections but is inherent to any kind of delivery mechanism. The works of Jennifer and Kevin McCoy experiment with a very different kind of enhanced cinema that focuses on the construction of single shots and the messages they convey. Using database narrative as a formal strategy, their video installations *Every Shot Every Episode* (2001) and *How I learned* (2002) carry the medium of film/video into the realm of digital art by fusing the characteristics of the two. The works are presented as videos on CDs that are neatly stacked or arranged on the wall and can be chosen and played by the viewer in the 'old-fashioned', hands-on

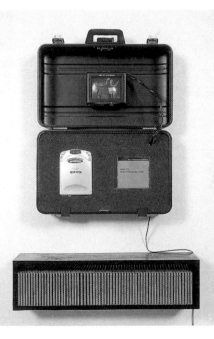

90. (above right) **Jennifer and Kevin McCoy**, *Every Shot Every Episode*, 2001

91. (right) **Jennifer and Kevin McCoy**, *How I learned*, 2002. The work, by systematically organizing and displaying film shots or sequences in categories such as 'How I learned about blocking punches', 'How I learned about exploiting workers', or 'How I learned to love the land', exposes the way learned behaviour is culturally conditioned.

interactive way. While the works appear to be a video installation in the classical sense, they would not be possible without the digital medium's possibilities for the classification, reproduction, and reconfiguration of existing materials. *Every Shot Every Episode* consists of every shot in twenty episodes of the American television series *Starsky and Hutch*, broken down into a database of single units (such as 'Every Zoom Out' or 'Every Stereotype'). The work examines the elemental aesthetics of familiar genres, exposing the subtexts of stereotypes and representation that the viewer might otherwise not necessarily perceive and thereby turning the database into a narrative of culture.

The element of interaction in film/video is not intrinsic to the digital medium and has already been employed by artists who experiment with light in their projection (for example, by incorporating the audience in the artwork through 'shadow play') or with live video captures that made the audience the 'content' of the projected image and artwork. Jim Campbell is among the artists who have frequently incorporated interaction in their video work (both digital and analogue). One of his earlier works, *Hallucination* (1988–90) undermines and distorts notions of the live image. A deceptively simple, yet powerful statement on the aesthetic implications of the 'live' image is Wolfgang Staehle's *Empire 24/7* (2001) [93] – an image of the Empire State Building streamed live over the Internet. Just like Andy Warhol's work of the same name (a seven-hour video of the building), Staehle's *Empire* suggests a constantly evolving photographic image that becomes a continuous record of minute changes in light and every aspect of the environment. The piece raises fundamental questions about the nature of the 'live' (yet mediated) image and its place in the context of art. Does the 'live' image render previous art forms obsolete? What role do the aesthetics of processing and mediation play in our perception of an artwork? By now, we are used to seeing live images of landmark buildings or sites on television or through Web cameras. Encountering this type of image on the wall of a gallery or museum, however, constitutes a radical change of context that poses essential questions about representation and the nature of art itself. *Empire 24/7* is a highly ephemeral, time-based document that cannot and will not ever be repeated (except as an archived version). Similarly, in September 2001, Staehle had a solo show at Postmasters Gallery in New York, where he presented three live views, one of them through a Web camera pointed at downtown Manhattan. The events of 11 September unfolded live on the

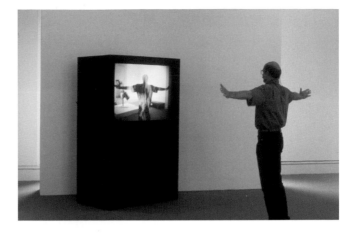

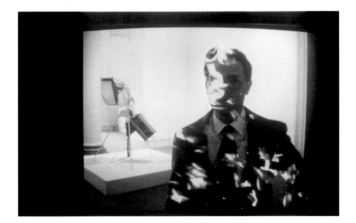

92. **Jim Campbell**, *Hallucination*,
1988–90. The video functions
as a mirror in which viewers
see themselves in the gallery
environment as they approach
the screen. Coming closer,
their bodies burst into flames,
accompanied by the sound of
fire; a woman then suddenly
appears next to the viewer on
the screen. Campbell's work plays
with the 'hallucination' of reality
and interactivity in the television
picture, blurring the boundaries
between a live and constructed
image and questioning the level of
the user's control.

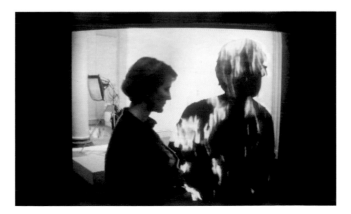

93. **Wolfgang Staehle**,
Empire 24/7, 2001

gallery's walls, creating an unexpected and shocking context for the concept of 'the ultimate realism' in art.

The exploration of non-narrative moving images in digital art has its counterpart in works that construct a digital cinema based on interactive visual narratives. Among the earliest interactive narrative films is Lynn Hershman's (b. 1941) *Lorna* (1979–84), a project that unfolds on the television screen and is navigated by viewers via a remote control. Interactive video and film is particularly challenging in that visuals tend to determine and characterize place, time, and character in a more pronounced way than text. While a hyperlinked textual narrative also incorporates the elements of 'montage' or 'jump cuts', the visual translation of a scene remains an entirely mental event that will be informed by the interpretation and meaning the reader supplies. As Grahame Weinbren, who has created some of the classics in the genre of narrative video, has pointed out, the abandonment of control over an image sequence implies giving up cinema as we know it. Weinbren's piece *Sonata* (1991–3), a narrative in which the viewer is able to modify a flowing stream of story, blends two classical works: the biblical story of Judith who pretended to seduce and decapitated the general Holofernes, and Tolstoy's *The Kreutzer Sonata*, in which a man's suspicion that his wife might have an affair with a violinist leads him to kill her. Viewers can move from one story to another or experience each of the stories from multiple points of view by pointing at the projection screen through a custom-designed interactive picture frame. The fact that the two stories fused by Weinbren mirror and reverse each other

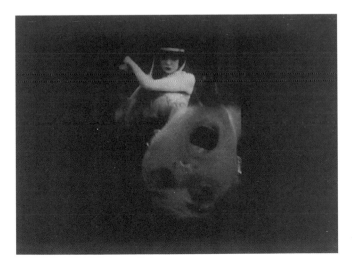

94. **Grahame Weinbren**,
Sonata, 1991–3

in their focus on murder and seduction establishes a narrative framework for the reader that transcends the necessity for linear development. The possibilities of interactive narrative are also at the core of Toni Dove's digital video installations *Artificial Changelings* (1998) and *Spectropia* (2007), the first two instalments in a trilogy of interactive films that address the unconscious of consumer economies. *Artificial Changelings* is the story of Arathusa, a nineteenth-century kleptomaniac, and Zilith, a woman of the future who is an encryption hacker. The installation consists of a curved rear-projection screen and four sensor-controlled zones on the floor in front of it. By stepping onto the interactive zones, viewers/participants influence and control the narrative. In 2008/2010 *Spectropia* was performed as a live-mix cinema event, a scratchable movie in which live performers orchestrate onscreen characters by means of a system of motion sensing that serves as a playable cinematic instrument creating a narrative form that combines characteristics of feature film, video game, and VJ mashing. Like Weinbren, Dove uses mirroring stories (as well as consumer culture, emerging technologies, and the economic and mental 'disorders' brought on by them) as a narrative technique for viewer orientation.

The first full-length interactive online feature film was David Blair's *WAXWEB* (1993) [97], a hypermedia version of his movie *Wax or the Discovery of Television Among the Bees*. An 85-minute

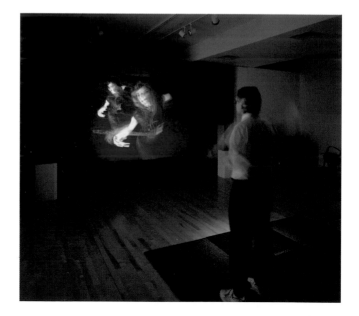

95. (right and opposite, top) **Toni Dove**, *Artificial Changelings*, 1998. On the zone closest to the screen, viewers find themselves inside a character's head; stepping onto the next zone prompts a character to address the viewer directly; the third zone induces a trance or dream state; the area most removed from the screen results in a time travel that lets the viewer emerge in the other century, switching from the reality of one character to the next. Within each of the zones, movements of the viewer cause changes in the behaviour of the projected video and sound.

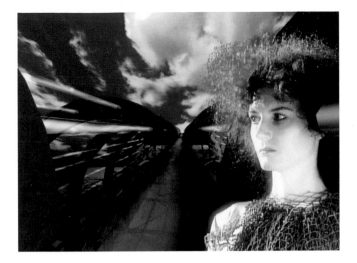

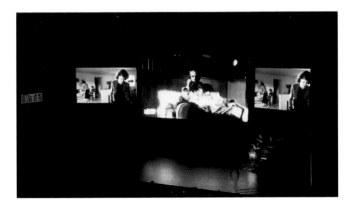

96. (centre) **Toni Dove**, *Spectropia*, 2008. Live mix interactive cinema performance at the Experimental Media and Performing Arts Center, Troy, New York.

(bottom) **Toni Dove**, *Spectropia*, premiered 2007. *Spectropia* uses the metaphor of time travel and supernatural possession to connect two narratives, one taking place in the future and the other in 1931, after the stock market crash.

WAXWEB { 25:59 / 1:20:00 } - { Round Again:Eye } - Netscape

File Edit View Go Window Help

Within the image:

Through the television, I could read my grandfather's diary at the Garden of Eden.

Images: A final gathering of static-sided tvs lets us travel through soft-edged bees into the black and white face of distorted Jacob.

14

Document: Done

97. **David Blair**, *WAXWEB*, 1993

movie in 80,000 pieces, *WAXWEB* is clearly embedded in the concept of database cinema, allowing users to assemble the discrete elements of the narrative, which itself reflects on the history of cinema and cinematography. The possibilities of a database cinema, with an emphasis on time, are explored in Jennifer and Kevin McCoy's *201: A Space Algorithm* (2001), an online software program that allows viewers to re-edit Stanley Kubrick's science-fiction film *2001: A Space Odyssey* by selecting shots and compressing or expanding viewing time. Users control not only the spatial components of the narrative but also its temporal construction, questioning the time and space paradigms of cinema. Database cinema has found its continuation in the so-called 'supercut', a popular YouTube genre, which obsessively edits together every instance of a specific theme. Cory Arcangel's (b. 1978) video *Drei Klavierstücke op. 11, 1909* (2009), for example, assembles Arnold Schoenberg's famous piano pieces entirely from YouTube clips of kittens playing piano, raising questions about the intersections between high art and pop culture enabled by online video sharing.

Short films on the Internet quickly became a genre in itself. Apart from digital video, another form of production and presentation of the digital moving image has been provided by software such as Adobe Director (formerly Macromedia

Director) and Flash, which allow for the creation of 'movies' by combining video, animation, and multimedia elements. Mark Amerika's project *Filmtext* (2001–2) introduces itself as a 'digital thoughtography' and connects the languages of film and text with multimedia features, reflecting on their inherent characteristics. One of the early and most original takes on the possibilities of 'Internet film' is British artist Nick Crowe's *Discrete Packets* (2000), which combines film with the language of the Web browser. The project presents itself as the homepage of a man called Bob Taylor from Manchester. Using graphic elements and layout that epitomize tasteless Web design, the page contains links to the local soccer team and Taylor's plea for help in the search for his daughter Angela, who went missing in 1984. The project creates an intricate web of fact and fiction by linking to actual websites (such as missing persons' sites on the Web, where one actually finds Angela listed) while a movie (created in Director) documenting Taylor's search unfolds in the window of the Web browser, using the browser's navigational features to drive the narrative.

Software such as Flash has also contributed to a new wave of animation, a genre that has experienced a revival as a result of

98. **Nick Crowe**, *Discrete Packets*, 2000

the advances of digital technologies. Animation has continuously merged disciplines and techniques and still exists at the border of the entertainment industry and art world. Exactly how far animation can and should be considered an art form remains the topic of debate, but it certainly is now more frequently incorporated in exhibitions. In 2001, the PS1 Contemporary Art Center in New York devoted a whole exhibition, 'Animations', to the form, juxtaposing different techniques and classics of the genre with projects done by established artists. The blurring of the commercial and artistic aspects of animation is perfectly captured in the project *No Ghost Just a Shell* by the French artists Pierre Huyghe and Philippe Parreno, who purchased a *manga* (comic) character, a Japanese figure template created for use in animation and comic books, from one of the major Japanese agencies that specializes in the production of these off-the-shelf characters. The character, Annlee, has few facial attributes, no history and no life; she is a fictional shell with a copyright, waiting to be filled with a story. Parreno and Huyghe both created

99. **Philippe Parreno and Pierre Huyghe**, *No Ghost, Anywhere Out of the World* from *No Ghost, Just a Shell*, 2000–present

animations – *Anywhere Out of the World* (2000) and *Two Minutes Out of Time* (2000) – in which Annlee reflects on her absurd and tragic situation. Further questioning the status of copyright and ownership, they also distributed the character to other artists (Liam Gillick and Dominique Gonzalez-Forster), who created additional interpretations of the character. The title of the work, *No Ghost Just a Shell*, alludes to the famous *manga Ghost in the Shell* by Masamune Shirow, a science-fiction story that takes place in a world that has been made borderless by the Net and allows augmented humans to live in virtual environments.

Related to animation is the cinematic form of Machinima, the shooting of movies in real-time virtual game environments and worlds, which has developed into a vast genre of its own. The advent of the video-sharing website YouTube in 2005 supported new levels of experimentation with moving images and an obsessive remix culture. In their ongoing *The Folksomy Project* (2009), the artist team jodi (Joan Hemskeerk [b. 1968] and Dirk Paesmans [b. 1965]), for example, selects user-generated videos from YouTube and uses the tagging strategies of folksonomies to reflect on YouTube memes.

Internet art and networked art
Digital art found a new form of expression with the advent of the World Wide Web in the mid-1990s. Since its beginnings in the late 1960s, ARPANET had been growing steadily, with a constantly increasing number of nodes. After the National Science Foundation became involved in the network's development in 1984, it advanced at an unprecedented speed (the original ARPANET formally expired in 1987). Among the pioneering arts organizations on the Net was the New York–based The THING (founded by Wolfgang Staehle), which, in 1991, already existed as a bulletin board service – an electronic messaging system – dedicated to contemporary art and cultural theory. The World Wide Web (WWW) as we know it today was conceptualized in the early 1990s by Tim Berners-Lee and CERN (the European Particle Physics Laboratory) with the intention to build a 'distributed collaborative multimedia information system'. The World Wide Web is based on the hypertext transfer protocol (http) that allows one to access documents written in HTML (Hypertext Markup Language), a language that makes it possible to establish links between documents and arbitrary nodes. Just like the Internet, the early WWW was dominated by education

and research institutions, a largely unregulated space for free information sharing. The commercial colonialization of the Internet, with the ensuing 'dot com' craze and demise, began only in the late 1990s and found its extension in the social media and Web 2.0 era. Art on the Internet is in many ways characterized by the tension between the philosophy of the free networked space and its existence in a commercial context.

Internet art has existed since the inception of the early World Wide Web, with several 'movements' developing at the same time. It has become a broad umbrella for numerous forms of artistic articulation that often overlap. There are textual and audio-visual projects that explore narrative or experimental forms; netactivism projects that use the network and its possibilities of instant distribution and copying of information as a staging platform for interventions, be they support of specific groups or a method of questioning corporate and commercial interests; and performative projects that have been taking place as actions on platforms ranging from early chat rooms and mailing lists to online games and Facebook, YouTube, and Twitter, where they can be experienced by Web visitors worldwide.

In the mid-1990s, a core group of European artists, among them Russian artists Olia Lialina (b. 1971) and Alexei Shulgin (b. 1963), British artist and activist Heath Bunting, Slovenian Vuk Cosic, and the Barcelona-based collective jodi, who were connected through the online mailing list nettime – founded by media theorists and critics Geert Lovink and Pit Schultz and devoted to Internet culture and criticism – drew attention to the genre of art on the Net and formed the 'net.art' (with a dot) movement. The term was officially used for the first time when Vuk Cosic organized a small gathering – 'net.art per se' – in Trieste in 1996. Discussions about the net art genre also took place on Rhizome, a New York–based online forum for new media art founded by Mark Tribe. Net art fairly quickly established its own art world on the Web with online galleries, curators, and critics, among them Tilman Baumgärtel and Josephine Bosma. Among the early online galleries was Benjamin Weil's äda'web, a digital foundry that featured work by net artists as well as established artists, for instance Jenny Holzer and Julia Scher, who expanded their practice with the new medium. In the early years, funding strategies for net art and online galleries were as experimental as the art itself. After äda'web lost its financial support, the gallery and its 'holdings' were permanently archived by the Walker Art Center in Minneapolis, which early on started

exhibiting and supporting net art. The Machida City Museum of Graphic Arts in Tokyo started sponsoring a competition for 'Art on the Net' in 1995, but recognition for net art in the art world at large would remain scarce until the end of the century.

The early WWW was a largely textual and not very sophisticated medium, and early net artworks were often very conceptual, driven by a sense of community and a spirit of spontaneous interventions. In 1997, Alexei Shulgin arranged the WWWArt Award, which consisted of found sites that were given awards in categories such as 'Research in Touristic Semiotics', which went to a guide for common traffic signs around the world, or 'Flashing' (blinking images were a characteristic of one of the Web's developmental stages); he also organized the Form Art Competition (1997), asking contributors to create art out of formal elements, such as radio buttons, scrollbars, and pull-down menus. Vuk Cosic popularized ASCII art, creating still images and videos that are made entirely out of alphabetic and numeric characters. With Walter van der Cruijsen and Luka Frelih, Cosic made works under the label ASCII Art Ensemble. The duo jodi literally turned the common Web interface and desktop elements inside out: pages of seemingly 'broken' HTML with integrated scroll bars and icons brought the desktop to the foreground of the Web page. Jodi's site was a decidedly low-tech graphics battle – a reminder of the standardization of the interface and the inherent beauty of its form elements and 'sign language'.

Early net art produced some classics of the genre, among them Olia Lialina's *My Boyfriend Came Back from the War* [101] and Heath Bunting's *Read Me (Own, be owned or remain invisible)*. Lialina's piece is a reflection on 'wars' (literally and metaphorically) as well as on communication over the Web. Clicking on the black-and-white images, questions and statements in the frames of the browser window causes a split of the frame (and conversation) into subdivisions of increasing complexity. Lialina herself has commented that the experience of *My Boyfriend Came Back from the War* has been forever changed by the accelerating speed of the Internet and the changes in its context: the tension of the conversation she constructed has been erased by the piece's fast loading time. Her project *Summer* (2013) is both a comment on these shifts in context and a nod to early projects that used the refresh of pages as stylistic means. The project is a short animation of the artist swinging from a playground swing that seems to hang from the top of one's browser window, with each frame of the animation being played back from a different

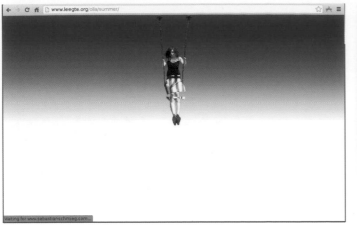

100. (above) **Olia Lialina**,
Summer, 2013

101. (opposite) **Olia Lialina**, *My
Boyfriend Came Back From the War*,
1996. In this interactive Internet-
based work, users move the
narrative on by clicking on images
and words, which causes the
window to split into frames. Lialina
expanded the piece into *The
Last Real Net Art Museum*, which
used the original *My Boyfriend
Came Back From the War* as a
starting point and then developed
into an archive of variations on
the work by other artists. The
project points to the possibilities
for creation and presentation
offered by digital networks, such
as the infinite reconfiguration of
information in an open system, but
not accommodated by traditional
museums.

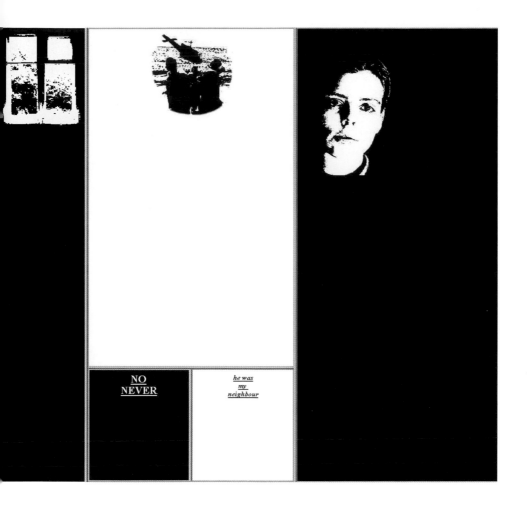

NO
NEVER

*he was
my
neighbour*

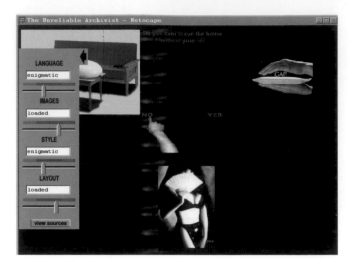

102. **Jon Ippolito, Keith Frank, and Janet Cohen**, *The Unreliable Archivist*, 1998

website. The browser is re-directed from one server to another so that the speed and cycle of the animation are dependent on the individual visitor's Internet infrastructure. Bunting's *Read Me* consists of a short biographical text about the artist, in which every word is linked to its corresponding domain name – the word 'is' links to is.com, for example, 'qualifications' to qualifications.com, etc. – indicating that presence and identity on the Web are a matter of owning domains and 'language', being owned or remaining invisible.

As an informational system that is in constant flux and reorganization, the Internet seems to defy a systematic arrangement of its constituent elements. Links make it possible to connect texts and visuals to the contextual network in which they are embedded, and to visualize a network of references that would normally be separated by physical space. Within this network, information is subject to infinite recycling and reproduction, two concepts that form the basis of a multitude of online art projects. These range from the so-called Web colliders of the 1990s – projects that mix existing information and make it 'collide' into new forms – to the online remix culture of the twenty-first century. *The Unreliable Archivist* (1998) by Jon Ippolito, Keith Frank, and Janet Cohen, for example, uses the projects featured on the original äda'web site as its raw material and allows visitors to reconfigure them. By adjusting four sliders (language, images, style, layout) to the categories 'plain', 'enigmatic', 'loaded', and 'preposterous', users can select text and visuals from any of the äda'web projects, which are subsequently displayed on the

screen in a collage. Authorship and boundaries of the original
projects are erased, and the context for understanding the collage
is largely set by subjective categories determined by the Archivist's
creators. A different approach to the 'remix' was taken by the
British duo Thomson & Craighead (founded in 1994; Jon Thomson
and Alison Craighead) in their project *CNN Interactive Just Got
More Interactive* (1999), which adds a separate browser window
to the CNN site that functions as a kind of 'music box' and allows
users to add a variety of soundtracks to the news provided by the
site. Mixing fact and fiction, *CNN Interactive* unveils and adds to the
infotainment aspect of the economy of news.

A genre specific to the net art of the 1990s is so-called
browser art, the creation of alternative browsers, which rewrite

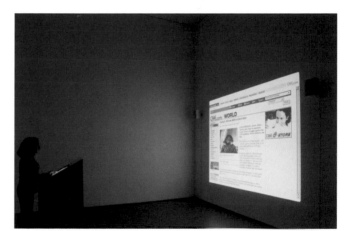

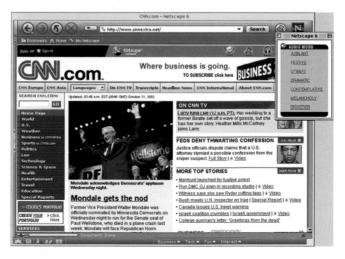

103. **Thomson & Craighead**,
*CNN Interactive Just Got More
Interactive*, 1999

the conventions of our ways of exploring the Web through browsers such as Netscape and Internet Explorer. The ways in which we usually experience information on the Internet is based on conventions rather than any inherent characteristic of the medium: we are viewing websites through the portal of browsers that are ultimately based on the page model of the printed book (or even the ancient format of the scroll). In the early days of the Web, numerous art projects questioned these conventions. The British group I/O/D single-handedly established the 'medium' of alternative browsers with their *WebStalker*, an application that allows users to draw 'frames' in a blank window and select information they would like to display in them – for example, a graphical map of the site that presents all its individual pages as little circles and the links between them as lines; the text from a URL and the source code of the HTML page; a 'stash' of URLs users would like to save. Although the *WebStalker* did not display graphics, it expanded the functionality of existing browsers in an aesthetic and creative way that questioned the paradigms of the conventional information display and Internet 'architecture'.

104. **I/O/D**, *WebStalker*, 1997–present. In his essay 'Visceral facades: taking Matta-Clark's crowbar to software', I/O/D's Matthew Fuller established a connection between the *WebStalker*'s approach to information architecture and American artist Gordon Matta-Clark's technique of 'splitting' buildings. Both are formal procedures that reveal the structural properties of their respective media.

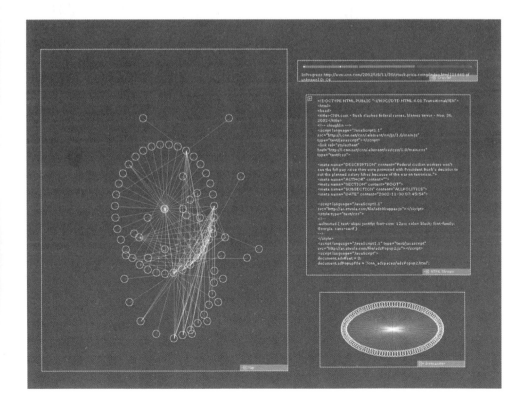

Fireworks Splice HTML...

Check out exhibit news, photos, the History Shop and the Museum's

Museum Background/Information. New Exhibits

The Museum of

Museum Ba

Located in Ann Arbor, the Univer

Where have you been? memory:17 74 speed:563 txt:10 img:10 snd:1

105. **Maciej Wisniewski**,
netomat™, 1999–present

A different approach to experiencing content on the Web is New York–based Maciej Wisniewski's (b. 1958) *netomat™* (1999–present), which abandons the page format of traditional browsers and treats the Internet as one large database of files. In response to words and phrases typed in by the viewer, *netomat™* dialogues with the Internet to retrieve text, images, and audio, and to flow them simultaneously onto the screen without regard to the display design of the data source. Using an audio-visual language designed specifically to explore the unexplored Internet, *netomat™* reveals how the ever-expanding network interprets and reinterprets cultural concepts and themes and takes visitors for a ride into the Internet's 'subconscious'. *Netomat™* is also notable in that it is a crossover between an artistic and commercial context. Originally an art project, Netomat is now also a company sells products for mobile devices based on its underlying language. *WebStalker, netomat™,* and Andruid Kerne's *Collage Machine* (since 1997), which allows users to collage and modify texts and visuals from selected sites, are just three examples of browser art that redefined the conventions of our network experience.

A project with a more explicitly 'political' twist is American Mark Napier's (b. 1961) *Riot* (1999), a 'cross-content' Web browser that combines in one browser window text, images, and links from the three most recent URLs that *Riot* users worldwide have accessed. The basic functionality of *Riot* is still rooted in traditional browser conventions: users surf the Web by entering a URL into the location bar, or by selecting from bookmarks. However, the project blends different websites – for example those of CNN, the BBC, and Microsoft – and, by collapsing territorial conventions like domains, sites, and pages, illustrates how the Net resists traditional notions of territory, ownership, and authority. What all these projects have in common is that they allow us to experience the network in a way that is radically different from the one provided by preconfigured and corporate portals. Today's net art largely takes the environment of the net and its conventions for granted. Artist Rafaël Rozendaal (b. 1980) creates individual web sites and domain names for each of his works, many of them – such as nothingeverhappens.com, mechanicalwater.com, colorflip. com – pop-inspired, colorful and elegant small gestures that owe as much to the history of net art as Op art or abstract painting.

106. **Mark Napier**, *Riot*, 1999

One of the most significant aspects of the Web is that it has created a global platform for exchange and communities of interest. E-mail and mailing lists early on established possibilities for remote communication, which were followed by 2D 'chat' environments and then virtual worlds and online chat that allowed multiple users to engage in live conversation. Among the early multi-user environments that developed on the Web were the so-called MUDs – Multiple User Dungeons (or Domains) that were modelled after the early text-based Dungeons and Dragons computer games such as Zork Zero. In the original game, players navigate through the environment by typing in directionals ('N' for North, 'SW' for Southwest); they pick up clues and objects with text commands ('Get candle') and use them to solve the puzzle and win the game. Online MUDs were based on the same principles but allowed thousands of players to navigate through the rooms, interact with each other, and engage in role-playing games. MUDs found their extensions in MOOs (Muds Object-Oriented), which are based on more sophisticated object-oriented programming and can be expanded by their users. MOOs lend themselves to the construction of anything from adventure games to conferencing systems, and many universities built MOOs that focused on a specific topic of research to enable students and faculty to engage in ongoing discussions. Chat environments entered a new phase with graphics-based worlds like Time Warner Interactive's *The Palace*, which visually represented its rooms and buildings, as well as their inhabitants, and made the communication between people visible in cartoon-like speech bubbles. Several early virtual worlds were created in VRML (Virtual Reality Modeling Language), the 3D counterpart of HTML and were then superseded by environments such as Second Life, which will be discussed later in this book.

In multi-user environments, people commonly create avatars for themselves, visual representations and assumed identities. The term 'avatar' originates from Hinduism and means 'descent', most commonly the descent of a deity to Earth in an incarnate form (although definitions tend to vary depending on the source). While it may be difficult to trace exactly how the term entered cyberspace vernacular, it is at least interesting to note its connotations in the context of identity and community on the Internet and the upload and download (descent) of information to and from the server.

Over the years, numerous artworks have employed multi-user worlds, be they text or graphics based, as performance spaces.

In their project *Desktop Theater* (1997–present), Adriene Jenik and Lisa Brenneis 'invaded' *The Palace* chat environment and used their avatars to stage performances, such as an adaptation of Samuel Beckett's *Waiting for Godot*. The theatrical interventions (in which anyone can take part) become experimental investigations of the virtual as performative environment. This type of experimentation continues in projects such as *Dorm Daze* (2011), a performance piece by British artist Ed Fornieles (b. 1983) and his friends and acquaintances that unfolded on Facebook. Over the course of three months the artist and his friends impersonated fictional characters, supposedly a group of students at the University of California, Berkeley, and staged an improvised soap opera with multiple subplots via Facebook status updates. Feeding off the narcissism of social media culture and exploring conventions of story and identity, Dorm Daze both subverts the online platform and highlights its narrative potential.

Network technologies have become all-pervasive and it would be wrong to understand the Internet and networks as a separate virtual territory that has no connection with our physical environment or that is mainly accessible through a computer in

107. **Adriene Jenik and Lisa Brenneis**, *Desktop Theater*, 1997–present. The crude graphics of the environment and the spontaneous and puzzled reactions of people who happen to stumble into the choreographed performance add a humorous aspect to the work, and at the same time reflect on the contextual parameters of performance, be it the role-play of theatre or that of life.

our homes and offices. We are increasingly networked through mobile networks and the use of smart phones, tablets, and locative media whose use as content and medium will be discussed later in the book. These projects are a continuation of previous artistic experiments involving telecommunication devices such as the telephone or fax. Several early art projects have made use of the SMS (Secure Message System) text messaging functionality of mobile phones. Among these projects was *Speakers Corner* by Jaap de Jonge, a commission organized by media theorist and curator Matt Locke. The physical *Speakers Corner* of the project was a 15-metre-long interactive LED text display on the outside of The Media Centre in Huddersfield, northern England. Participants could interact with the system by sending messages either through their mobile phone, via a phone outside the centre that would convert speech to text, or through a website. During a residency at the Waag Society in Amsterdam, Graham Harwood (a member of the London-based artists' group Mongrel), in collaboration with Matthew Fuller, developed *TextFM*, a program that uses the SMS functionality to turn text into speech and thus allows spoken messages to be transmitted at specific locations.

Other early networked art projects made use of the Global Positioning System (GPS), now a common feature in cars and smart phones. In their project *alpha 3.0*, the Singapore-based artists' collective tsunamii.net tracked and captured their movements in physical space with a GPS device, which in turn triggered browsing activity on the Internet, establishing a synchronicity between motions and communities in real and Web space. For *alpha 3.4* (2002), which was part of Documenta XI in Kassel, central Germany, in 2002, the artists continued this investigation by physically and virtually walking from the Documenta exhibition space to the Documenta website, that is, the website's server – the computer on which it is located – in the city of Kiel in northern Germany. The Web browsing was made possible by a program developed by tsunamii.net called webwalker 2.2, which requires its user to walk to the web page's server.

The first generation of mobile devices, such as Palm Pilots and Game Boys, was early on used by artists to allow people to download artwork from the Internet, take it with them, and exchange it with other people. *Tap* (2002) [109] by James Buckhouse (b. 1972) created a dance school for animated characters that could be downloaded onto Palm Pilots, where they could take lessons, practise, give recitals, and learn from

108. **tsunamii.net**, *alpha 3.4*, 2002. In the Documenta XI exhibition space, several screens documented different aspects of the walker's journey, including the addresses of the websites he accessed on the trip, a satellite map of his geographical position, and his movements as GPS coordinates.

109. **James Buckhouse (in collaboration with Holly Brubach)**, *Tap*, 2002. Users can choose from a variety of tap-dance steps that they want their character to practise (the dancers initially make mistakes) and can choreograph whole dances. The routines can either be performed on their own Palm Pilots or beamed to other people, whose dancers in turn can learn from the new dance and incorporate its steps into their moves. *Tap* translates the concepts of learning through exchange and spreading of ideas into a simple, visual format, and can be seen as a microcosm of the Internet as a communication network.

each other. Today's networked art, further discussed in the chapter on locative media, exists on various platforms and fluidly travels from the Internet to mobile devices.

Software art

The category of so-called 'software art' is another manifestation of blurry terminology. Software is generally defined as formal instructions that can be executed by a computer. However, every form of digital art employs code and algorithms at some level. Many of the previously mentioned installations are based on custom software, even if their physical and visual manifestations distract from the underlying layer of data and code. Any visual, digital image, from print to video, has ultimately been produced by instructions and the software that was used to create or manipulate it. However, the term 'software art' is usually applied to projects that have been written from scratch by artists. Both I/O/D's *WebStalker* and Maciej Wisniewski's *netomat*™ are ultimately (networked) software art. Further early examples would be British software artist Adrian Ward's (b. 1976) *Auto-Illustrator* (2002), a graphic design application that allows users to play with a variety of procedural techniques in the production of their own graphic designs, and British artist Alex McLean's *forkbomb.pl* (2001), a script written in the language Perl that creates an artistic impression of the user's computer system under pressure (by repeatedly creating new processes at such a speed that the system comes to a halt).

What distinguishes software art from other artistic practices is that, unlike any form of visual art, it requires the artist to write a purely 'mathematical' description of their work. The *Process* series of Casey Reas (b. 1972), one of the most prominent artists in this field, explicitly explores the relevance of the instruction-based conceptual art of Sol LeWitt (1928–2007) to the idea of software as art. Reas, together with Benjamin Fry, also created Processing, an open source programming language and integrated development environment that is now widely used in arts and academia. The aesthetics and signature of artists who write their own source code manifest themselves both in the code itself and its visual results. John F. Simon, Jr. talks about code as a form of creative writing. Code has also been referred to as the medium, the 'paint and canvas', of the digital artist but it transcends this metaphor in that it even allows artists to write their own tools – to stay with the metaphor, the medium in this case enables the artist to create the paintbrush and palette.

Virtual reality

The term 'virtual reality' (VR) is commonly used for any space created by or accessible through computers, ranging from the 3D world of a game to the Internet as an alternate 'virtual' reality constructed by a vast networked communication space. The original meaning of VR, however, referred to a reality that fully immersed its users in a three-dimensional world generated by a computer and allowed them an interaction with the virtual objects that comprise that world. The term was coined by Jaron Lanier, whose company VPL Research, founded in 1983, was the first to commercially introduce immersive virtual reality products. Among these products were a glove device for interaction with virtual worlds (1984), head-mounted displays that enabled users to enter 3D worlds (1987), and a networked virtual world system (1989). VR is the most radical form of insertion of a user into a virtual environment (or vice versa), since it puts the screen right in front of the viewer's eyes through a headset or glasses, immersing the user in an artificial world and eliminating or augmenting the physical one. Full immersion into a simulated world that allows users to interact with every aspect of it is still more of a dream than a reality, although the technology has made considerable advances. Entertainment parks with elaborate gaming scenarios that make use of force-feedback devices – which translate phenomena and actions in the virtual world into a physical sensation for the user – are among the most advanced experiments in this direction. On one level, this form of virtual reality constitutes a psychology of disincarnation, since it ultimately promises the possibility of leaving the obsolete body behind, and inhabiting the datascape as a cyborg. From this point of view, virtual reality is the manifestation and continuation of a flight from the body that has its origins in the fifteenth-century invention of linear perspective vision. However, the concept of disembodiment radically denies the physicality of our bodies and the reality of our interaction with computers, which still very much is a physical process that in many ways forces us to conform to the set-up of a machine (e.g., wear a headset).

Issues of embodiment vs. disembodiment and the perception of space obviously play a central role in the artistic explorations of virtual reality. Relatively few virtual-reality environments that completely immerse a viewer into an alternate world have been developed within an art context, and Canadian artist Charlotte Davies's (b. 1954) *Osmose* (1995) [110] and *Ephemere* (1998) [111] are classics of the genre. In *Osmose*, 'immersants' enter a virtual

world by means of a head-mounted display and a motion-tracking vest that monitors the wearer's breathing and balance. The world first presents itself as a three-dimensional grid that introduces coordinates for orientation. The breathing and body balance of the system's users transport them into a forest and other natural environments. One of the extremely effective strategies Davies employs is to avoid representational realism in the creation of her worlds: although the environments are partly representational, they also have an element of translucency and use textures that suggest a constant flow of particles. Painterly in its sensibility,

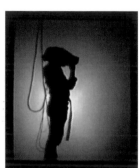

110. **Charlotte Davies**, *Osmose*, 1995

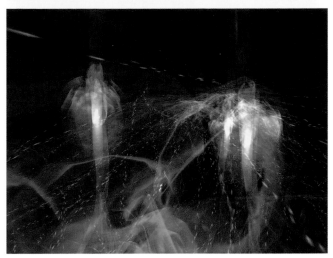

111. **Charlotte Davies**, *Ephemere*, 1998. Like *Osmose*, this work is based on natural worlds, but it uses a vertical structure to distinguish between three main levels (landscape, earth, and interior body). It features body organs and blood vessels as organic worlds, and a temporal layer is introduced through the change of seasons and different life-cycles. *Ephemere*'s inclusion of an 'interior body' realm blurs the boundaries between the subject and its surroundings, seemingly turning the body inside out (or collapsing it onto itself) and allowing immersants to enter it. Davies's projects radically challenge traditional notions of embodiment and the body's connection with its physical environment by immersing viewers in a virtual world driven by their own body and breathing.

Osmose creates a myopic vision of a dream world. Apart from natural surroundings, the VR environment of *Osmose* also includes a layer of 'Code' and 'Text', which illustrate, respectively, the software on which the work is based and quotes from the artist's own writings and texts on technology, nature, and body. The more abstract meta-layers frame the natural environments in the context of a dataspace.

The predominantly software-based level of immersion and embodiment developed in Davies's work is still unusual among the VR environments developed in an art context. Most artistic VR projects make use of physical structures in order to create the immersive effect of their virtual worlds. In Jeffrey Shaw's *EVE* (1993) [112], the environment consists of a large inflatable dome with two video projectors on a robotic arm at its centre, which can fluidly move projected images over the inside of the dome.

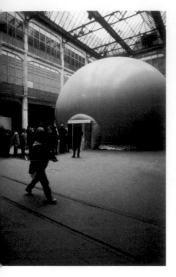

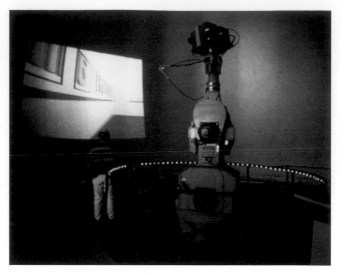

112. **Jeffrey Shaw**, *EVE*, 1993.
The original *EVE*, which stands for
'Extended Virtual Environment',
was subsequently adapted for
different scenarios. In one
manifestation, *The Telepresent
Onlookers* (presented at ZKM in
Karlsruhe, Germany, in 1995),
the projectors inside the dome
were linked to cameras outside,
transposing the exterior into the
interior space.

The images are presented as a stereo pair, so that viewers –
wearing polarizing glasses – encounter a three-dimensional world.
This world is in turn influenced and manipulated by one of the
viewers who wears a helmet that tracks the position and angle of
its wearer's head and controls the positioning of the projectors.
The view of the scenery consistently corresponds to the viewer's
point of view. In this case, the virtual reality is a multi-user
environment where only one of the immersants is the navigator,
while the others are subjected to the chosen view. The control
over perspective that is usually the photographer's or director's
domain is therefore placed into the hands of one 'viewer'.

Issues of embodiment and the relationship between body
and space also play a crucial role in *ConFIGURING the CAVE*
(1996) by Shaw, Hungarian-born Agnes Hegedüs (b. 1964), and
German Bernd Lintermann (b. 1967). The project employs the
CAVE (Cave Automatic Virtual Environment, or Computer
Automated Virtual Environment), which was conceived by
Americans Thomas DeFanti and Dan Sandin in 1991. Working at
the Electronic Visualization Laboratory (EVL) at the University of
Illinois in Chicago, they developed the environment with several
collaborators and first presented it at the 1992 SIGGRAPH, the
annual convention of the Special Interest Group for Graphics
of the Association for Computing Machinery. Reproducing
visual cues used by the brain to interpret the world, the
CAVE produces stereoscopic imagery by means of four rear-
projected screens and an active stereo system. The name of the

environment alludes to the famous cave allegory introduced by Greek philosopher Plato in his *Republic*. Plato used the image of prisoners in a cave who define the basis of their reality through the shadows of fire dancing on the walls of the cave to develop concepts of reality, representation, and human perception. *ConFIGURING the CAVE* creates its immersive environment through projections on three walls and the floor and allows viewers to interact with it by means of an almost life-size wooden puppet. The puppet functions as the immersants' avatar and enables them to affect imagery and sound through moving the wooden mannequin's limbs and body.

A more conceptual and historically oriented exploration of virtual reality unfolds in Agnes Hegedüs's *Memory Theater VR* (1997). Combining four different virtual worlds, the project consists of an interactive film – focusing on the history of illusionary visual space – that is projected onto a circular enclosure. The interface for interacting with the piece constitutes a doubling of the situation, again reflecting on illusion in space. Hegedüs's project establishes an explicit connection to the old concept of the memory theatre, which has experienced a revival in the digital age since it outlines the basic concepts of information space and architecture. The idea of an 'information space' dates back centuries and is closely connected to the ancient concepts of the memory palace and mnemonic techniques developed in rhetorics. In the second century BCE, the Roman orator Cicero

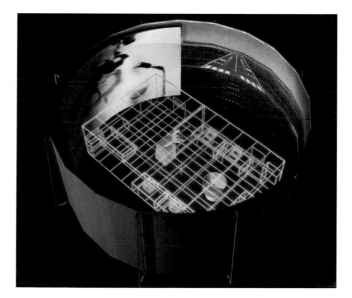

113. **Agnes Hegedüs**, *Memory Theater VR*, 1997

imagined inscribing the themes of a speech on a suite of rooms in a villa, and then delivering that speech by mentally walking from space to space. At the basis of this technique is the realization that our memory works in a spatial way. In the sixteenth century, the images and techniques used in memory systems were further developed into sign systems and physical structures that were supposed to function as portals to a transcendental knowledge of the world. Extrapolating the idea of the memory palace, Giulio Camillo (1480–1544) constructed a memory theatre, a wooden structure that was displayed in Venice and Paris. The structure consisted of pillars inscribed with images, figures, and ornaments that supposedly contained the knowledge of the universe and were intended to enable visitors to converse on any subject no less fluently than Cicero. Hegedüs's *Memory Theater VR* combines these and other precedents of imagined space into a reflection on the history of 'virtual reality'.

As well as immersive VR environments, there is also a category of work that creates complex three-dimensional worlds that do not necessarily make use of a specially constructed environment but take the form of a more traditional screen projection. *Beyond Manzanar* (2000) by American Tamiko Thiel and Iranian-American Zara Houshmand is an interactive 3D world based on the actual location of Manzanar, the first of more than ten internment camps built to incarcerate Japanese-Americans during World War II. The life-size image of the 3D space is projected onto a wall within a darkened space, and viewers navigate and change the viewpoint by means of a joystick on a pedestal. Archival photographs from the internment camp are juxtaposed with Japanese scrolls and paintings in a constantly shifting environment that – reacting to the viewers' presence – illustrates a chasm of cultural identity, contrasting a dream world of cultural heritage with a reality of political injustice. The juxtaposition of simulated worlds in a political context also becomes a core element in *VR/RV: A Recreational Vehicle in Virtual Reality* (1993) [113] by Peter D'Agostino, who has been working in video and interactive multimedia for decades. *VR/RV* is a projection of a 3D world that simulates a travel along the electronic superhighway (in the literal sense) by joining scenes from Philadelphia, the Rockies, Kuwait City, and Hiroshima – experienced from the inside of a computer-generated car. Mixing the scenery with the 'soundtrack' from the constantly scanning car radio as well as CNN broadcasts, the project becomes a reflection on the increasing mediation of our world and the way

114. **Tamiko Thiel and Zara Houshmand**, *Beyond Manzanar*, 2000. Not a photorealistic environment, this work combines the aesthetics of computer games with the techniques of stage design. Viewers move through a landscape consisting of shifting layers and creating alternate realities: opening the door in a building of the camp, they may find themselves in a Japanese paradise garden that suddenly disappears if they try to enter; following a road, they may find their way blocked by barbed wire.

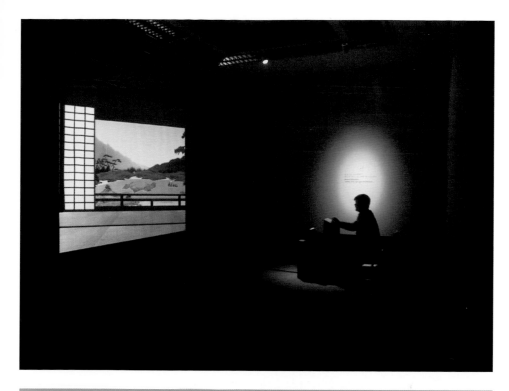

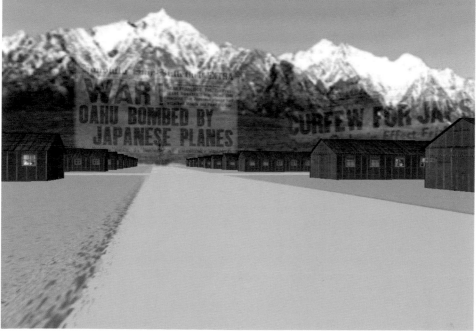

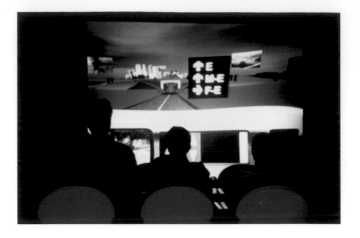

it is shaped by technologies. Hiroshima and Kuwait, in particular, point to the military use of technology, which again is closely connected to the mediation of war. In both *Beyond Manzanar* and *VR/RV*, virtual reality is not used to create a seamless alternate world but to create a clash of the 'realities' of physical location and perception. The interfacing with virtual worlds has entered a new area with motion sensing input devices such as the Kinect (developed by Microsoft for the Xbox 360 video game console) and Wii Remote Controller (Nintendo) as well as PlayStation Move. The Kinect, in particular, is increasingly used by artists whose works are based on navigation of virtual environments. Virtual and physical realities are increasingly intersecting, in art as well as daily life, which will be further explored in the chapter on augmented and mixed reality.

Sound and music

The impact of digital technologies on the creation, production, and distribution of sound and music projects is a vast topic that would require a book of its own and can only be briefly outlined here. Computer-generated music was in many ways a driving force in the evolution of digital technologies and concepts of interactivity itself, and is also closely connected to the history of electronic music.

Besides technological developments, the evolution of digital sound and music was shaped by a multitude of earlier musical experiments that pointed to the possibilities of the new medium. John Cage's work with found sounds and rules, or Pierre Schaeffer's *musique concrète* – a term Schaeffer coined in 1948

for composing with materials from an existing collection of experimental sounds – are highly relevant to the digital medium's possibilities of copying and remixing existing music files. Brian Eno's sound environments and Laurie Anderson's audio-visual installations/performances also had a profound influence on developments in digital sound and music. Apart from remix and DJ culture, artistic digital sound and music projects are a large territory that includes pure sound art (without any visual component), audio-visual installation environments and software, Internet-based projects that allow for real-time, multi-user compositions and remixes, as well as networked projects that involve public places or are distributed as apps on mobile devices. Many digital artworks, from installation to Internet art, involve sound components without being specifically focused on musical aspects. The projects described below are just a few examples of the use of digital technologies in the field of sound and music.

Among the artists who have explored communication protocols in the simultaneous creation and interconnection of image and sound is Golan Levin (b. 1972), an artist, composer, performer, and engineer who received his degrees from the MIT Media Lab, where he studied with John Maeda in the Aesthetics and Computation Group. Levin's *Audiovisual Environment Suite* (1998–2000), an interactive software that allows for the creation and manipulation of simultaneous visuals and sound in real time, strives to establish inherent, 'organic', and fluid connections between the unfolding of musical and visual form. Many of the digital media projects focusing on the combination of visuals and sound stand in the tradition of kinetic light performance or the

116. **Golan Levin**, *Audiovisual Environment Suite*, 1998–2000. Levin's *Scribble* (2000), a concert performed live with the *Audiovisual Environment Suite* software, created an interplay of scored and improvised composition, and examined the possibilities of experimental interfaces for a multimedia performance. The *Suite* software consists of five interfaces for audio-visual composition that allow performers to create abstract visual forms accompanied by sounds. Each of the interfaces differs in its relationships between visuals, the pitch and tone of sounds, and the performer's movement of the mouse.

'visual music' of the German abstract animator and painter Oskar Fischinger (1900–1967).

The concepts of multi-user environments, gaming, and file-sharing are central to John Klima's (b. 1965) software *Glasbead*, (1999), a multi-user collaborative musical interface, instrument and 'toy' that allows players to import sound files and create a myriad of soundscapes. The interface consists of a rotating, circular structure with stems that resemble hammers and bells. Sound files can be imported into the bells and are triggered by flinging the hammers into the bells. While *Glasbead* creates a contained world where sounds and visuals enhance each other, it allows up to twenty players to remotely 'jam' with each other. The project was inspired by Hermann Hesse's novel *Das Glasperlenspiel* (*The Glassbead Game,* published in English under the title *Magister Ludi*), which applies the geometries of music to the construction of synaesthetic microworlds.

The participatory, networked creation of soundscapes is also increasingly explored through the use of portable 'instruments'. Expanding his musical work into the realm of nomadic devices, Golan Levin (with nine collaborators) created *Telesymphony* (2001), a performance where sounds were generated by the choreographed ringing of the audience's mobile phones. The

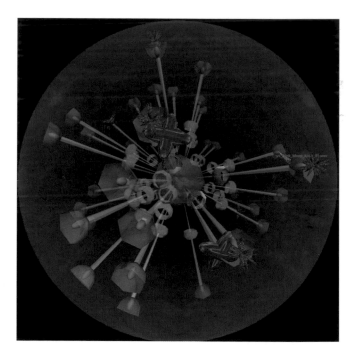

117. **John Klima**, *Glasbead*, 1999

118. **Golan Levin**, *Telesymphony*, 2001. When an audience member's phone was 'played', a spotlight above them was switched on. The resulting grid of lights illuminating the audience was visible as a 'score' on projection screens at the sides of the stage. The performers dialled the phones by means of custom-software, and at times, nearly two hundred mobile phones were ringing simultaneously.

concert took place at the Ars Electronica Festival in Linz in 2001. Audience members were asked to register their phone number at a webkiosk before the event and in return received a ticket which assigned them a seat in the concert hall. New ring tones were automatically downloaded to their mobile phones. Since each spectator at the concert had a registered phone number, seat, and ring tone, the performance itself could be precisely choreographed by the musicians/performers. The audience thus became a distributed melody in a 'cellular' space, while the disruption often induced by the ring of a phone was unified into a symphony. An installation-based project of a similar kind, *Telephony* (2001) by Thomson & Craighead, allowed visitors to a gallery and remote participants to dial up forty-two mobile phones that were installed as a grid on a wall. The phones would in turn start to also call each other, creating a layered audio environment. Works such as *Telesymphony* and *Telephony* continue the explorations of pioneers such as Max Neuhaus, who defined new arenas for music performance by staging sound works in public arenas and experimenting with networked sound as a form of 'virtual architecture'. In the first instalment of his

project *Public Supply* (1966), he established a connection between the WBAI radio station in New York and the telephone network, implementing a twenty-mile aural space around New York City, where participants could intervene in the performance by making a phone call.

Sound and music projects also commonly take the form of interactive installations or 'sculptures' that respond to different kinds of user input or translate data into sounds and visuals. The sound 'sculpture' *Ping* (2001) by American Chris Chafe (b. 1952) and Swiss-born Greg Niemeyer (b. 1967) is an audio-networking project driven by data travelling over the Internet. The sound created by the installation is created by ping commands, which contact servers to see if a connection can be established and thus provide a form of measuring time and distance. *Ping* translates the time lag of the data flow into audible information. Through the installation, users can pick instruments and scales or influence speaker configurations, as well as add to or change the list of websites to be 'pinged'. The invisible phenomenon of the rhythm and time of Internet traffic is transformed into a sensory experience. In Japanese artist Toshio Iwai's (b. 1962) interactive audio-visual installation *Piano – as image media* (1995), a virtual score is used to trigger the keys of a piano, which in turn induce

119. **Chris Chafe and Greg Niemeyer**, *Ping*, 2001

120. **Toshio Iwai**, *Piano – as image media*, 1995

the projection of computer-generated images on a screen. The score is 'written' by the visitors who can position dots on a moving grid projected in front of the piano. The melodies played, as well as the visuals they produce, are generated through the pattern of dots assembled by the users. Iwai's project establishes connections between both notation, sound and visuals, as well as between the mechanical and virtual. The piano as physical object manifests itself as 'image media', both driven by and initiating different media elements. Iwai's project underscores the fluidity and easy translatability of diverse media elements that are characteristic of the digital medium and produces a synaesthetic experience, abandoning the focus on any one single element of sensory experience.

Chapter 3: Themes in Digital Art

A number of themes in digital art are in many ways specific to the digital medium. That is not to say that these themes do not surface in more traditional media, or that digital media do not address issues that have been explored by artists throughout the centuries. Among the more medium-specific subjects that will be discussed here are artificial life and intelligence; telepresence and telerobotics; database aesthetics and data visualization; (net) activism and tactical media; gaming and narrative environments; the redefinition of public space through locative media and public interactives; augmented and mixed reality; and social media and the Web 2.0 era. The topics of body and identity, which obviously have been issues in art throughout the twentieth century and before, also figure prominently in digital art. The attempt to give a survey of all the themes addressed by art employing the digital medium is beyond the scope of this book, and the topics outlined in this chapter are meant as the main coordinates of a larger territory of inquiry.

Artificial life

Our machines are disturbingly lively, and we ourselves frighteningly inert.
Donna Haraway, *Simians, Cyborgs, and Women*

Artificial life and intelligence have for a long time been an area of research and speculation in science and science fiction. The idea of the blurring of human and machine, of automatons and the autonomous intelligence of inanimate matter, has been explored for centuries. In the 1940s, Norbert Wiener pointed to the fact that the digital computer had raised the question of the relationship between the human and the machine, and that it was necessary to explore that relationship in a scientific manner. In *Cybernetics: or, Control and Communication in the Animal and the Machine* (1948), he defined three central concepts which he maintained were crucial in any organism or system – communication, control, and feedback – and postulated that the guiding principle behind life and organization is information,

121. **Karl Sims**, *Galápagos*, 1997

the information contained in messages. The first theories about computation with decentralized systems and so-called 'cellular automata' date back to the same time. Wiener's ideas were further explored by J. C. R. Licklider (1915–90), who in 1960 authored the paper 'Man–Computer Symbiosis'. According to Licklider, the main aims of this symbiosis are to let computers facilitate formulative thinking and to enable man and computers to cooperate in making decisions and controlling complex situations. Wiener's concept of information and feedback as organizing principles of life also relates to British zoologist Richard Dawkins's concept of memetics: analogous to genes, 'memes' – a term coined by Dawkins in his 1976 book *The Selfish Gene* – constitute ideas and cultural information units that replicate through communication, thus driving a social and cultural evolution. Both Wiener's and Dawkins' theories are particularly relevant to current artistic explorations of artificial life where the developing 'life-form' in question is essentially digital information – be it a text, image, or communication process. At the basis of many digital art projects addressing artificial life are the inherent characteristics of digital technologies themselves: the possibility of infinite 'reproduction' in varying combinations according to specified variables; and the feasibility of programming certain behaviours (such as 'fleeing', 'seeking', 'attacking') for so-called 'autonomous' information units or characters.

Among the early artificial-life projects that establish an explicit link between aesthetics and evolution are Karl Sims's installations *Genetic Images* (1993) and *Galápagos* (1997) [121], named after Charles Darwin's journey to the Galápagos Islands in 1835, which had a formative influence on his theories on natural selection. Both of Sims's projects allow participants to influence a simulated evolution of images/organisms by making aesthetic decisions. In *Galápagos,* abstract computer-generated organisms are displayed on an arc of twelve screens, and viewers may choose the life-forms they find most appealing by stepping on sensors placed in front of each screen. The selected organisms 'respond' by mutating and reproducing, while those not selected are removed and replaced by the offspring of the survivors, which combine the 'genes' of their parents but are also randomly altered by the computer. The simulated evolution is the result of an interaction between human and machine, where users' creative control consists in the aesthetic decision of preference, while random alterations are executed by the computer. *Galápagos*

thus simulates the ability of evolution to create a complexity that transcends the influence of either human or machine and becomes a study of an evolutionary process.

Issues of the transformation of information and the survival of the (aesthetically) fittest also form the basis of *A-Volve* by Austrian artist Christa Sommerer (b. 1964) and Frenchman Laurent Mignonneau (b. 1967), which establishes a direct connection between the physical and virtual world. The interactive environment allows visitors to create virtual creatures and interact with them in the space of a water-filled glass pool. By drawing a shape with their finger on a touch screen, visitors produce virtual three-dimensional creatures that automatically become 'alive' and start swimming in the real water of the pool as simulated appearances. The movements and behaviours of the virtual creatures are dependent on their forms, which ultimately determine their fitness for survival and ability to mate and reproduce in the pool – aesthetics becomes the crucial factor in the survival of the fittest. The creatures also react to the visitors' hand movements in the water: people can 'push' them forward or backward or stop them (by holding their hands right over them), which may protect them from their predators. *A-Volve* literally translates evolutionary rules into the virtual realm and at the

122. **Sommerer and Mignonneau**, *A-Volve*, 1994

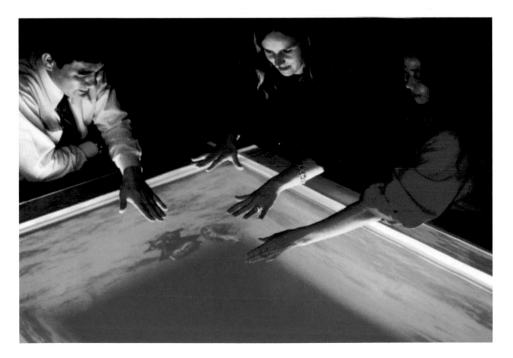

Life Spacies

© 99, Christa & Laurent http://www.ntticc.or.jp/~lifespacies

this is going to be a nice creature

Please write any text in the above window. Your text is transformed into a 3D creature after you press the 'Esc' key. Your creature then appears on the right window and on the large screen in front of you. There it will interact with the other creatures, look for food and if it has eaten enough it also can mate and have kids.

Drag the cursor into the above window and press any key. This will release characters on the large screen; they are the creatures' food. Creatures eat the same characters as they are made of. As long as you feed them, the creatures stay alive. You can retrieve the previous 6 creatures by pressing the 'F1' to 'F6' keys.

F1 F2 F3 F4 F5 F6

Life Spacies II
(c) 99, Christa Sommerer & Laurent Mignonneau
developed at ATR MIC Labs Japan

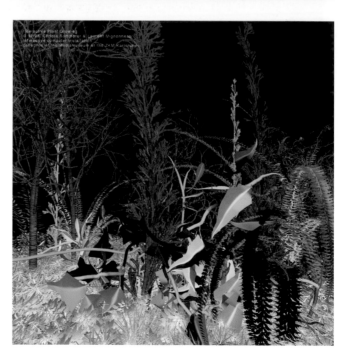

123. (left) **Sommerer and Mignonneau**, *Life Spacies*, 1997. The work consists of a website and a physical environment. Visitors to the website type in words or messages that become the genetic code for virtual creatures: the typed-in characters determine the coordinates and form of the organisms, a process that emphasizes both the fluid transition between different forms of digital information and the underlying textual component (programming and code) that creates the graphics and the organisms' behaviour. The *Life Spacies* creatures 'live' in the physical environment of the installation, and visitors interact with their three-dimensional virtual world through body movement, motion, and gestures.

124. (left) **Sommerer and Mignonneau**, *Interactive Plant Growing*, 1992. Visitors trigger the growth of a virtual plant (projected onto a screen in front of them) by approaching or touching real plants (equipped with sensors that read body tensions).

125. (right) **Thomas Ray**, *Tierra*, 1998. The image of the *Tierra* synthetic life program shows sixty segments of 1,000 bytes each. Every 'organism' is represented by a coloured bar: hosts are red, parasites are yellow, and immune hosts are blue.

same time blends the virtual with the real world. Allowing visitors to interact with the creatures in the pool, *A-Volve* reinstates human manipulation of evolution. Sommerer and Mignonneau also explored the connection between physical and virtual life-forms in projects such as *Interactive Plant Growing* (1992) *Life Spacies* (1997), and *Life Writer* (2005), which explores ideas of writing and code as life form by letting user type text on an old-style typewriter. The typed text produces virtual animated creatures that come to life as projections onto the paper in the typewriter. A significant aspect of all these projects is the direct intervention in and communication with a virtual environment (and its inhabitants) that responds to the physicality of the human body.

An artificial life project more conceptual in nature – neither allowing direct interaction by users nor involving specific visual components – is Thomas Ray's (b. 1954) *Tierra* (1998), which transports the concept of the wildlife reserve into the digital realm. *Tierra,* essentially a network-wide 'biodiversity reserve' for digital 'organisms', is based on the premise that evolution by natural selection should be able to operate effectively in genetic languages based on the machine codes of computers. The project explored the possibility of using evolution to generate complex software: the *Tierra* source code creates a virtual computer and a Darwinian operating system, so that machine codes can evolve by mutating, recombining, and ultimately producing functional code. The self-replicating machine code programs were able to 'live' in the memory of a computer or even a computer network. With collaborators, Ray developed several ways of visualizing

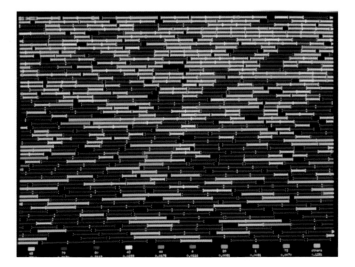

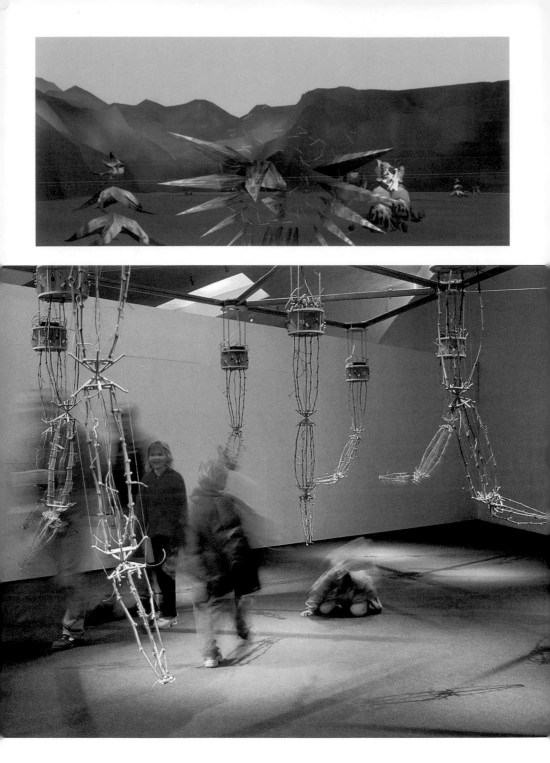

126. Rebecca Allen, *Emergence: The Bush Soul (#3)*, 1999. The environments are inhabited by autonomous, animated characters, and visitors entering the world are represented as 'avatars'. The project uses artificial-life algorithms to specify the behaviours of and relationships between characters and objects, and animation and sounds (voice, music, or ambient effects) can be assigned to both. In the *Emergence* system, the combination of simple behaviours can trigger complex exchanges and lead to performative events and nonlinear narratives.

the process of evolution that allowed observers to watch the evolution of the programs. In 2000, Ray implemented a new system called 'Virtual Life' that was derived from Karl Sims's work on evolved virtual creatures.

Artworks incorporating artificial life do not necessarily address the evolution of digital organisms (in whatever form they may take) explicitly but, as mentioned before, often use algorithms for specifying behaviours of autonomous objects and characters. The ongoing project *Emergence* – a software system developed by Rebecca Allen and a team of collaborators – for example, creates three-dimensional, computer-generated environments that are geared towards the exploration of social behaviours and communication through gestures and movements. *Emergence*, which includes several projects – among them *The Bush Soul* and *Coexistence* – explores communication in a virtual environment and the resulting community. A very different approach to an evolution of 'behaviour' and exchange is Kenneth Rinaldo's *Autopoeisis* (2000), a robotic sound sculpture installation that was commissioned for the *Alien Intelligence* exhibition at the Kiasma museum in Finland in 2000. The installation consists of fifteen robotic sculptures with arm-like extensions, each equipped with a series of infrared sensors that can determine the position and movement of visitors. Through a central computer, all the sculptures communicate with each other and compare their sensor data, which allows them to interact both with visitors and with each other as a group. *Autopoeisis* thus becomes a constantly evolving environment that, like a living system, seems to create itself. Rinaldo's project does not visibly involve any virtual environment or component but allows principles of intelligent behaviour to drive a physical, sculptural environment.

127. Kenneth Rinaldo, *Autopoeisis*, 2000. Sensors allow the sculptures to react to a visitor by moving their arms towards the person and stopping within inches (which can be interpreted as a kind of attraction and repulsion). Tiny cameras at the tips of the arms observe the visitors, and everything they see is projected onto the walls of the space. The sculptures' 'communication' is made audible by telephone dial tones, which create a musical language and seem to indicate emotional states: at times, a sculpture may sound as if it is whistling to itself; at others, high and rapid tones suggest fear or excitement, while lower, slower tones may indicate a relaxed state.

All the previously mentioned artificial-life projects point to the possibility that computers may not only help us to understand the structure of ideas, the nature of intellectual processes (as Licklider hoped), but they may very well change these very processes and the way we think. The term evolution has itself undergone an evolution, and has become a process that can be influenced with the help of technology. Perhaps this process can be seen as an evolution of the cooperation between man and machine or the vanishing of the boundaries between them, an evolution that is both a product of design and a process with its own dynamics. Crucial to this evolution is the question about the 'intelligence' of machines.

> *Behind much art extending through the Western tradition*
> *exists a yearning to break down the psychic and physical*
> *barriers between art and living reality – not only to make an*
> *art form that is believably real, but to go beyond and furnish*
> *images capable of intelligent intercourse with their creators.*

> Jack Burnham, *Beyond Modern Sculpture: The Effects of*
> *Science and Technology on the Sculpture of this Century*

Highly developed machine or artificial intelligence (AI) that
operates on the level of human intelligence and lives up to the
personality of the computer Hal in Stanley Kubrick's *2001:*
A Space Odyssey may still belong in the realm of science fiction,
but research in this field, which goes back to at least the 1930s,
has made considerable advances. One of the early influential
theoreticians of AI was Alan Turing (1912–54), a mathematician
who established the famous Turing Test – a machine-intelligence
test based on the ability of a person to tell the difference between
the 'intelligence' of a human and that of a machine. In 1936, Turing
submitted a paper outlining the Turing machine, a theoretical
apparatus which established a connection between the process
of the mind, logical instructions, and a machine. Turing's paper
'Computer Machinery and Intelligence' (1950) was a major
contribution to the philosophy and practice of artificial intelligence,
a term that was officially coined in the 1960s by computer scientist
John McCarthy. AI had one of its groundbreaking victories in May
1997, when IBM's Deep Blue Supercomputer beat the reigning
world chess champion, Garry Kasparov. Deep Blue's 'intelligence'
is a strategic and analytical one and an example of a so-called
'expert system' that has expertise in a specific area and is able to
draw conclusions based on that knowledge. Another wide area
of AI research is that of man–machine communication, which is
based on speech-recognition systems. The best-known artificial-
intelligence 'characters' are Eliza and ALICE – software programs
you can talk to, also known as chatbots (chat robots). Eliza was
developed by Joseph Weizenbaum, who joined the MIT Artificial
Intelligence Lab in the early 1960s. Admittedly, Eliza does not
have much 'intelligence' but works with what could more or less
be considered tricks, for example, string substitution and pre-
programmed responses based on selected keywords. Eliza's much
more advanced colleague ALICE (Artificial Linguistic Computer

128. **Kenneth Feingold**, *Self-Portrait as the Center of the Universe*, 1998–2001. A head modelled after the artist's own and surrounded by ventriloquist dummies talks to a virtual counterpart projected on a wall. The virtual head is embedded into scenes that reconfigure themselves on the basis of their conversation. In addition, the virtual head is surrounded by autonomous animated characters that can 'get into' the virtual head's mind, affecting its perception. People can influence these autonomous characters through a website, and their navigation affects what is seen and heard in the gallery space, giving them control over the installation. The gallery visitors, on the other hand, can only watch, but they have access to the imagination and thoughts of the heads.

Entity) was designed by Richard S. Wallace and operates on the basis of AIML, or Artificial Intelligence Markup Language, a markup language that allows users to customize ALICE and program how she could respond to various input statements. Both Eliza and ALICE are accessible online and people can chat with them through their respective websites.

Although artists have been incorporating artificial intelligence and speech programs (mostly based on AIML) into their art, their works cannot be simply labelled 'AI projects' for they are broader in their scope and metaphoric implications. Artist Ken Feingold (b. 1952), for instance, has created a whole series of works – among them *Séance Box No.1* (1998–9), *Head* (1999–2000), *If/ Then* (2001) [130], *Sinking Feeling* (2001) [129], and *Self-Portrait as the Center of the Universe* (1998–2001) – that incorporate animatronic (mechanized) heads and make use of speech recognition, natural language processing, conversation or personality algorithms, and text-to-speech software. In *If/Then*, two eerily humanoid heads are sitting in a box surrounded by styrofoam nuggets normally used as packaging materials. As Feingold explains, he wanted them 'to look like replacement parts being shipped from the factory

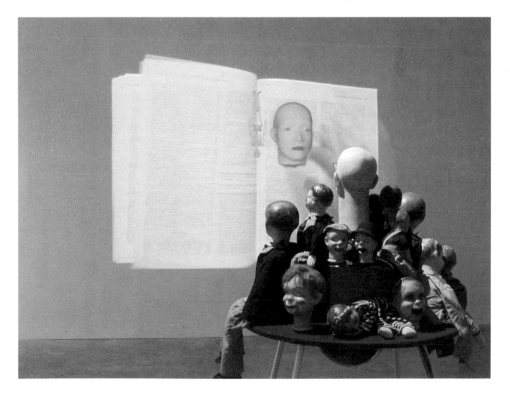

that had suddenly gotten up and begun a kind of existential dialogue right there on the assembly line'. The heads are involved in an ever-changing dialogue probing the philosophical issues of their existence as well as their separateness and likeness. Their conversation, based on a complex set of rules and exceptions, points to larger issues of human communication: picking up on syntax structure and strings of words in their respective statements, the heads' communication at times may seem conditioned, limited and random (as human conversations sometimes do) but highlights the meta-levels of meaning created by failed communication, misunderstandings, and silences. The heads' dialogue unveils crucial elements of the basics of syntax structure and the way we construct meaning, with often extremely poetic results.

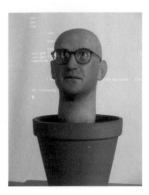

129. (above) **Kenneth Feingold**, *Sinking Feeling*, 2001. The head (again modelled after the artist) is sitting in a flowerpot, suggesting an 'organically grown' human. It ponders on why it is 'bodyless' and how it ended up being where it is. Visitors can talk to the head, and their dialogue is projected onto the wall behind it, adding a textual layer and unveiling both what the head hears, as well as its thought process.

130. (right) **Kenneth Feingold**, *If/Then*, 2001

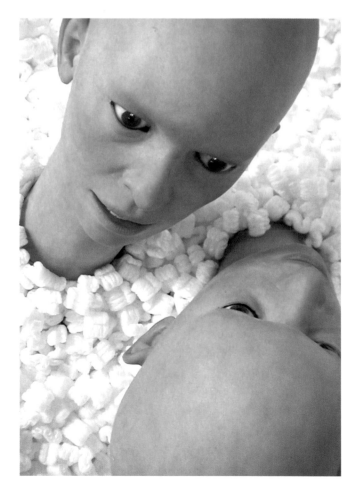

131. **David Rokeby**, *Giver of Names*, 1991–present

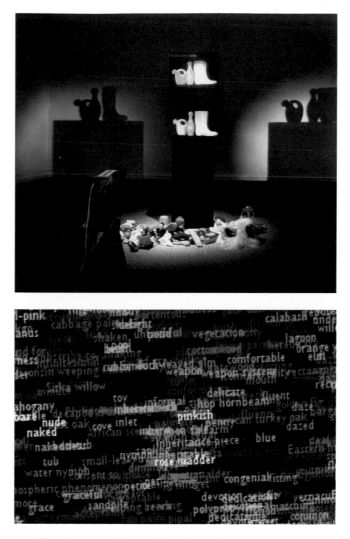

While distinctly different from Feingold's heads, *Giver of Names* (1991–present) by Canadian artist David Rokeby (b. 1960) addresses similar issues of 'machine intelligence' in an equally poetic way that transcends the merely technological fascination with AI and becomes a reflection on semantics and the structure of language. The *Giver of Names* is a computer system that quite literally gives objects names by trying to describe them. The installation consists of an empty pedestal, a video camera, a computer system, and a small video projection. Visitors can choose an object or set of objects from those in the space or from the ones they might carry with them, and place them on

the pedestal, which is observed by a camera. When an object is placed on the pedestal, the computer grabs an image and then performs many levels of image processing (outline analysis, division into separate objects or parts, colour analysis, texture analysis, etc.). These processes are visible on the life-size video projection above the pedestal. The computer's attempts to arrive at conclusions about objects chosen by visitors lead to increasing levels of abstraction that open up new forms of context and meaning. *Giver of Names* is an exploration of the various levels of perception that allow us to arrive at interpretations and creates an anatomy of meaning as defined by associative processes. The project ultimately is a reflection on how machines think (and how we make them think). The idiosyncratic 'dialect' of skewed sentence structures and grammatical mistakes that evolved in *Giver of Names* prompted Rokeby to develop *n-Cha(n)t* (2002), a networked community of givers of names.

The works of Feingold, Rokeby, and other artists working with machine intelligence broaden the context for a discussion of artificial intelligence by allowing it to reflect on human communication and the workings of the human mind, as well as definitions of subjectivity/objectivity. The latter obviously have always been a topic in various art forms but the artistic exploration of these issues in digital art focuses more on the way in which current technological developments have affected our notions of the subject, object, and communication.

Human–machine communication on the level of the above-mentioned projects is still far from a daily routine. At the same time, we have entered the age of smart homes, intelligent buildings and the Internet of Things, where objects increasingly have sensors embedded in them, monitor and process their environment and are able to communicate. Artificial 'intelligence' has become part of our lives in the form of 'bots' (in the 1990s commonly referred to as 'intelligent agents') – software programs that automatically filter and customize information for us and offer us products on the basis of our perceived likes and dislikes. Siri, the personal assistant developed by Siri Inc., then bought by Apple and available for the iOS is yet another example of an intelligence that has become part of many people's daily life.

Bots are either hailed as the personal assistants that make us smarter or despised as the invaders who destroy our privacy and imagination – depending on the form they take. A virtual personal assistant can be helpful in finding information for you or turn you into an easy target for marketing and advertising schemes. It was

the latter group that early on prompted virtual reality pioneer Jaron Lanier to proclaim that 'the idea of "intelligent agents" is both wrong and evil' in his 1995 essay 'The Trouble with Agents', later expanded into 'Agents of Alienation'. The transparency of software bots and the amount of control we have over them will ultimately determine if Lanier's predictions are accurate, but in all likelihood bots and visible or invisible virtual 'assistants' will have an impact on our daily transactions and society.

It comes as no surprise that bot projects have also been created within an art context, be they actual software bots or a more metaphorical exploration of this type of software. An early example of these works is the Web project *Impermanence Agent* (1998–2003) [132] by Noah Wardrip-Fruin, Adam Chapman, Brion Moss, and Duane Whitehurst, which extends the functionality of the user's browser and constructs a narrative from the sites he or she visits. Once the agent has been downloaded to a user's computer and installed, it takes the form of an additional little browser window that runs in the background. It takes approximately a week until the agent, incorporating the user's interests and browsing habits through sampling from websites visited, begins to tell a personal story. As its name suggests, the *Impermanence Agent* is focused on the ephemeral nature of the Web, the mourning of fleeting information and websites that cannot be found any more, and tells both a personal story and reflects on the constant flux that can cause a feeling of disconnection or loss. A very different take on the subject is Robert Nideffer's (b. 1964) *PROXY* (2001) [133], which constructs a game about agents and agency that is based upon online role-play and data sharing. Packaged as a gaming environment, *PROXY* uses agent software for a playful exploration of online identity. Users personify their agent by rating their social abilities and can begin to explore the gaming environment once they download the application and log in. *PROXY* uses several interfaces that allude to different gaming experiences, including a MOO and a 3D arcade-style game interface. As players move through the MOO environment via typing in directionals (north, south, up, down etc.), they encounter monsters (such as the curator, the professor, or the hacker) in a play on the art world and academia that allows you to choose quests involving 'Celebrity' or 'Strategic Interests' as they relate to institutional politics and psychological encounters. A more recent example would be the Facebook game *Naked on Pluto* (2010) by Dave Griffiths, Aymeric Mansoux, and Marloes de Valk, in which anthropomorphized bots prompt

132. (right) **Noah Wardrip-Fruin, Adam Chapman, Brion Moss, and Duane Whitehurst**, *Impermanence Agent*, 1998–2003

133. (below) **Robert Nideffer**, *PROXY*, 2001. As in the game of 'real life', rules keep changing and the player must maintain a psychological steady state in order to 'win' and be successful. The 'evaluation' of a player's state of mind – influenced by the way they personify their agent and their performance in the environment – appears as a message on their computer screen, a friendly reminder of our emotional identity's volatility.

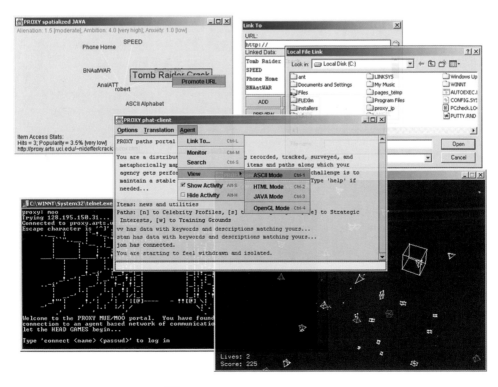

the user for responses and give feedback on the game world. The bots generate the game's story based on the contexts in which they find themselves and are both based and critically comment on the actual algorithms used by Facebook and other social media platforms to gather and distribute information from and to the user.

The agent as intelligent character is also the focus of Lynn Hershman's *Agent Ruby* (2000). Ruby combines aspects of artificial intelligence with agent software, and her behaviour is shaped by the encounters and conversations she has with her users. The character can be downloaded to the user's desktop or Palm Pilot while the website accompanying the project functions as a hub that collects information from users. Ruby emphasizes the possibilities of softward bots as autonomous characters who take on a life of their own and essentially are social beings. The exploration of 'intelligent' technology in an art context addresses issues ranging from data-surveillance (dataveillance), datamining and the invasion of the private sphere to the relationship between preformatted information and the imagination, as well as the artistic process in the age of information technologies. While these projects obviously require the development of an artistic concept and quite complex programming, the artists in the end quite literally vanish behind and from their work, while their creation, an intelligent 'being', takes on its own life. Ultimately, issues about information and machines as an intelligent, artificial life-form are only one of the complex topics that digital technologies have brought about in the context of man–machine symbiosis. Networked digital technologies have already created new forms of a man–machine interaction by enabling us to have a shared presence in different contexts, to directly establish connections between remote locations or interact with remote environments – a process that is known as telepresence and telematics.

Telepresence and telerobotics
The concept of telepresence is obviously not only connected to digital technologies but inherent to any form of telecommunication – communication over a distance (from the Greek *tele*, meaning 'far off', 'distant'). Samuel Morse sent the first long-distance telegraph message ('What hath God wrought?') in 1844, and the telephone initiated a whole new era of telepresence.

Telecommunication art has decades of history, and artists have long used devices ranging from fax and phone to satellite TV for the creation of projects that involved remote locations. In 1922, for example, László Moholy-Nagy used the telephone to order five paintings in porcelain-enamel from a sign factory in what could be considered the first event of telecommunication(-related) art: with the factory's colour chart in front of him, he sketched the paintings on graph paper while the factory supervisor on the other end of the line took a 'dictation' by transcribing Moholy-Nagy's sketch on the same paper. In a 1978 report to French president Giscard d'Estaing (published in English as *The Computerization of Society*), Simon Nora and Alain Minc coined the term 'telematics' for a combination of computers and telecommunications. One of the prominent theorists of telematic art is the British artist Roy Ascott, who, since 1980, has consistently explored the philosophy and impact of the art form (particularly with regard to the idea of a 'global consciousness'). An exhibition exclusively devoted to the 'genre' of telematic art was the 2001 travelling show 'telematic connections: the virtual embrace', which established a historical framework for recently created work of this kind. Including installation works, film clips, online projects, and a 'telematics timeline', the show set out to explore the utopian desire for an expanded, global consciousness in connection with the dystopian consequences that computer-mediated communications may induce.

While telepresence is an old concept, digital technologies have allowed for unprecedented possibilities of 'being present' in various locations at the same time. The Internet can be considered as one huge telepresence environment that allows us to be 'present' all over the world, participating in communication and events or even intervening with remote locations from the privacy of one's home. The latter is made possible through telerobotics, the manipulation of a robot or robotic installation over the Internet. While robotic projects have a long history in art – quite a few of them were created during the 1960s – digital technologies have opened up new opportunities for robotically controlled interventions. Telematic and telerobotic projects explore a wide range of issues, from the technological 'distribution' of our physical body and networked community to the tension between privacy, voyeurism, and surveillance made possible by Web cameras that broadcast a local view live to the Internet, opening a window to locations all over the world and often into people's private lives.

Among the first telerobotic projects on the Internet was the *Telegarden* (1995–2004) by Nigerian-born Ken Goldberg (b. 1961) and Joseph Santarromana (with a project team). Goldberg, both an artist and a trained engineer, has created numerous telerobotic projects that explore remote collective experiences. The *Telegarden* installation, which was accessible online and was exhibited at the Ars Electronica Center in Linz, Austria, consisted of a small garden with living plants and an industrial robot arm that could be controlled through the project's website. Remote visitors, through moving the arm, could view and monitor the garden as well as water it and plant seedlings. *Telegarden* explicitly emphasized the aspect of community by inviting people around the world to collectively cultivate a small ecosystem. Survival of the ecology was dependent on a remote social network. With his project *Mori* (1999–present; with Randall Packer, Wojciech Matusik, and Gregory Kuhn) [135], Goldberg took a different approach to telematic experience and a natural environment by allowing a visceral experience of the Earth's movements.

Issues similar to those raised by *Telegarden* are addressed in *Teleporting an Unknown State* (1994–6) [136] by Brazilian artist Eduardo Kac (b. 1962). Kac, whose works frequently incorporate telematic components, also created numerous telecommunication artworks (using fax, slow-scan TV, and videotext) before the advent of the Web. In *Teleporting an Unknown State*, the gallery installation takes the form of a pedestal with earth and a single

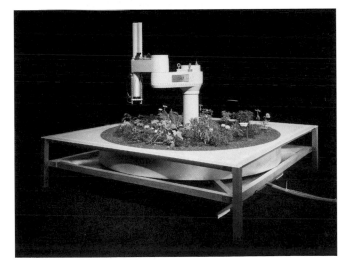

134. **Ken Goldberg and Joseph Santarromana**, *Telegarden*, 1995–2004. By allowing users worldwide to remotely nurture plants, the *Telegarden* transcended the temporal and spatial continuity that is characteristic of nomadic life (or agriculture in general). The community in this case was a 'post-nomadic' one, travelling without a fixed pattern of movement and collectively inhabiting a place as nomads do, yet not physically present at the same location at the same time.

135. **Ken Goldberg**, *Mori*, 1999–present. In *Mori*, the movements of the Hayward Fault in California (monitored by a seismograph) are converted into digital signals and transmitted to the installation over the Internet. The installation itself is an enclosed space, at the centre of which is a monitor in the floor displaying a visual graph of the live seismic stream. At the same time, the seismic activity is translated into low-frequency sounds that resonate through the enclosure. *Mori* transforms the Earth into a living medium and turns its movements, normally imperceptible to humans, into a palpable experience.

136. (below) **Eduardo Kac**, *Teleporting an Unknown State*, 1994–6

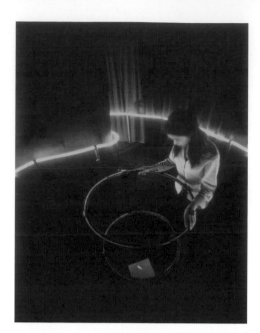

seed in it, as well as a projector suspended above it. Via the project's website, online visitors send light through the projector and allow the seed to photosynthesize and grow in total darkness. Teleportation becomes a process of remotely moving light particles as opposed to 'objects', and the transmission of images is disconnected from representational content and reduced to an optical phenomenon that enables and sustains life. Curators initially had some doubts whether a shared responsibility of online visitors would be able to ensure the seedling's survival, but the Internet (community) turned out to be a strong enough life-support system. The motif of light also appears in Masaki Fujihata's *Light on the Net* (1996), which allows users to remotely turn on a grid of lights in the Gifu Softopia Center in Japan and change a public physical space through a site in the public space of the Internet.

Kac continued the exploration of a connection between natural and virtual environments in a very different context through his installation *Uirapuru* (1996–9) [138]. Kac's work often juxtaposes organic and artificial 'life-forms' within a telepresence situation, and his work *Rara Avis* (1996) [139] used this combination

137. **Masaki Fujihata**, *Light on the Net*, 1996

138. (right) **Eduardo Kac**, *Uirapuru*, 1996–9. Uirapuru is an Amazonian bird that sings just once a year while building its nest. It has become a symbol of ethereal beauty in legend. In Kac's piece, Uirapuru takes the form of a 'flying' telerobotic fish that hangs above a small forest in the gallery. The fish streams audio and video from its point of view to the Web, and its position can be changed through an interface in the gallery and on the website. The fish is also surrounded by robotic birds, which monitor Internet traffic to and from servers in the Amazon region, and then sing real Amazonian birdsongs in response to the flow of information.

139. (below) **Eduardo Kac**, *Rara Avis*, 1996

to concentrate on issues of identity and points of view. *Rara Avis* is an example of a particularly hybrid work, combining a site-specific installation with networked transmission and making use of a range of media, including video, VR components, and CUseeMe The installation consists of an aviary with (living) zebra finches and a telerobotic macaw, whose eyes are made of a pair of colour video cameras. Upon entering the gallery, visitors could put on a VR headset which would 'transport' them into the aviary and enable them to experience the scene through the eyes of the macaw. The head of the telerobotic macaw was moved by a servo-motor controlled by a PC receiving directional information from the virtual reality headset. The video feed from the eyes/point of view of the telerobotic bird was broadcast live over the Internet, so that remote participants could equally observe the gallery space and 'share' the macaw's body with local participants. Through the Internet, the remote participants were also able to use their microphones to trigger the vocal apparatus of the telerobotic bird. Juxtaposing and fusing a local ecology with cyberspace, *Rara Avis* erased boundaries between points of views, bodies, and locations at the same time as it reaffirmed them, raising issues about what constitutes identity. The project also reflects different aspects of immersion and insertion enabled by the various technologies.

A variety of telepresence and telerobotics projects use the technologies involved primarily to explore remote human communication and exchange (sometimes in a performance situation). Eric Paulos (b. 1969) and John Canny (b. 1959) have continuously examined these aspects in their ongoing project *PRoP – Personal Roving Presence* (1997–present). Their 'PRoPs'

are Internet-controlled telerobots that establish video and
audio links to the space they inhabit and allow their users to
engage in various activities in the space, among them wandering
around, talking to people, examining objects, and reading.
The robots thus enable simple, daily human activities, allowing
people to experience a space without providing too much of a
preconfigured scenario and literally becoming an extension of the
user in a different space, with remotely extended arms and eyes.
A more performative approach to telepresence has been taken
by Nina Sobell and Emily Hartzell, two pioneers of performance
on the Web who created their work under the label ParkBench.
As artists-in-residence at New York University's Center for
Advanced Technology (in 1994), Sobell and Hartzell began
using the Center's telerobotic webcam to stream live weekly

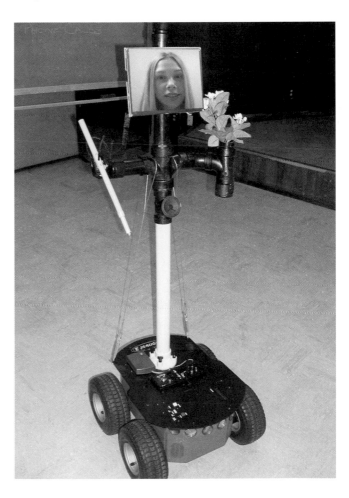

140. **Eric Paulos and John
Canny**, *PRoP – Personal Roving
Presence*, 1997–present

performances onto the Web. In 1995, they created *VirtuAlice*, a 'wireless, mobile, content-collection vehicle' that consists of a wheelchair-like throne equipped with a telerobotic camera, which can be controlled over the Internet and uploads video stills to the project website.

Performance was also at the core of Adrianne Wortzel's (b. 1941) *Camouflage Town* (2001), a project that was shown as part of the 'Data Dynamics' exhibition at The Whitney Museum of American Art and created a theatrical scenario for a robot living in the museum space and interacting with visitors. The robot, named Kiru, transmitted video images to the Web through its 'head', which consisted of a monitor and video camera. Kiru could be remotely controlled by visitors to the *Camouflage*

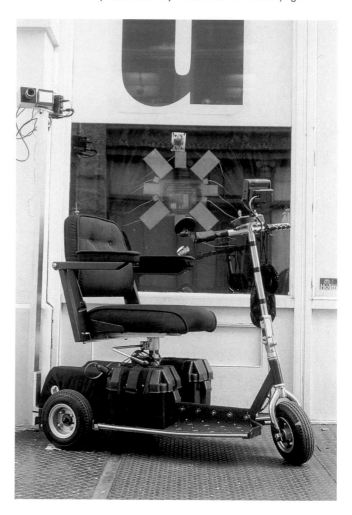

141. **ParkBench**, *VirtuAlice*, 1995. Visitors to the physical space could drive around the gallery, while the direction of the throne's camera was controlled by participants through the website. A monitor on the handlebars showed the driver the Web visitor's point of view, and he thus became a kind of 'chauffeur' for the Web visitor.

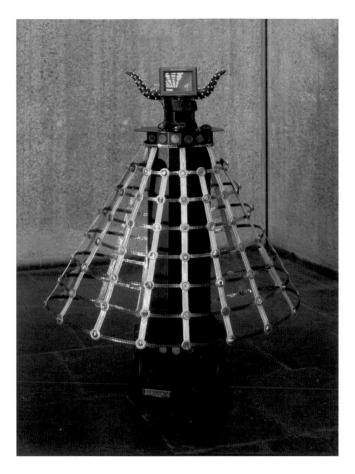

142. **Adrianne Wortzel**, *Camouflage Town*, 2001. Visitors could move the robot around, play pre-recorded sound files (in which the robot played the role of a 'cultural curmudgeon'), type in text for it to speak, and look at video imagery recorded from its head or from various other cameras throughout the museum space.

Town website or through a computer in one of the museum's galleries. As a 'character', Kiru was neither here nor there: at any given point it could be controlled by people in the space or anywhere in the world. People talking to and interacting with Kiru in the physical space could never be sure with whom they were engaging, as every movement and statement was mediated through the robotic 'performer'. The robot functioned as each visitor's avatar/alter ego and its performance played with people's willingness and capabilities to interact with a digital machine/character. A very different take on this motif of robotic extension is Lynn Hershman's *Tillie, the Telerobotic Doll* (1995–8) [143], an actual doll whose camera eyes can be controlled through a website. For the remote users, Tillie became an extension of their gaze; in the gallery space itself, the perception of being watched by an inanimate object temporarily 'inhabited' by someone else's

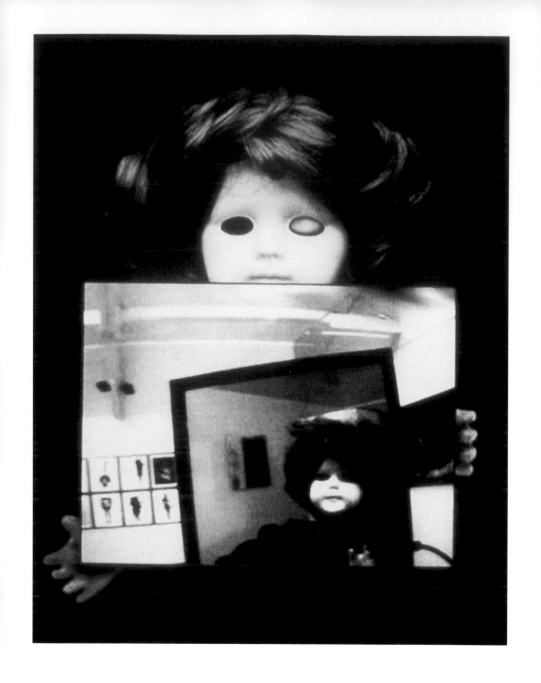

eyes pointed to the darker aspects of being the object of the gaze. As opposed to Kiru, who could engage in dialogue and became a surface for people's projection of a (human) personality, Tillie suggested a live doll, yet remained withdrawn, leaving people exposed to her seeming scrutiny. Telerobotic and biorobotic systems are constantly being advanced and used in contexts ranging from exploration of outer space to military interventions and surgery. In recent years, drones have increasingly become a focus of the discourse on telepresence and a subject of artistic exploration, which will be addressed in the chapter on locative media and mobile technologies.

Networked performance does not necessarily rely on robotic components but often takes the form of participatory installation projects – installation components in a physical space where local and remote visitors and performers can communicate through technologies for the duration of an exhibition or peformance. The artists' collective Fakeshop (formerly FPU – Floating Point Unit), founded by Jeff Gompertz and Prema Murthy in 1996, created several of these types of performances since the mid-1990s. Their project *Capsule Hotel* (2001) is inspired by the 'short-stay' hotels in the Shinjuku district of Tokyo that, instead of rooms, rent capsule-like chambers their guests can 'crawl' into for the night. The project is intended to establish a link between one of the actual capsule hotels in Tokyo and a physical installation in a gallery that consists of similar compartments. Enhanced by an Internet and videoconference connection, the capsules create a networked environment that allows selected 'inhabitants' to participate in an ongoing narrative and time-based performative actions. Crucial to the concept of *Capsule Hotel* is the doubling of environments in radically different contexts, one of them 'staged', the other one a commercial accommodation (and utilitarian absurdity of society).

On the one hand, telepresence projects enable users to observe, intervene, and communicate with a remote location and 'insert' themselves into a distant environment. On the other hand, they allow one to broadcast a specific point of view to the Internet. The projects of Toronto-based Steve Mann, a pioneer in the field of 'wearable computing', are an early example of the sharing of personal experiences via networked mobile devices that is now commonly done by means of mobile phones and tablets. Mann has over the years used numerous wireless devices – from his *Wearable Wireless Webcam* (1980) [144] to his EyeTap digital eye glass implant – which turn him into a mobile

143. **Lynn Hershman**, *Tillie, the Telerobotic Doll*, 1995–8

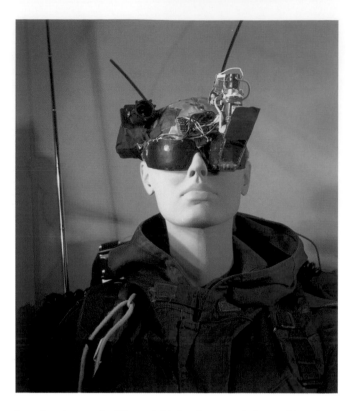

144. **Steve Mann**, *Wearable Wireless Webcam*, 1980–present

broadcasting studio. Through his headwear and glasses, Mann has been sending live video and audio to the Internet, sometimes in performance-type projects. Telepresence is inherently connected to issues of voyeurism and surveillance, which have been explored extensively in video art. The technologies and culture of constant observation, from video cameras to reality TV, have long been a topic of artistic exploration, but the possibilities for social control and monitoring have been tremendously increased through digital technologies. While telepresence and telematics establish a phenomenon of global connectedness and the 'translocal', they also raise serious issues about the merging of private and public spheres and the way in which we construct our identity.

Body and identity

The body and identity have become prominent themes in the digital realm, centring on questions of how we define ourselves in virtual as well as networked physical space. While our physical bodies are still individual, physical 'objects', they have also become increasingly transparent: exact surveillance and identification

seem to threaten the idea of individual autonomy. Ubiquitous surveillance cameras and GPS technologies track our movements; biometric technologies, such as electronic fingerprints, face-recognition software, and retina scanning, push into the market as a means of identification. Our virtual existence suggests the opposite of a unified, individual body – multiple selves inhabiting mediated realities. Sherry Turkle, director of the MIT Initiative on Technology and Self and author of *Life on the Screen: Identity in the Age of the Internet*, has described online presence as a multiple, distributed, time-sharing system. Both Turkle's book and *The War of Desire and Technology* by cultural theorist Allucquère Rosanne Stone investigate the decentring of the subject brought about by digital technologies.

Online identity allows a simultaneous presence in various spaces and contexts, a constant 'reproduction' of the self without body. In virtual worlds and online chat environments, people choose avatars to represent themselves, and slip in and out of character. Virtual life allows people to have a presence in several windows and contexts simultaneously, a condition that has become a central aspect of many online art projects. From the early works of Tina LaPorta, who investigated CUseeMe technology, to projects using Chatroulette, an online chat website that pairs random people from around the world together for webcam-based conversations, artistic explorations have consistently focused on online identity and the impact of webcams onto the relationship between the private and public spheres.

The relation between virtual and physical existence is a complex interplay that affects our understanding of both the body and (virtual) identity. The underlying question is, to what extent are we already experiencing a man–machine symbiosis that has

145. **Tina LaPorta**, *Re:mote_ corp@REALities*, 2001. This project remixes Web camera images (showing people connecting online on CUseeMe sites), texts extracted from real-time online chat rooms, and voiceovers of interviews with New York City net artists and theorists. While fragments of text from the chat rooms scroll across the screen, two windows display the CUseeMe participants and Images from live webcams from dispersed geographical locations. The voiceover interviews address questions such as 'Is cyberspace your window or your mirror?', 'Is the machine an aspect of our embodiment?', and 'How (or in what situation) does communication break down?' Juxtaposing these different forms of communication, LaPorta's piece examines the effect of technologies on social relations.

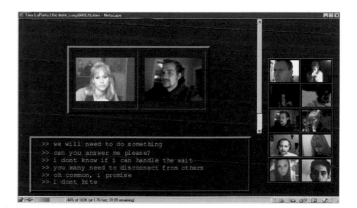

turned us into cyborgs – technologically enhanced and extended bodies? In her book *How We Became Posthuman*, Katherine Hayles, one of the prominent theorists of the 'technologized body', states: 'Increasingly the question is not whether we will become posthuman, for posthumanity is already here. Rather, the question is what kind of posthumans we will be.'

Notions of the cyborg, the extended body, and the posthuman frequently surface in digital art projects. The Australian-based performance artist Stelarc, for example, has created numerous works that construct human–machine interfaces – incorporating robotics, prosthetics, and the Internet. As Stelarc claims, human beings have always to some extent been prosthetic bodies and cyborgs in that they constructed 'machines' which could be manipulated by their limbs. With

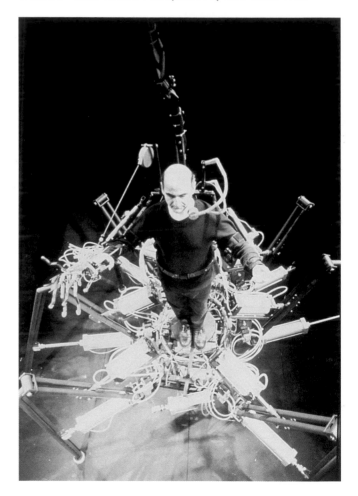

146. **Stelarc**, *Exoskeleton*, 1999. The artist's body is positioned at the centre of the structure on a turntable and activates the machine through an extended 'arm' with a pneumatic manipulator. Combining mechanical, electronic, and software components, the machine is controlled by the artist's gestures and performs a 'dance' that is entirely choreographed by his arm movements.

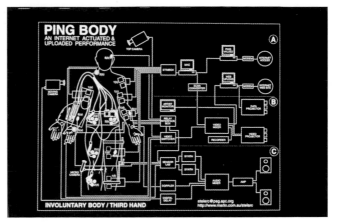

digital technologies, not only do the prosthetics become more sophisticated but we are experiencing an increasing fusion of the body and the machine.

Stelarc's piece *Exoskeleton*, first performed in Hamburg in 1998, extended the artist's body through a six-legged, pneumatically powered walking machine that allows movements forwards, backwards, and sideways, as well as turning on the spot. In earlier performances, Stelarc had implemented a system that allowed a remote audience to actuate the artist's body through muscle stimulation. In *Ping Body* (1996), the stimulation was triggered by Internet traffic itself – the flow of data. 'Ping' commands were randomly sent to Internet domains. The ping values, ranging from 0 to 2,000 milliseconds were then 'translated' into 0–60 volts that would be directed to the muscles of Stelarc's body through an interface that also represented the physical body's movements. This way, *Ping Body* established a direct connection between (and inversion of) Internet activity and body movement, to some extent integrating the physical body and the network. Allowing the body to be controlled by the machine, Stelarc's work operates on the threshold between embodiment and disembodiment, a central aspect of discussions about the changes that digital technologies have brought about for our sense of self.

When Galileo's telescopic eye reached the moon in 1609, the telescope not only extended the range of human vision; to some extent, it detached the eye from the physical environment of the perceptual body. In virtual reality and online environments, this detachment or flight from the body has been taken to new levels.

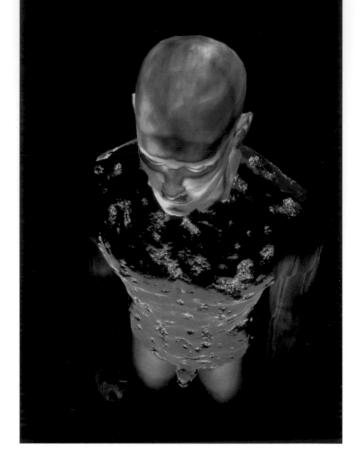

One of the attractions of online presence consists in the possibility of remaking the body, of creating digital counterparts released from the shortcomings and mortal limitations of our physical 'shells'. Online worlds allow visitors to create their own (cyber) self and be all they want to be. Victoria Vesna's (b. 1959) *Bodies, Inc.* (1995), a website allowing visitors to create a cyberbody and online representation out of different components, was created at a time when the Web's capacities were still limited but was visionary in terms of the concept of the incorporated body, which has gained new significance with the rise of e-commerce and the ways in which our data-bodies and online behaviours are tracked. Vesna developed this basic concept into further manifestations of data-bodies that function as data containers on the network and allow users both to represent themselves as a container of various kinds of information and to search information contained in other

bodies. In Vesna's project *Notime* (2001) people are invited to represent themselves as 'meme fabrics' – geometries of data-bodies containing information about their creators. In projects such as *Bodies, Inc.* and *Notime* – as well as any communication taking place in chat environments or virtual worlds – the exchange is always mediated by the gaze of the computer. In addition to the reflection of an 'other' encountered in this space, people are also confronted by a reflection of themselves, their online representation. The 'self-reflection' encountered in avatars connects to the inversion of reality and dichotomy of identity and difference, presence, and absence that was epitomized in the classical myth of Narcissus, who fell in love with his own reflection in a pool of water, and has inspired artistic explorations for centuries. The motif of the mirror reflection is explicitly addressed in the installation *Liquid Views* (1993) by German artists Monika Fleischmann (b. 1950), Wolfgang Strauss (b. 1951), and Christian-A. Bohn. *Liquid Views* re-creates a virtual pool of water in the form of a screen embedded in a pedestal. Bending over the pedestal, viewers see their reflection on the monitor, and their touch on the screen produces wave-shaped forms, created by an algorithm, that distort the image. *Liquid Views* both translates the corporeal experience of the reflection into the virtual realm and at the same time unveils the function of the interface as a technological device that translates the viewer's image into the virtual space of reflections. Interaction entails a distortion of the image that is controlled by the laws of the machine.

Apart from offering possibilities for creating virtual counterparts, the virtual realm has also been used for the

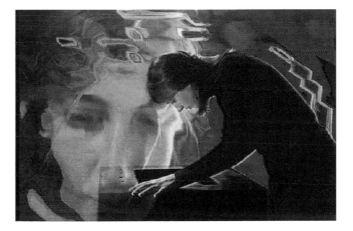

149. **Monika Fleischmann, Wolfgang Strauss, and Christian-A. Bohn**, *Liquid Views*, 1993

creation of fictitious personalities that take on a life of their own. An example would be the website of Mouchette, which presents itself as the personal site of a teenage girl, yet is an entirely fictitious construct. A project specifically addressing issues of gender was Shu Lea Cheang's BRANDON, which was launched at the Guggenheim Museum in New York in 1998. BRANDON was conceived as a multi-artist, multi-author, multi-institutional collaboration and unfolded over the course of a year. The project derived its title from the story of Teena Brandon from Falls City, Nebraska, a gender-crossing woman who, at the age of twenty-one, was sexually assaulted and seven days later murdered by two local men who found out that Brandon was a woman living as a man. Teena Brandon's life story also became the subject of a documentary and the feature film Boys Don't Cry. Cheang's project translated the story of Brandon into cyberspace by using multiple interfaces to explore the multi-layered narrative of gender and identity as well as issues of crime and punishment. The Internet in many ways provided an ideal medium for Cheang's BRANDON, a person and work existing at the cross-section of real and virtual identity.

The motif of leaving the physical body behind may be a crucial aspect of virtual identity but the concept of disembodiment suggested by the previous projects also neglects the materiality of the interfaces that are being created and the effect of these interfaces on our bodies. This materiality begs the question of how far the human body has already become an extension of the machine. As Eduardo Kac puts it, 'the passage into a digital culture – with its standard interfaces that require us to pound a keyboard and sit behind a desk while staring at a screen – creates a physical trauma that amplifies the psychological shock generated by ever-faster cycles of technological invention, development, and obsolescence'. Current interface standardization has led to an overall restraining mechanism for the human body, which is forced to conform to the computer and monitor – although these standard interfaces will probably radically change in the future. The tension between embodiment/disembodiment can not be constructed as a choice of either/or but rather has to be understood as a reality of both/and.

Kac's project Time Capsule took a radical approach to this issue by crossing the frontier between the body and technology invasion and turning the body into a 'site' for hosting artificial memory. The Time Capsule event took place on 11 November 1997 at Casa das Rosas Cultural Center in São Paulo, Brazil:

using a special needle, Kac inserted a microchip with a programmed identification number into his left leg. After implantation, a thin layer of connective tissue formed around the microchip preventing migration. At the event, Kac placed his leg into a scanning apparatus, and his ankle was then remotely scanned from Chicago (the scanner's button was pushed via a telerobotic finger). The scanning of the implant generated a low-energy radio signal that energized the microchip and caused it to transmit its unique and unalterable numerical code, which was shown on the scanner's sixteen-character LCD. Kac then registered himself in a Web-based animal identification database, originally designed for the recovery of lost animals. It was the first time a human being had been added to the database – Kac

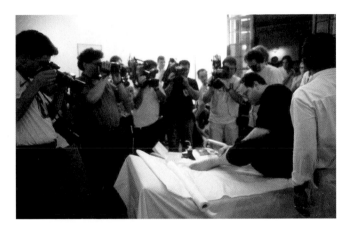

150. **Eduardo Kac**, *Time Capsule*, 1997

151. (right) **Stahl Stenslie**,
The First Generation Inter_Skin Suit,
1994

breastpads

arm pad

arm pad

back effectors/
sensors

controller

genital sensors/effectors

leg pad

leg pad

152. (below) **Kazuhiko Hachiya**,
Inter Discommunication Machine,
1993

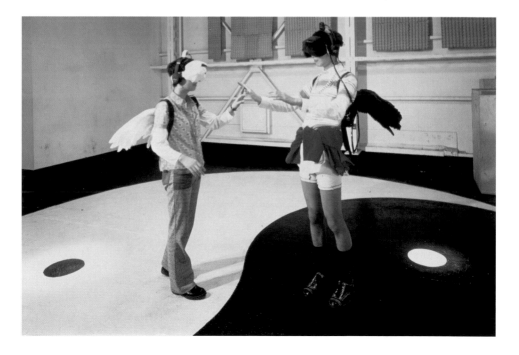

registered himself both as animal and owner. The event was shown live on national television in Brazil and on the Web. Walking on the edge of surveillance and liberation from the machine, *Time Capsule* might be considered an Orwellian dystopia come true. Implanted microchips – which have become perfectly acceptable in medical usage – might well become the passports of the future, allowing the identification and tracking of the individual and offering the ultimate protection from crimes such as abduction. At the same time, *Time Capsule* might be seen as a radical liberation of the body from the machine – a reconciliation of aspects still generally regarded as antagonistic, such as freedom of movement, mobile data storage and processing. *Time Capsule* combines the ephemeral (identification through webscanning) with the permanent (the implant itself). In a clash of the tangible and the virtual, the project frees the body from the machine and at the same time makes it permeable and readable to the Internet.

Networked communication has created instant connectivity and a form of disembodied intimacy, but it also largely remains detached from the realm of the primal senses – such as touch and smell. Several art projects have been striving to expand these perceptual limits of technology, among them Norwegian artist Stahl Stenslie's (b. 1965) *Tactile Technologies*, which try to introduce the body to 'digital perception' by remotely translating bodily sensations and stimuli over a network. In Stenslie's *Inter_Skin* project, participants wear an outfit equipped with sensors that is capable of both transmitting and receiving stimuli, such as touch. The communication system is aimed at transmitting and receiving sensual experiences. The possibilities of 'connecting' bodies are taken to a further level by Kazuhiko Hachiya's *Inter Discommunication Machine* (1993). Used by two people wearing head-mounted displays, the 'machine' projects one player's sight and sound perception of a virtual 'playground' into the other one's display, thus confusing the borders between 'you' and 'me'. The *Inter Discommunication Machine* is reminiscent of the 'Sim-Stim' device described in William Gibson's novel *Neuromancer*, which allows a user to 'enter' another person's body and perception without being able to influence it.

The boundaries between the self and other are also at the core of Scott Snibbe's *Boundary Functions* (1998) [153], an interactive project that visualizes the usually invisible relationships between individuals in physical space. The *Boundary Functions* manifest themselves as lines that are projected onto the floor from overhead and demarcate the space occupied by people in

153. **Scott Snibbe**, *Boundary Functions*, 1998. This form of regional demarcation is known as Voronoi diagrams, which are used in various fields, including anthropology and geography (for a description of patterns of human settlement); biology (for depicting patterns of animal dominance); marketing (for strategic placement of chain stores); and computer science (for solving triangulation problems). The project takes its title from the PhD thesis of Theodore Kaczynski, the infamous Unabomber, whose antisocial, criminal behaviour exemplifies the conflict between individual and society.

the gallery. As people move around in the gallery, the lines divide the floor into cellular regions around the visitors and adjust to people's movement. Each region has the mathematical quality that all space within is closer to the person inside than any other. Using analytical methods that are applied for an understanding of nature and mathematical questions, *Boundary Functions* concretizes the usually invisible limits that outline personal space and separate the self from the other in social relationships. By giving disembodied information about our bodies a concrete diagrammatic form, Snibbe's piece underlines the digital medium's capacity to visualize abstract processes in a dynamic way.

Database aesthetics and data visualization

In the digital age, the concept of 'disembodiment' does not only apply to our physical body but also to notions of the object and materiality in general. Information itself to a large extent seems to have lost its 'body', becoming an abstract 'quality' that can make a fluid transition between different states of materiality. While the ultimate 'substance' of information remains arguable, it is safe to say that data are not necessarily attached to a specific form of manifestation. Information and data sets are intrinsically virtual, that is, they exist as processes that are not necessarily visible or graspable, such as the transferral and transmission

of data via networks. The meaningfulness of data relies on possibilities of filtering the information and creating some form of organizing structure or 'map' – be it mental or visual – that can allow for orientation. Static methods for representing data-charting, graphing, sorting, etc., have been established over centuries. Since the advent of digital technologies, 'information spaces' and the creation of visual models that allow for a dynamic visualization of any kind of data flow have become a broad field of experimentation and research, be it in science, statistics, business, architecture, design, digital art, or any combination of these.

Every 'container' of information – be it a library, a building, or a city – essentially constitutes a dataspace and information architecture of its own, even though its characteristics are quite different from the virtual, dynamic dataspace. The idea of 'information architecture' directly relates to the principles of the previously mentioned memory theatres and palaces, which have experienced a revival in the context of digital art. A project directly inspired by the concept of the memory palace is the website *Apartment* (2001) [154] by Martin Wattenberg (b. 1970) and Marek Walczak (b. 1957). On a blank screen, viewers type in words and texts of their choice, which trigger the appearance of rooms on the monitor as a two-dimensional plan, similar to a blueprint. The architecture of each apartment is based on a semantic analysis of the viewers' words, reorganizing them to reflect the underlying themes they express: the word 'work' may create an office; 'media', a library; 'look', a window. This structure is then translated into navigable three-dimensional dwellings composed of images that were the result of Internet searches for the words previously typed in. Viewers may navigate these 3D environments, while the texts they typed are read back by means of text-to-speech software. The 'apartments' created on the website are clustered into cities according to their semantic relationships. The cities can be arranged according to semantic complexes such as 'Art', 'Body', 'Work', 'Truth' – the apartments with the highest occurrence of the respective theme will move to the centre. Establishing an equivalence between language and space, *Apartment* connects the written word with different forms of spatial configuration.

Dynamic visualizations of data flow allow users to navigate visual and textual information and experience changes over time. For any given set of data, there are always multiple possibilities for giving it a visual form. An example of a project that creates dynamic visual constructions from large bodies of information is

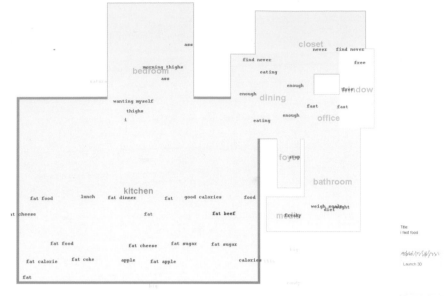

ass

morning thighs

closet

never find never

find never free

bedroom ass eating free

enough window free

wanting myself enough dining fast fast

thighs enough

i eating office

foy stop

bathroom

kitchen

fat food lunch fat dinner fat good calories food weigh scale/weight diet

t cheese fat fat beef m freaky

fat food fat cheese fat sugar fat sugar

fat calorie fat coke apple fat apple calories

fat

Title:
i fast food

Launch 3D

New apartment
See all apartments

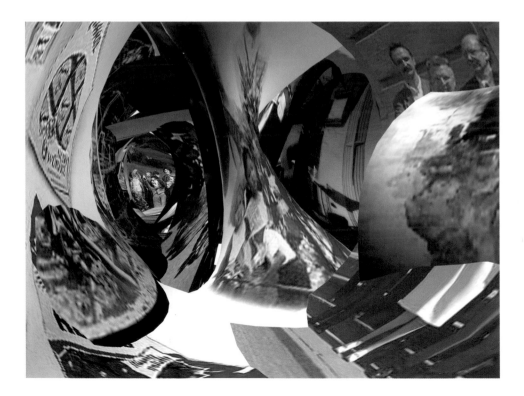

176

155. (right) **Benjamin Fry**, *Valence*, 1999. *Valence* has been used for visualizing website traffic, reading Mark Twain's *The Innocents Abroad*, comparing Goethe's *Faust* to Wittgenstein's *Tractatus Logicus Philosophicus*, or comparing the genomes of a human, fruitfly, and mouse. Reading a text, *Valence* adds each word into a three-dimensional dataspace and connects them by lines; frequently used words appear at the outside of the space, and less common ones at the centre.

156. (right) **W. Bradford Paley**, *TextArc*, 2002. The split image shows *TextArc*'s reading of *Alice's Adventures in Wonderland* in the interactive version (top) and print version (bottom). *TextArc* represents the novel's entire text on one page as two ellipses (line by line and word by word, respectively). A pool of words appearing in the middle of the ellipses forms the main organizing structure: words that appear more than once are located at the average position in which they appear in the spirals' text and frequently used words stand out from the background. In the interactive version, a coloured curved line 'reads' the words by connecting them in the order they appear in the text. In the print version, coloured stars next to each word point to every place the word is used in the text.

154. (opposite) **Martin Wattenberg and Marek Walczak**, *Apartment*, 2001

Benjamin Fry's (b. 1975) data-visualization software *Valence* (1999). The software visually represents individual pieces of information according to their interactions with each other. *Valence* can be used for visualizing almost anything, from the contents of a book to website traffic, or for comparing different data sources. The resulting visualization changes over time as it responds to new data. Instead of providing statistical information (i.e., how many times a particular word appears in a text), *Valence* provides a feel for general trends and anomalies in the data by presenting a qualitative slice of the information's structure. *Valence* functions as an aesthetic 'context provider', setting up relationships between data elements that might not be immediately obvious, and that exist beneath the surface of what we usually perceive. An interesting counterpart to Fry's project is W. Bradford

Paley's online project *TextArc* (2002) [156], a visual model that represents an entire text, such as a novel, on a single page. *TextArc* allows users to filter a text in various ways and, similar to *Valence*, expose patterns of content. *TextArc* also has a physical manifestation as offset prints. The two-dimensional architecture of *TextArc* radically differs from that of Fry's project, and 'feeding' both projects with the same text for analysis would expose very different patterns and connections.

The underlying concept and structure of these visualization projects are the archive and database, which are key elements in mapping and our understanding of digital culture. During the 1990s, digital archives and databases developed into what could be seen as a cultural form. From the digitization of libraries, historical records, and museum collections to data collection for commercial purposes and the Internet as a gigantic data storage and retrieval system, archives and databases have become an essential form of cultural organization and memory. Databases in themselves are essentially a fairly dull affair, consisting of discrete units that are not necessarily meaningful. The power of databases consists in their relational potential, the possibility of establishing multiple connections between different sets of data and constructing narratives about cultures. While the general concept of the database is an underlying aspect of digital art in general, many digital art projects explicitly focus on the various aspects of database culture. Hungarian George Legrady (b. 1950), for example, is another artist whose work has concentrated on the impact of databases in the context of cultural narratives. His installation and CD-ROM *An Annotated Archive of the Cold War* (1994) investigated archive construction by making personal and official documents from Stalinist Hungary accessible through an interface modelled after the floorplan of the former Hungarian Communist propaganda museum. His interactive installation *Slippery Traces* (1997) invited viewers to navigate through more than 240 linked postcards that were categorized according to topics such as nature, culture, technology, morality, industrial, urban environments, etc. Using postcards as a readymade expression and trace of cultural memory, Legrady creates a narrative environment that transcends the sum of its parts, reflecting both on the construction of narration and mediated memory. Legrady's *Pockets Full of Memories*, an installation with an accompanying website, which was shown at the Centre Pompidou in 2001, invites visitors to digitally scan an object in their possession at a scanning station and answer a set of

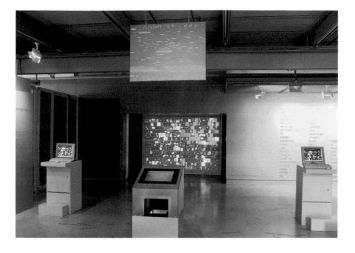

questions regarding the object. An algorithm classifies the scanned objects in a two-dimensional map based on similarities in their descriptions. Users can review each object's data and add their own personal comments and stories. The result of the project is a growing map of possible relations between items that range from the merely functional to a signifier of personal value. The mapping of these objects points to the potentiality and absurdities of classifying objects endowed with personal meaning. The project operates on the threshold between logical classification and meanings that are not quantifiable.

One of the inherent characteristics of digital art is the tension between the hierarchical structure of instructions and data sets and the seemingly infinite possibilities for reproducing and reconfiguring the information contained within these structures. *Carnivore* (2001–present) [158], a project by Alex Galloway and the artists' collaborative RSG (Radical Software Group), perfectly illustrates this tension between the data stream and the visual form this data takes. The project is inspired by the software DCS1000 (nicknamed 'Carnivore'), which is used by the FBI to perform electronic wiretaps and search for certain 'suspicious' keywords. This electronic wiretapping is done by means of so-called packet-sniffing programs that monitor network traffic and 'eavesdrop' on the information exchanged. One part of the *Carnivore* project is the Carnivore Server, an application that performs packet-sniffing on a specific local area network and serves the resulting data stream. The other part consists of 'client' applications created by numerous other artists, which interpret

the data in visual ways. At the core of the *Carnivore* project are the unlimited possibilities of visualizing the server's data stream in a collaborative, 'open source' way – making the source code of the software available to anyone interested in using it, as opposed to limiting its use for the purpose of surveillance. The piece specifically defies an easy categorization of surveillance as either positive or negative, allowing its users to create maps of the data stream that often remain detached from or obscure the original data source.

From the 1990s to the twenty-first century, artistic practice in the field of database aesthetics and data visualization has undergone a significant shift. Projects in the 1990s and early 2000s often experimented with the dynamic mapping of the Internet as territory or specific data sets or networked communication. The Web 2.0 era brought forth the phenomenon of big data, collections of data sets so complex that they require new software tools for capture, search, analysis, and visualization. Big data analytics, the process of examining big data to uncover hidden patterns and unknown correlations also became a subject in art.

Swedish artist Lisa Jevbratt's (b. 1967) website *1:1* (1999/2001) [159] is a landmark early project that creates a portrait of the World Wide Web focusing on database aesthetics and the formal qualities of the network. The project consists of five different visualizations of the web as a 'numerical' space. Every website has a numerical Internet Protocol (IP) address – a string of numbers such as 12.126.155.22 – that usually remains hidden behind the .com, .org, .net address. *1:1* is a visualization of a database of these numerical addresses compiled by C5, a research group of which Jevbratt is a member. To build the database, C5 sent out 'crawlers' – software that would pick a sample of possible IP addresses, iterate all the potential variations, search for them on the Net, and then start a new search with other samples. If a site existed, no matter if it was accessible to the public or not, its address was included in the database. In *1:1*, the IP addresses are presented in colour-coded 'portraits', where each pixel represents an IP address that can be accessed by clicking on it. The experience of *1:1* very much differs from the usual access to the Web through search engines or different portals: many of the hosts have restricted access or not even a visible front-end web page. The Web is presented in its entire territory and not as the directory of designed sites that one accesses through a search engine. One of the most interesting aspects of *1:1* is the

158. **Alex Galloway and RSG**, *Carnivore*, 2001–present

(top) *amalgamatmosphere* by Joshua Davis, Branden Hall, and Shapeshifter.

(centre) *Black and White* by Mark Napier. *Black and White* reads and visually translates the 0s and 1s in *Carnivore's* data stream, with 0 creating a black horizontally moving pattern and 1, a vertically moving white one.

(bottom) *Guernica* by Entropy8Zuper!

159. **Lisa Jevbratt/C5**, *1:1*,
1999/2001. Jevbratt originally
created *1:1* in 1999 and generated
a second database of addresses in
2001: the *1:1* interfaces now show
both data sets in split screens,
allowing users to compare the
Web in 1999 and 2001. In the
'Every: IP' interface the pixel's
specific colour is generated by
using the second part of the IP
address for its red value, the third
for its green, and the fourth for
its blue. In the 'Every: Access'
interface, accessible IP addresses
are represented as green pixels,
inaccessible ones as red, and
server errors as white. The
'Every: Top' interface (below)
colour-codes the top level domain
names (.com, .org, .edu, etc.)
thus allowing users to see the
distribution of these domains
throughout the Web.

way it collapses the distinction between a map and interface: the
interface becomes a 1:1 representation of the environment that
it portrays.

Apart from explorations of the mapping of networks in
their entirety, there is a plethora of art projects that visualize a
specific set or type of data. An interesting subject for comparison
are projects that take 'live' financial or stock market data as
their source. Among these works are Nancy Paterson's *Stock
Market Skirt* (1998), John Klima's *ecosystm* (2000) [161], and Lynn
Hershman's *Synthia* (2001) [162], each of which provides a radically
different context for understanding and representing the changing
data flow of financial markets. Paterson's *Stock Market Skirt*
incorporates a physical object, a dressmaker's mannequin wearing
a blue taffeta dress to which are attached a stepper motor,
weights, and pulleys. A computer analyses stock prices from online
stock market quote pages and sends the values to an application
which raises or lowers the hemline of the skirt depending
on the rise or fall of a stock price. Klima's *ecosystm* software
(commissioned by Zurich Capital Markets) depicts global currency
data in a 3D environmental simulation, where the population and

behaviour of flocks of insect-like 'birds' (representing countries' currencies), are determined, respectively, by the currency's value against the dollar and its daily/yearly volatility. *Ecosystm* is a simulation in the original sense where the functioning of the financial market is visualized through the functioning of another system, the behaviours of flocks of birds (which are depicted in a rather abstract way). Branching tree-like structures depict the respective countries' leading market index and if a currency's daily volatility is more than double the yearly volatility, the flock starts 'feeding' on its country's leading market index. Depending on the 'behaviour' of the world's currencies, *ecosystm* can appear either as a serene and beautiful world experienced from the point of view of a majestically gliding bird or as an aggressive and eerily threatening environment. Lynn Hershman's *Synthia* also translates stock market fluctuations into behaviours, in this case the 'human' kind. Synthia is a virtual character whose actions reflect the changes in the market: she goes to bed if the market is flat, dances if it is up, and chain-smokes if it goes down, to name just a few of her behaviours. The project was exhibited in the office building of the investment company Charles Schwab in San Francisco. Images of visitors to the building – recorded by an on-site camera – were incorporated into the artwork in real time, integrating people into

161. **John Klima**, *ecosystm*, 2000

161. **John Klima**, *ecosystm*, 2000

Synthia's world. While all of the previously mentioned works use a similar data source, the translation of the information into visuals (or, in Paterson's case, an object) radically differs and shapes the context for perceiving and understanding the data.

The increasingly easy access to data sources of all kinds at best leads to a transparency that allows one to gain insight and make more informed decisions and, at worst, creates an information overload with paralysing effects. The growing accessibility of data about the world has been the subject of several early art projects that created digital globes for the information age, mapping various information resources about the planet. Among these is *TerraVision* (since 1994), a project by the Berlin-based collaborative ART+COM that strives to create

162. **Lynn Hershman**, *Synthia*, 2001

163. (below) **ART+COM**, *TerraVision*, 1994–present. The data layers include transparent cloud covers, temperatures, maps of cities, neighbourhoods and buildings, as well as temporal geophysical and demographic processes such as global warming and migration.

a virtual representation of the Earth on a 1:1 scale. By means of a globe-like interface, the Earthtracker, users can navigate the virtual Earth, accessing numerous types of data and zooming in on details. Depending on the data source, information can be presented in a static or dynamic way and the system is open to the integration of any type of data layer. A project with a similar approach but more focused on real-time, publicly accessible data and the aesthetics of representation is John Klima's networked software *EARTH* (2001) [164]. *EARTH* is a geo-spatial visualization system that culls real-time data from the Internet and accurately positions it onto a three-dimensional model of the Earth, allowing users to zoom in on data layers such as a spherical mapping of current weather imagery from the GOES-10 satellite, Landsat 7 satellite pictures, and topographical maps created from digital elevation data provided by the US military mapping agency. In *EARTH*'s final layer, the viewpoint switches to a local one, where viewers can 'fly' through a five-degree by five-degree patch of the Earth's terrain that the artist dynamically generates from the previous topographical layer. Included in this local terrain are the current weather conditions as reported by the local weather stations of the respective area. *EARTH* is an aesthetic investigation of the world as it currently exists 'in data', exploring imagery that purportedly depicts reality and at the same time unveiling the underlying characteristics of this reality as mediated, processed representation. *EARTH*, a limited edition of software, also has an installation component, where the overview of the planet – the outer layer of the software – is projected onto a weather balloon. The projection indicates what people navigating the *EARTH* software at the user stations in the physical space are looking at: the satellite image they are accessing at any given point is included in the overview as a small square – what they see is observed. The overview of the complete system including viewers' positions creates a 'Big Brother' in a benign informational universe, a reminder of the more sinister nature of the techno-informational landscape developing in the real world.

The tracking of information flow, with less of a focus on surveillance, was also the subject of ART+COM's installation *Ride the Byte* (1998) [165], which visually translated the routes of information through the global communication network. Users could choose a website from a predefined selection on a display. On a large projection, they could then see the route taken by the actual data packet travelling to the requested site in order to retrieve the information. *Ride the Byte* reinstates the paradigms of

164. (opposite) **John Klima**, *EARTH*, 2001

165. (below) **ART+COM**, *Ride the Byte*, 1998. The process of tracking the data transfer, known as tracerouting, was represented by a line drawing itself across the globe (similar to flight routes of aeroplanes) from one server to the next. The route of a packet from A to B always varies depending on the current usage of the Internet. The geographical locations and IP addresses of the servers visited by the packet were also indicated, and once it had reached its location, the requested website appeared on the projection.

a physical map and its emphasis on geographical location for the process of data travel, a process that is not usually visible but which vanishes behind a global network that transcends time and place.

Dynamic visualizations of processes are not only created for different forms of data: they can also chart our personal interactions, interventions, and communication. Social media platforms have created new forms of communication environments open to data mining, the analysis of data from various perspectives by means of software tools in order to generate useful information, mostly for marketing purposes and generating revenue. With the development of more elaborate filtering tools, the visualization of communication processes has become increasingly sophisticated and a field for artistic exploration. Projects such as American artist Warren Sack's *Conversation Map* (since 2001) [166] early on experimented with the mapping of communication: the *Conversation Map* is a browser that analyses the content of large-scale online e-mail exchanges (such as newsgroups) and uses the results of the analysis to create a graphical interface that allows users to see different social and semantic relationships. An earlier, well-known graphical representation of large-scale communication is *Chat Circles* by

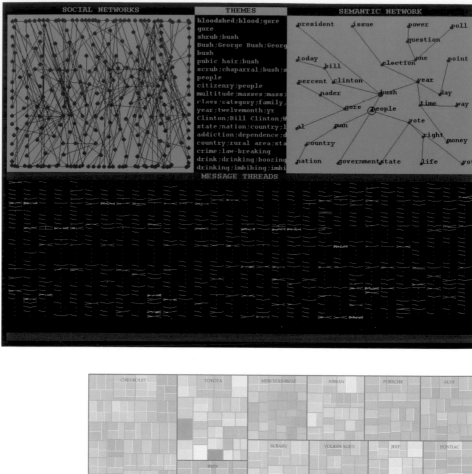

166. **Warren Sack**, *Conversation Map*, 2001–present. Participants in the conversation are represented as little nodes, and their exchanges are displayed as lines connecting them (proximity of the nodes indicates the amount of messages that have been exchanged between them). A menu of discussion themes lists the most commonly discussed topics in hierarchical order, and an overview panel presents the history of all messages exchanged over a given period of time. Terms in the conversation that are synonyms or have similar meaning are connected in a semantic network.

Judith Donath and Fernanda B. Viégas. Each person connected to the chat environment is represented as a coloured circle with the person's name attached to it. If users post a message it appears within their respective circle, makes the circle grow, and then gradually fades as time passes. In the age of big data and 'cultural analytics', data visualization has to explore and make sense of an increasingly larger territory. In their project *The Aggregate Eye* (2013) [1], Lev Manovich, Nadav Hochman and Jay Chow investigate urban representations through the aggregation of the millions of photos shared by people on social networks. The collaborators downloaded and analysed 2,353,017 Instagram photos shared by 312,694 people in thirteen cities over a three-month period. Large prints and video combine these photos to reveal unique patterns. One set of images compares New York, Tokyo, and Bangkok on the basis of 150,000 Instagram photos. A visualization of 23,581 photos shared in Brooklyn during Hurricane Sandy captures the visual narrative of that day. *The Aggregate Eye* is a part of *Phototrails*, a research project initiated by Hochman, Manovich and Chow that uses experimental media visualization techniques for exploring visual patterns, dynamics, and structures of user-generated shared photos. Tools for data visualization are typically accessible in the context of academia, business or government. In an attempt to 'democratize' visualization and enable collaborative techniques, Martin Wattenberg, Fernanda Viégas and collaborators built *Many Eyes* (2007–present), a website where people can upload their own data, create interactive visualizations, and discuss them together.

Beyond the book: Narrative environments
The electronically linked environments one now encounters in digital art and on the Internet are mostly mixed forms, incorporating text, images, and sounds and allowing users to manipulate them in various ways. While the WWW may be the most advanced actualization of Ted Nelson's dream of hypermedia so far, his concepts of hypertext became a field of experimentation before there was a WWW, particularly in the writing community. One of the most popular hypertext environments is *Storyspace*, distributed by Eastgate Systems, who have published numerous titles of fiction and non-fiction created with the software since the early 1990s. Electronically linked environments have already had a profound impact on how we think about reading and writing by emphasizing the position of words in a contextual and referential framework.

167. **Fernanda Viégas and Martin Wattenberg**, *Many Eyes: Treemap*, 2007. *Many Eyes* provides different templates for visualizations, among them the tree map, which is particularly effective in illustrating hierarchical structures. Through size and colour coding, tree maps can show attributes of data – in this case car manufacturers and models – and enable users to compare them, helping them to spot patterns and exceptions.

As electronically linked, nonlinear text, hypertext both embodies and tests aspects of postmodern critical theory, particularly those concerning textuality, narrative, and the roles or functions of reader and writer. With its webs of linked text segments and networks of alternate paths, hypertext favours a plurality of discourses and blurs the boundaries between reader and writer. The author creates a map of the text with alternate paths and various options; readers assemble the story by choosing their routes through it (or even rewriting the text) and thus create an individual version of it. Since the reading process is nonsequential, the author can only to a certain extent predict which path readers will follow (or if they can follow at all). The author and reader of hypertext and hypermedia become collaborators in the mapping and remapping of textual, visual, and aural components.

Postmodern and poststructuralist theory would argue that textuality is by nature open-ended and the reading process is never sequential. Readers do not progress from word to word, line to line, page to page until they have finished the text. Rather they *perform* a text within referential frames and make multiple connections and associations while reading. Since the 1960s, reader-response criticism has emphasized the role of the reader in the construction of the text (is there a text without a reader?). However, the stability of traditional texts is both physical and psychological. The physical, stable presence of a text printed in a book or paper tends to deny the intangible, psychological text the reader attempts to construct. Hypertext and hypermedia abandon the physical stability of the printed text itself by adding technologized conventions: due to the mechanism of links, it is not predominantly the reader's interpretation of the text that changes but the text itself. Hypermedia applications strive to mimic the brain's ability to make associative references and use these references in order to access information. Hypertext fuses the reader and writer in a visible, surface-level manner that emphasizes the very qualities – the play of signs, intertextuality, the lack of closure – posed as the ultimate limitations of literature and language by the theory of deconstruction.

Digital technologies have induced an increased flexibility and instability of the printed text – from typography to the book and the construction of narrative – which has become a large field of artistic exploration. The artworks addressing these issues range from hypertext novels, which often combine text with visuals and sound, to experiments with typography and notions of the book. Masaki Fujihata's *Beyond Pages* (1995) is a classic of

168. **Masaki Fujihata**, *Beyond Pages*, 1995. The apple and stone can be rolled and dragged across the page while sounds emulate the motion against the paper. Each object is accompanied by its name in Japanese script and if readers select a syllable of the script, a voice reads it.

林檎

this genre, a project that explicitly juxtaposes traditional reading conventions with the possibilities brought about by the digital medium. In the installation, images of a leather-bound tome are projected onto a table. Readers can activate the book by means of a light pen, animating the objects named in it, among them stone, apple, door, light. *Beyond Pages* materializes the metaphor of words becoming alive on the page, and part of its magical beauty resides in the fact that it visibly transcends the physical limitations of the book. A similar magical effect is achieved by *Text Rain* (1999), an installation by American artist Camille Utterback and Romy Achituv that enables users to physically interact with floating text. Users stand and move in front of a large projection, which shows their shadow image as well as a colour animation of letters that seem to be falling like raindrops. Since the letters are stopped by anything darker than a certain colour value, they 'land' on peoples' shadows and can be caught, lifted, or let fall through the movement of the users' hands, arms, and bodies. The participants thus literally construct the text through their movement, becoming 'bodies' that both

169. **Camille Utterback and Romy Achituv**, *Text Rain*, 1999

inhabit the same space and interact with each other. Concepts of reactive graphics, interactive text, and typography have most consistently been developed by John Maeda (b. 1966). Blurring the boundaries between art and design, Maeda has created a body of work that expands concepts of the desktop metaphor and of conveying information in digital and paper media. His project *Tap, Type, Write* (1998) creates a kind of typographic dance, in which letters move and rearrange themselves in ever-changing patterns, revealing the possible relationships between form and meaning. Maeda's digital works stand in the tradition of many famous typographers who investigated the nature of the letter's design as a carrier of meaning, and his intellectual and aesthetic rigour turns his investigations into spiritual rather than design exercises.

Through the lens of digital culture, books can be seen as information spaces with their own specific 'architecture'. Every form of writing is also a spatial practice, occupying and outlining space on paper or the screen and employing structural elements such as sentences, sections, and paragraphs. In his *Talmud Project* (1998–9), David Small (with Tom White) created a virtual reading space that both establishes connections to and transcends the information architecture of the book. Using a portion of the Talmud – the ancient book of Jewish religious law – as well as commentary on the Talmud by the French philosopher Emmanuel Levinas, Small created a narrative and reading space that makes all the text available in its entirety, yet allows readers to focus on specific sections without losing the contextual framework. Small and White approached the concepts of multiplicity from

171. **David Small**, *Talmud Project*, 1999. The text is 'stacked' in transparent layers and readers can shift scale and focus to make sections of the text readable while others fade to the back, becoming illegible yet staying in context. The architecture of the space becomes a metaphor both of the reading process – as layered and contextual – and Talmudic study itself.

172. **David Small and Tom White**, *Stream of Consciousness/ Interactive Poetic Garden*, 1998. The installation consists of a small, two-metre-square garden with water streaming down a series of cascades into a pool. Strings of words are projected onto the water's surface, flowing and whirling around, seemingly moved by the current. Users can interact with the words by touching the flow, blocking and dividing the words and arranging them into new connections. The flow and words are pulled into the pool's drain and pumped back to the spring where they start flowing down again.

a different angle in their project *Stream of Consciousness/ Interactive Poetic Garden* (1998) [172], which quite literally establishes a connection to the 'stream of consciousness' technique of literary modernism. Authors such as James Joyce and Virginia Woolf invented and perfected this technique by striving to locate their narratives completely within the thoughts and perceptions of their novels' protagonists. The *Interactive Poetic Garden* turns the 'stream of consciousness' into a natural, tangible phenomenon, extrapolated from the mind into an environment where text seemingly takes on its own life.

Projects addressing the 'physicality' of typography and writing spaces are complemented by the vast body of hypertext writings that consist of predominantly text-based, nonlinear narratives. While the hypertext writing community is quite large, relatively few of these writings have been recognized in an art context. Among them are Mark Amerika's *Grammatron* (1997), one of the first online hypertext novels, which tells the story of the creature Grammatron, a digital being encoded in a magic sorcerer-code called Nanoscript – the underlying code that transcribed the evolution of consciousness in a natural world. *Grammatron* aspires to be an electronic book of origins, a form of digital bible and consists of over a thousand text spaces, a soundtrack, as well as animated and still-life images. Hypertext reading and writing in many ways differ from the process of creation and reception of printed texts. Hyperfiction tends to obscure cause-and-effect relationships and requires structures that can function as a tool of orientation for the reader (such as underlying metaphors). The absence of a 'physical' ending, a last page, is another challenge unique to the hypertext medium. Readers may quit the text without an ending unless they supply the story with a form of closure themselves. All hypertexts are open-ended in the sense that the story can be endlessly reconfigured depending on the choices the reader makes while navigating it.

Most of the narrative projects in the realm of digital art are not primarily text-based but tell their stories in a hypermedia environment, connecting text with visuals and sounds. The term 'narrative' is obviously extremely broad and, in this context, is meant to refer to works that explicitly represent an unfolding story (as opposed to the story that is told by a picture, or cultural narratives that develop on a meta-level). Many projects mentioned within the interactive film and video section of this book – such as Toni Dove's interactive films or Grahame Weinbren's *Sonata* and David Blair's *WAXWEB* – are prime

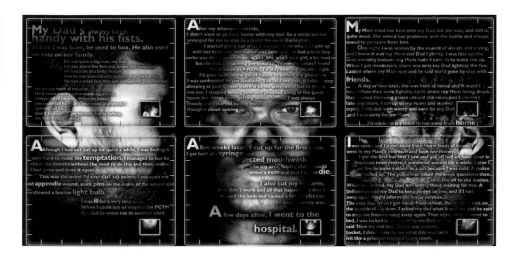

173. **Graham Harwood**, *Rehearsal of Memory*, 1996. Moving over body parts, many of them covered with tattoos, users uncover text fragments that tell the stories of the inmates – stories of revenge, violence, and self-mutilation. The multimedia collage successfully blends the surface of the body with its psychology, inscribing personal stories on the person's skin.

examples of hypermedia narrative. The Electronic Literature Organization (ELO) has systematically chronicled forms of electronic writing – from hypertext fiction to installations and chatbots – and makes a selection of outstanding examples, as well as two volumes of the *Electronic Literature Collection* (published in 2006 and 2011, respectively) available on its website.

A variety of early hypermedia narratives were published on CD-ROM, many of them at a time when the WWW did not have an infrastructure to support complex visual experiments and when the average speed of computers and Internet connections were much slower. The CD-ROM *Rehearsal of Memory* (1996) by the British artist Graham Harwood, a member of the artists' teams Mongrel and YoHa, creates its interface out of a collage of the skins of the inmates and staff of Ashworth Hospital, a hospital for the criminally insane in Liverpool where Harwood worked with a staff-patient artist group for several months. Harwood forces us to look into the face of a part of society we are inclined to forget, staging 'a rehearsal of memories not quite forgotten'. A very different type of collage interface was created by Jim Gasperini and Tennessee Rice Dixon *ScruTiny in the Great Round* (1996), a CD-ROM incarnation of a book of collage art by Dixon that was 'translated' into its new medium in a collaborative effort. The basic structure is formed by a variety of scenes, each of them collages consisting of morphing images, animated sequences, and 3D elements. The CD-ROM is, as Dixon puts it, 'scrutinizing in the great round of life': the morphing images suggest seasons passing and cycles of death and birth, blending various symbols

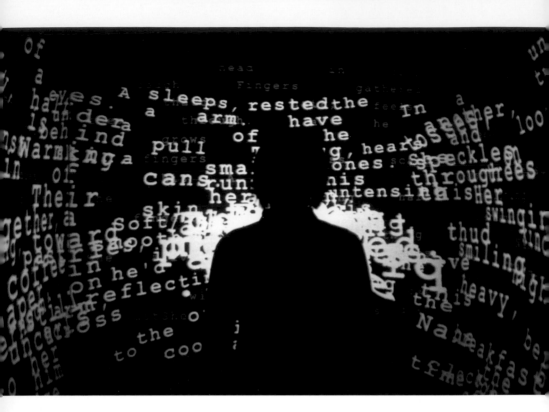

174. **Noah Wardrip-Fruin, Josh Carroll, Robert Coover, Andrew McClain, and Ben 'Sascha' Shine**, *Screen*, 2002–present

from Greek and Egyptian mythology and Buddhist religion, such as fertility symbols or mandalas. Narrative environments have also made use of more sophisticated bodily play in virtual reality. *Screen* (2002–present) by Noah-Wardrip Fruin and collaborators, for example, was created for the room-sized virtual reality display of the CAVE. Users initially find themselves surrounded by stories of memories that appear as words on the Cave's walls. The words then peel off and users can knock them back onto the walls with their hands, thereby changing the memories. In the end, all words come off the wall, swirling around the user and finally collapsing in the way memories fade. The element of play in textual environments is one of the obvious connections to games, which create a different form of narrative and have experienced an explosion since the advent of digital technologies.

Gaming

The gaming industry has been an important element in the 'digital revolution' and has become a billion-dollar enterprise that exceeds the film industry. Games are an important part of digital

art's history in that early on they explored many of the paradigms that are now common in interactive art. These paradigms range from navigation and simulation to linked narratives, the creation of 3D worlds, and multi-user environments. Games come in a variety of genres, such as strategic ones, shooters, god games, and action/adventure. The game Myst and its successor Riven are early examples of elaborate environments that combine basic structures of hypertext and the detective game: players have to search for clues (sometimes consisting of notes and inscriptions) to navigate the world and solve the puzzle. Early text-based Dungeons and Dragons games were expanded in more sophisticated, visual online games such as Ultima Online, Everquest and World of Warcraft.

Many, if not most, of the successful video games are extremely violent 'shooters' that seem antithetical to art. At the same time, these games often create very sophisticated visual worlds. It seems only natural that digital artworks would take a critical look at their interactive predecessors and counterparts and explore their paradigms in a different context. Among the often referenced classics in the pantheon of video games are Castle Wolfenstein, a World War II game named after Hitler's castle in which players have to escape a Nazi dungeon and fight the Third Reich, and Quake and Doom, where players fight as warriors on stages of harrowing landscapes or battle demons on the moons of Jupiter. One essential characteristic that many of these games share with interactive, digital art is that they are collaborative and participatory: players/users often have to collaborate with each other in order to win the game; they form guilds and communities, cooperative relationships. Just as many artworks rely on audience input, be it in the forms of visuals or text, some games are open to expansions and contributions from the player, which might take the form of so-called 'skins' or 'patches'. Metaphorically speaking, skins are the 'clothing' that players/ users can add to a character or scene, while patches are self-programmed extensions that actually modify the 'behaviour' of a game world or character. Role-playing is yet another crucial element that surfaces in both computer games and the digital art projects focusing on communities and allowing users to create virtual representations.

Video games also early on explored paradigms of 'point of view' that manifest themselves in the classic categories of the first-person or third-person shooter, the distinction between a player experiencing the world of the game from their own

position and point of view and a player creating or choosing a visual representation that acts as a stand-in throughout the game. In addition, games and digital art both share a connection to the military-industrial complex, which ultimately created the Internet and laid the groundwork for many other digital technologies. The simulators first created by the military and industry are at the basis of many video games that allow players to pilot an aircraft, car, or motorbike. With developments in digital technologies, games have become increasingly sophisticated and incorporate complex behaviours and user options. One of the most influential games in this category, widely considered as a piece of art, is Will Wright's The Sims, an example of a non-violent community-based game. The Sims are virtual characters, and players of the game can not only design their personalities, skills, and appearance, but also guide their relationships and careers and expand the Sims' world. In 2012 the Museum of Modern Art in New York acquired fourteen video games for its collection, The Sims among them.

While games play an important role in digital art, there is no consistent approach to the topic, and artists have used and referenced existing games and game-like structures in multiple ways. Natalie Bookchin's website The Intruder (1999), based on Jorge Luis Borges's short story of the same name, uses gaming as a reflection on and metaphor of narration. Bookchin took a different approach to gaming in her online project Metapet (2002), a resource management game that develops a fictitious corporate scenario for virtual workers of the future, with ties

175. **Natalie Bookchin**, The Intruder, 1999. Players progress through ten different arcade game interfaces (ranging from Pong to shooters and a war game), which they have to play in order to 'win' a piece of the narrative. Borges's story centres on a tragic love triangle and, proceeding through Bookchin's game tableaux, players find themselves on opposing sides of the story, their shifting positions mirroring the complexity of conflict. The story appropriately ends with a war-game interface. On one level, Bookchin's piece also tells a story of the history of computer games, with the ten game scenarios representing stages of development.

The Nilsons kept to themselves.

to the biotech industry. The game is 'based on the premise that biotech innovation and corporate creativity gave birth to a genetically engineered worker, a new class of virtual pet that replaces the all too human worker'. Players choose between three biotech companies – a gene therapy research company, a genetics diagnostic devices manufacturer, and a biopharmaceutical company – and start a job as manager, which allows them to hire a metapet. The goal is productivity: players have to monitor their pets' discipline, genetic health, energy, and morale in order to improve their productivity and position in the company. From a humorous perspective, Bookchin touches upon the serious implications of productivity in the corporate world in the context of biotechnology and the replacement of the human worker by the robot of the future, an artificial life-form.

Behavioural aspects of the market also are at the core of John Klima's software *ecosystm2* (2001), an expansion of his previously mentioned *ecosystm* project that allows users to 'play' with their stock portfolios. *Ecosystm2* is a multi-user securities trading game where players compile stock portfolios that create flocks of birds whose appearance, behaviour, and survival is determined by the market and the selection of stocks. *Ecosystm2* represents the stock market as a natural world obeying complex rules and evolutionary principles. Players have a certain control over their flock, yet the system also follows its own behavioural rules and genetic algorithms.

While works such as *Metapet* and *ecosystm2* develop their own unique worlds, many artist-created games build on the

aesthetics of existing games or 'hack' them by breaking and making modifications to the original code. American artist Cory Arcangel, for example, has created several pieces by hacking and reverse-engineering cartridges for the Nintendo game Super Mario Brothers, that is, replacing the chips of a Super Mario cartridge with his self-manufactured ones. For *Landscape Study #4* (2002), Arcangel took 360-degree landscape photographs of a neighbourhood in his hometown Buffalo, New York, scanned them, and adapted them to the format of the Nintendo Entertainment system, fusing traditional landscape photography with gaming aesthetics. In his *Super Mario Clouds* (2002–present), he has removed everything from the game except for the white clouds that are endlessly scrolling across the blue sky. Both *Landscape Study #4* and *Super Mario Clouds* create a scenery that effectively transcends the media from which they borrow and seem to evolve into a new manifestation of pop art.

Contrary to Arcangel's pieces, which establish only a loose connection to an original system, many gaming artworks have a more symbiotic relationship with their commercial counterparts. In their remix of Olia Lialina's *My Boyfriend Came Back From The War* for Lialina's *The Last Net Art Museum*, the duo jodi used aesthetic and architectural elements of Castle Wolfenstein, juxtaposing Lialina's poetic reflection on personal 'wars' and

177. **Cory Arcangel**, *Super Mario Clouds*, 2002–present

178. jodi, SOD, 1999

communication with architectural elements of the commercial war game. Jodi also 'deconstructed' the original Castle Wolfenstein in their online game SOD (1999), which replaces the representational elements of the game with black, white, and grey geometrical forms and creates a new architecture that challenges both orientation and navigation. The dysfunctional elements of jodi's game effectively expose and undermine Wolfenstein's paradigms of navigation and construction of space. SOD also exposes and demolishes the balance between the user's and the system's control, which is an essential element of any action game. Jodi continued this investigation with the CD (and website) *Untitled Game*, which consists of a dozen modifications of the fight game Quake I. Stripping the game of its original architecture, reducing it to interface and sound elements and re-engineering its structure and interactivity, Jodi used the original game engine as a tool for the creation of abstract art. Glitches and bugs in the original code were employed to produce aesthetically beautiful effects from the original system's failures. A different kind of appropriation is the Quake modification by Chinese artist Feng Mengbo (b. 1966), whose work frequently explores pop culture such as video games and Hong Kong action cinema. Feng used the software of Quake III Arena (known as Q3A) to create *Q4U* (Quake For You; 2002) [179], in which he inserted a 'skin' – a

202

visual representation of himself equipped with a weapon and camcorder – into the game and made himself the main character. Seemingly reappropriating the prefabricated environment, Feng populates it with an army of his clones that can be played by the audience (or the artist himself). *Q4U*, which was shown at Documenta XI in 2002, questions concepts of online identity in the context of role-playing but directly implements the artist in the commercial environment and violence of the game. A more critical intervention in an existing game is the project *Velvet-Strike* by Anne-Marie Schleiner, Joan Leandre, and Brody Condon, which was conceptualized as a direct response to President Bush's so-called 'War on Terrorism'. *Velvet-Strike* is a collection of graffiti that can be 'sprayed' on the walls and rooms of the shooter game Counter-Strike, a multi-user game that allows participants to play either as members of a terrorist group or as counterterrorist commandos. Putting the 'weapon' of public opinion back into the hands of the players, *Velvet-Strike* enables users to spray their anti-war graffiti (one of them reads 'Hostages of Military Fantasy') onto the walls of the game environment. In his performative intervention *dead-in-iraq* (2006–11), artist Joe de Lappe (b. 1963) enters the online US Army recruiting game America's Army, and manually types in the name, age, service branch and date of death of each service person who has died to date in Iraq. The work is both a form of online memorial and reflection on the role of military games in contemporary culture. Both projects directly intervene in and 'rewrite' a commercial product, a strategy often used in activism and in the creation of tactical media.

180. **Anne-Marie Schleiner, Joan Leandre, and Brody Condon**, '*Shoot Love Bubbles*' from *Velvet-Strike*, 2002

Tactical media, activism, and hacktivism

Activism in art is not a new phenomenon and has a long history. When Sony portapaks, the first portable video cameras, became available in the late 1960s, artists and activists used this portable recording power for establishing alternative media networks, addressing issues of documentation and representation in the context of control over media distribution. Cooperatives and collectives such as Paper Tiger Television, Downtown Community Access Center, Video In (Vancouver), Amelia Productions, Electronic Café International, and the Western Front established and used public video-production facilities and telephone networking, media training initiatives, and cable access for the creation of alternative media networks linking artists and communities. The power structure of media, anti-racism, gender-activism, and support of underrepresented communities are among the issues that have continually been addressed by cooperatives of artists and activists. The Critical Art Ensemble and the Surveillance Camera Players – a New York-based group that stages performances in front of surveillance cameras – are among the artists' groups that have critically examined authoritarian culture as it manifests itself through the use of media. Organizations such as the Old Boys Network (initiated by Cornelia Sollfrank) and the mailing lists 'faces' are virtual forums for cyberfeminism, contributing to the discussion of the gender-specific aspects of new media.

Affordable software and hardware, the Internet, and mobile devices have brought about a new era for the creation and distribution of media content. The utopian promise of this era is 'technologies for the people' and a many-to-many (as opposed to one-to-many) broadcasting system that returns the power over distribution to the individual and has a democratizing effect. The Internet promised immediate access to and transparency of data and, in its early days, was dominated by research and educational institutions and was a playground for artistic experimentation. The dream of a 'network for the people' did not last long, however, and from the very beginning, it obscured the more complex issues of power and control over media. While the Internet is hailed as a 'global' network, not all of the world is connected to it. At a time when the traffic on the information superhighway was consistently increasing in the US, many other countries had not yet come along for the ride, largely due to the lack of local access and the fees charged by telecommunications companies; wide areas of the world do not have access to the

Internet and some countries have been subject to government-imposed access restrictions. The Internet itself quickly became a mirror of the 'real' world, with corporations and e-commerce colonizing the landscape.

Activist projects in the realm of digital art frequently use digital technologies as 'tactical media' for interventions that reflect on the very impact of the new technologies on our culture. A popular strategy is to turn the technology back on itself, as the Institute for Applied Autonomy does in its *iSee* project. *iSee* is a Web-based application that creates maps of the positions of closed-circuit television surveillance cameras in urban environments. The maps allow users to find routes through the city that avoid these cameras and to choose 'paths of least surveillance'. Although not explicitly an activist project, New Zealander Josh On's (b. 1972) *They Rule* (2001) [181] inverts technology in a similar way: the website enables users to create and browse through maps that investigate corporate power relationships in the United States. Based on publicly available information, *They Rule* depicts the connections between companies such as Pepsi, Coca-Cola, Microsoft, and Hewlett Packard through diagrams of their boards of directors, which represent CEOs as an iconic male or female holding a briefcase. *They Rule* is a reminder that data access on the Internet is a two-way street: the project subverts the use of the Web as a mere marketing tool that turns us into transparent customers by making visible the intricate web of relationships between corporate entities and the ruling elite. The concept of a shared, public archive also formed the basis of Spanish artist Antonio Muntadas's (b. 1942) *The File Room* (1994) [182], an installation and website originally produced by Randolph Street Gallery (a non-profit artist-run centre in Chicago). *The File Room* is an open archive and database that collects cases of censorship submitted by the public. Rather than providing an encyclopedic or scholarly resource, it experiments with alternative methods for the collection and distribution of information. Projects such as *They Rule* and *The File Room* strive to transform the closed circle of power systems into an open network. The re-engineering of technology as artistic strategy has also been consistently pursued by Natalie Jeremijenko and the Bureau of Inverse Technology, which frequently repurposes existing technologies for activist ends. Their project *Sniffer* (2002) consists of the rewiring of robotic dogs that are currently available on the toy market (such as Sony's Eibo) to make them work as detectors of radioactive

181. **Josh On**, *They Rule*, 2001.
Users can run Web searches on
CEOs by clicking on their briefcase
and accessing information about
them, the donations they have
made, or their companies. They
can also add to a list of URLs
relevant to that company or
person and create their own map
of connections, complete with
annotations, for others to view.

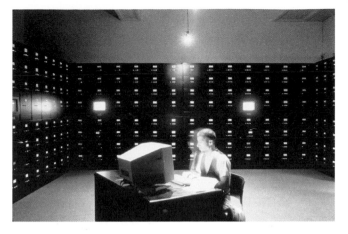

182. (right) **Antonio Muntadas**,
The File Room, 1994

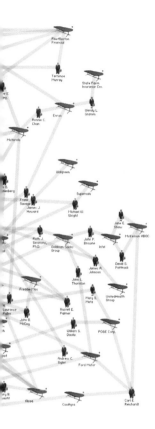

sources over a certain threshold. The dogs can be deployed locally and become environmental detectors that can store information 'on board' and report it back to the Bureau's base stations.

As a vast distribution network, the Internet obviously provides an ideal platform for disseminating information, staging interventions and protest, or supporting remote and underrepresented communities. British groups such as Mongrel (with core members Matsuko Yokoji, Mervin Jarman, Richard Pierre-Davis, and Graham Harwood) and irational.org (Heath Bunting et al) both use digital technologies for social engagement, distribution of self-programmed and -engineered technology, services, and products, as well as the formation of strategic alliances. Irational.org's website includes anything from links to databases of public network services and media labs to a manual on 'how to be a radio pirate' or a publication on bedroom biotechnology.

Activist interventions occasionally take the form of hacktivism, a method of engagement that uses hacking – the breaking, reformatting, and re-engineering of data and systems – as a creative rather than merely destructive strategy. The spectrum of hacktivism encompasses both projects that are harmless pranks and interventions that operate on the border of legality. The Electronic Disturbance Theater, which frames its actions as 'electronic civil disobedience', has staged a number of virtual 'sit-ins' in support of the Zapatista rebels in Chiapas, Mexico, by using self-authored Web-based software called FloodNet. The sit-ins were aimed at disrupting the service of targeted websites – in one case, the sites of the president of Mexico and the US Department of Defense (the latter because the US military allegedly trained

the soldiers carrying out the human rights abuses). Participants in a FloodNet protest are asked to load the FloodNet webpage, which contains a Java applet that requests target websites every few seconds and is intended to create a disruption of service by overwhelming the server. (The Pentagon reportedly countered with its own Java applet that sensed the attack and loaded an empty browser window on the attacker's desktop. Both sides declared their strategies to be successful.) The denial of service created by these sit-ins is the virtual counterpart of the physical blocking of entrances to buildings.

Similar interventions were at the core of the 'Toywar' staged by the Swiss-based artists' collective etoy in 1999, after the billion-dollar US toy company eToys had filed suit against them in California. The company eToys claimed that the art group etoy had taken advantage of their brand recognition and were deliberately directing potential eToys' customers to the artists' website. Lawyers worldwide voiced the opinion that there was no legal basis for this suit since the artists' collective predated the e-commerce toy company by over three years and

183. **etoy**, *Toywar*, 1999

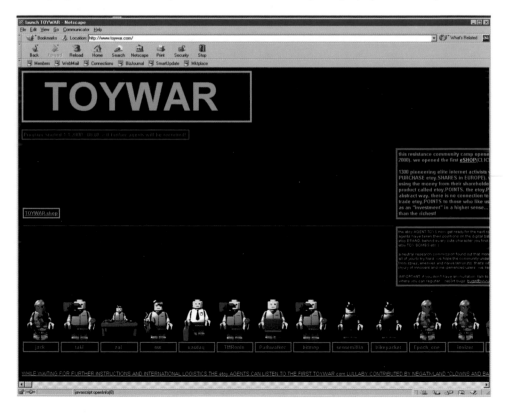

was active in a completely different market sector. When the California court nevertheless ordered etoy to shut down their server, the artists enlisted the help of almost a dozen lawyers and launched a virtual war – supported by other artists' groups and over two thousand individual 'toy soldiers' – that entailed different forms of virtual activism and campaigns that gained considerable attention in the media. The combined legal, social, and media pressure finally led eToys to withdraw their law suit, which never had a solid legal basis in the first place. Etoy, as well as the artists' collective ®TMark – active supporters of both the 'Toywar' and the interventions of the Electronic Disturbance Theater – are examples of artists' groups that use corporate strategies and a corporate image to frame and construct their 'intellectual product'. ®TMark uses a mutual funds model to raise funds for and support project ideas suggested by Internet users. The projects are usually aimed at undermining or providing a counterbalance to corporate interests.

Corporate models in activist art point to the fact that the Internet radically reconfigures context and the boundaries of the physical world: on the Web, every artist's project is always embedded in (only one click away from) the context of corporate sites and e-commerce. The alternative space of the Internet resists our traditional, physical model of ownership, copyright, and branding. As an open system and archive of reproducible data, the Web invites or allows for instant recontextualization of any information. The virtual real estate of a company or institution can easily be copied ('cloned') and reinserted into new contexts, a tactic that many artists, net activists, or hacktivists have pursued. When Documenta X decided to 'close down' its website after the end of the physical exhibition, the artist Vuk Cosic cloned the site, which remains available online to this day. The project Uncomfortable Proximity (2001) by Mongrel's Harwood, the first piece of net art commissioned by the Tate in London for its website, is a perfect example of shifting institutional contexts: reproducing the Tate website's layout, logos, and design, Harwood tells a history of the British art system that may be less than comfortable for an art institution.

Tactical media activism often engaged with media structures themselves, the new millennium saw a shift towards the use of free media and open source principles for addressing copyright issues and green topics, such as environmentalism and sustainability. Appropriation, remixing, and the cloning of websites are frequently used by artists to make a 'political' statement by

challenging control over information and intellectual property. Another example of these strategies are the projects by the Italian artist duo behind the site 0100101110101101.org, which focuses on data access, document, and archiving models as well as the political, cultural, and commercial aspects of the network. Their projects included the cloning and remixing of other artists' and organizations' websites as well as the creation of a virus. With the project *life_sharing* (2001), 0100101110101101.org turned their site into public property: the site consists of the organization's hard disk, published in its entirety on the Web (in HTML format) and thus reproducible by anybody. *Life_sharing* highlights issues of intellectual property and copyright which have become a pressing issue in the digital age. The early Internet was a space for

184. **0100101110101101.org**, *life_sharing*, 2001

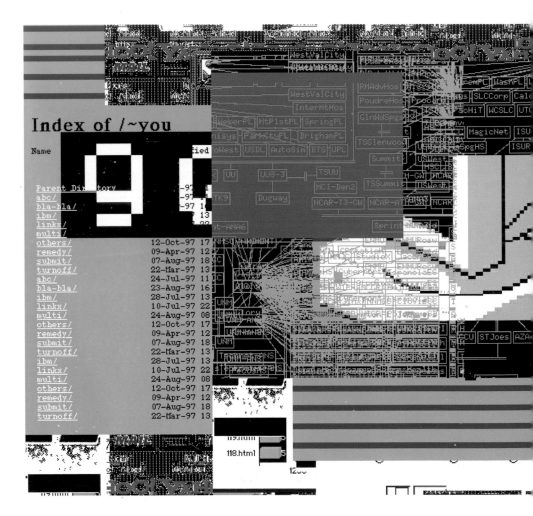

'free' information exchange, and data is the hottest commodity of the twenty-first century. The philosophy of free data and information exchange is the driving force behind the open source (and 'Copyleft') movement, which promotes unrestricted redistribution and modification of source code (provided that all copies and derivatives retain the same permissions). The flagship of the open source movement is the Linux operating system – initiated in 1991 by the then twenty-one-year-old Linus Thorvald – which has become increasingly popular, rocked the world of commercial software, and put Thorvald on the cover of Forbes magazine. Many artists and activists commonly make the source code of their projects available to the public and give them control over the processing of information in an attempt to shift and balance the power structures of media control.

Many of the projects and artists' groups mentioned above exist on the crossroads of art and activism. ®Tmark, etoy, the Bureau of Inverse Technology, Heath Bunting and Harwood have all been shown at prestigious art museums and received major art awards. The growing importance of privacy and data protection and the public debate surrounding these issues have made activist art a new force that the art world cannot afford to ignore. Several art exhibitions have been dedicated to activism, hacking, and open source in the information age, among them *Open_Source_Art_Hack* at the New Museum of Contemporary Art in New York; *Kingdom of Piracy* at Ars Electronica; *I Love You – Computer_Viren_Hacker_Kultur*, an exhibition at the Museum for Applied Art in Frankfurt, Germany; and *F.A.T. Gold*, a retrospective of works by the Free Art & Technology Lab, or F.A.T. Lab, at the Eyebeam Art & Technology Center in New York City. The presentation of this type of work in an institutional context obviously raises its own set of issues since the work itself may run counter to what an institution represents or may create legal conflicts that museums are not prepared to face. Due to the advanced methods of data processing that digital technologies offer, privacy, protection, and 'control' of media information have become pressing issues that also play an increasingly important role in the creation of art. These issues again surface in the context of the reconfiguration of public space that has been enabled through mobile devices and will be further discussed in a later chapter.

Technologies of the future

From a very general perspective, art, be it digital or analogue, has always addressed a set of core issues: the aesthetics of

representation and perception; the human condition as it changes due to cultural and political developments; the emotional and spiritual realm; and the individual's relation to society and community – to name just a few. Art will always reflect on the specifics of cultural change, and 'technologies' in the broadest sense have always been an important part of this transformation of culture. Considering the massive developments that digital technologies have brought about just since the 1990s, it is not easy to predict what exactly the future of digital art will be. Nevertheless, there are pointers to possible directions for a 'technological future', among them the intersection of digital, bio-, and nanotechnology, as well as new forms of intelligent interfaces and machines. Digital technologies will become more and more pervasive and an increasingly integral part of life and art in general.

We are already living in a world where bioengineering and the cloning of life-forms have become a reality, and the areas of genetics and biotechnology have increasingly become a focus in art. While art involving biotechnologies and genetic engineering were originally considered part of new media art, so-called bio art – as a practice involving live tissues, bacteria, living organisms, and life processes – has meanwhile emerged as a field of its own. Among the prominent practitioners are Eduardo Kac (b. 1962), Natalie Jeremijenko (b. 1966), as well as Oron Catts and Ionat Zurr who initiated the Tissue Culture and Art Project in 1966 and are leading SymbioticA, the Centre of Excellence in Biological Arts at The University of Western Australia. Genetically altered life-forms in the context of art are not as radically new as one might expect and have had their precedents: in 1936, American photographer Edward Steichen exhibited genetically altered flowers, delphiniums, at the Museum of Modern Art in New York. Steichen still used the traditional method of selective breeding (along with a drug that altered genetic makeup) but his *Delphiniums* anticipated the future artistic investigations of genetics. In his project *Genesis* (1999), Eduardo Kac created a synthetic 'artist's gene' by translating a sentence from the biblical book of Genesis into Morse code, and converting the code into DNA base pairs. The synthetic gene is cloned into plasmids, which are transformed into bacteria. Kac also stirred a media frenzy when he created – with the help of scientists – a genetically engineered green fluorescent rabbit that glowed in the dark under certain lights, and declared it to be his artwork. The rabbit is the result of the manipulation of green fluorescent

185. **Eduardo Kac**, *Genesis*, 1999. In the *Genesis* gallery installation, visitors encounter a pedestal with a petri dish containing the bacteria and a UV light over it, which disrupts the DNA sequence in the plasmids and accelerates the mutation rate. Visitors to the *Genesis* website are remotely able to turn on the UV light, thus interfering with and influencing the process. *Genesis* examines the relationship between bio- and information technology, belief systems, ethics, and the Internet, which literally becomes a life-shaping force.

Let man have dominion over the fish of the sea and over the fowl of the air and over every living thing that moves upon the earth

.....- --.-.-...- -.-----.-.-...-. ---...-.-.
-..... ..-.......... ---.-. -.....- .-.-. ---.-.
..-. -..... ..-.--.-.-. ---.-. -..... .-.-.- ..-.
---...-.-.-.-.-.- .-.......-.-. -......-.-. -.
.....-- -----....- ..-.-.---. -..... ..-.-...

Morse to DNA conversion principle

DASH (-) = T A = WORD SPACE

DOT (.) = C G = LETTER SPACE

CTCCGCGTATTGCTGTCACCCCGCTGCCCTGCATCCGTTTGTTGCCGTCGCCGTTTGTCA
TTTGCCCTGCGCTCATGCCCCGCACCTCGCCGCCCGCCCCATTTCCTCATGCCCGCACC
CGCGCTACTGTCGTCCATTTGCCCTGCGCTCATGCCCCGCACCTCGTTTGCTTGCTCCAT
TTGCCTCATGCCCCGCACTGCCGCTCACTGTCGTCCATTTGCCCTGCGCTCACGCCCTGC
GCTCGTCTTACTCCGCCGCCCTGCCGTCGTTCATGCCCCGCCGTCGTTCATGCCCCGCTG
TATTGTTTGCCCTGCGCCCACCTGCTTCGTTTGTCATGCCCCGCACGCTGCTCGTGCCCC

protein (GFP), which has been researched by scientists for over a decade (silk worms and rabbits are animals commonly used for this research). Kac's project lay less in the actual creation of the bunny than in the transposition of this scientific experiment into a wider cultural realm, where it created public debates about the ethical implications of a genetic manipulation of life-forms. A critical examination of 'transgenics' – the isolation of genes from organisms in order to create new organisms – was also the focus of the *GenTerra* performance of the Critical Art Ensemble, which challenged the idea of organisms that help solve ecological or social problems as products. The relationship between genetic determinism and environmental influence was investigated in Natalie Jeremijenko's project *OneTrees,* which consists of over a hundred identical clones of a Paradox Tree created in collaboration with scientists. The convergence of art and science in these projects may still be the exception rather than the rule, but the growing amount of works in this category and organizations devoted to its support is indicative of the necessity to create a public platform for the discussion of the effects of science and technology on our culture.

Yet another area that is likely to undergo profound changes is the human–machine interface. The now common set-up of the computer, monitor, and keyboard is increasingly superseded by interfaces that make it possible to communicate with machines through voice commands, gestural control, eye movements, and similar mechanisms. 'Physical computing' in the form of appliances with embedded computing power, wearable computing, and The Internet of Things have already become broad areas of research. The final frontier of human–machine interaction are the Brain Computer Interface (BCI) and brain-to-brain interaction, fields that are continuously developing.

The art of the future will equally reflect the cultural changes induced by developments in information technology as it intersects with biotechnology, neuroscience, nanotechnology, and other disciplines. While art constitutes a cultural value in itself and does not need to fulfil a purpose, it certainly has a function in that it can be an open-play field for aesthetic, emotional, or political explorations. This role becomes more important in a future that confronts us with new questions that profoundly challenge how we define ourselves and the world around us.

186. **Natalie Jeremijenko**, *OneTrees*, 2000. The clones, exhibited together as plantlets at the Yerba Buena Center for the Arts in San Francisco, have been planted in public sites, and the development of these biologically identical life-forms will reveal the interdependency of genetics and different environmental conditions.

Redefining public space: Locative media and public interactives
In the twenty-first century, wireless networks and the increasing
use of mobile devices such as smart phones and tablets have
blurred the boundary between the non-local (or non-site-specific)
and the locative (or site-specific). Locative media use a location
in public space as a 'canvas' for implementing an art project and
have become one of the most active and fast-growing areas in
new media art. Smart phones and tablet computers have become
new platforms for cultural production, providing an interface
through which users can participate in networked public projects,
as well as the formation of ad hoc communities. In his 2002
book *Smart Mobs: The Next Social Revolution*, Howard Rheingold
described the self-structuring social organizations supported by
wireless digital technologies. This potential manifested itself in
the uprisings of the 'Arab Spring' from 2011 onwards, in which
mobile media and social media platforms were used as tools for
organizing events and reporting. The revolution was multicasted,
brought international attention to the protests and influenced the
broadcast news agenda.

Mobile locative media are not only a technological format
but also a concept and theme that have been increasingly
explored by artists. Electronic networks in general and mobile
devices in particular have brought about formal redefinitions of
what we understand as 'public space'; more specifically, they have
opened up new sites for artistic intervention, broadening our
concept of so-called 'public art' – a term that has traditionally
been used for art displayed in public spaces outside of a
designated art context or for public performative events, from
graffiti to site-specific interventions by art movements such as
Fluxus or the Situationist International. New media art in the
public space of networks – be it net art or art involving mobile
devices or so-called public interactives, participatory public
interfaces – can be understood as a new form of public art.
Compared to more traditional forms of public art practice,
these artworks can be both trans-local (connecting people
across geographical locations) and site-specific, enhancing
or augmenting physical space with information that can be
deposited and/or retrieved. Mobile locative media have found
a broad spectrum of use in artistic practice that ranges from the
enhancement of urban spaces or landscapes with information, and
the creation of participatory platforms of production, to critical
engagement with the cultural impact of mobile technologies, and
enhancement of the public's agency.

A number of locative media projects have focused on mapping existing physical spaces and architectures. *PDPal* (2003) by Marina Zurkow, Scott Paterson, and Julian Bleecker, an early example, is a mapping tool (a Web interface and application downloadable to one's PDA) for recording personal experiences of public space, more specifically the Times Square area in New York City and the Twin Cities, Minnesota. Users create maps by marking locations with graphic symbols and giving them attributes and ratings. While the categories for mapping are relatively structured, the prescription of certain categories or meta-tags also makes it easier to map contributions more effectively. *PDPal*

187. **Marina Zurkow, Scott Paterson and Julian Bleecker**, *PDPal*, 2003

wifi.ArtCache

is inspired by the idea of emotional geographies and the concept of psychogeography – the study of the effects of the geographical environment on individuals' emotions and behaviours – which was developed by the Situationists, a political and artistic movement that emerged in the late 1950s. A different form of mapping and an early example of a public interactive is Q.S. Serafijn and Lars Spuybroek's *D-tower* (1998–2004), an art piece commissioned by the Dutch city of Doetinchem and co-developed by V2_lab. *D-tower* maps the emotions of the city's inhabitants in a more specific way than *PDPal* by concentrating on happiness, love, fear, and hate. In the project, which has three parts – a physical tower, a questionnaire, and a website – human values and feelings become networked entities that also manifest themselves in physical space through colour. Each of the participants receives four questions every other day and the answers, together with the postal codes of participants, are used to create graphical maps showing where in the city people are most scared or in love, and for what reason. In different ways, these mapping projects create a virtual, public repository for information that supplements physical sites. They consist of shared information resources that are collectively built by a more or less well-defined community and involve boundaries established through rules and mechanisms of access. In the case of *PDPal*, the information can also be accessed at the physical site itself, and in *D-tower* a physical structure is transformed through the virtual repository. Both strive to create a new awareness of the urban landscape as a space inscribed by human perception and emotion.

Locative media projects have also explored location-based storytelling and new approaches to landscape. Julian Bleecker's (b. 1966) *WiFi.ArtCache* (2003) – an access point for digital art consisting of a free-floating WiFi node which has been deliberately disconnected from the Internet – investigates the possibilities of wireless, location-based narrative and the production of space itself as the user needs to be within physical range of the node to retrieve information. The project thus demarcates an invisible yet physical space for art. Once people are close enough to the cache, they can download Macromedia Flash animations created by artists to their own WiFi-enabled devices, such as PDAs and laptops. Whereas Bleecker's cache uses a specific location as a form of wireless art repository, Teri Rueb's (b. 1968) *Core Sample* (2007) [190] augments a location with an abstract narration of its history. Rueb's project offers an insight into Spectacle Island in Boston Harbor, which has a multifaceted history of urban

190. (above) **Teri Rueb**, *Core Sample*, 2007

191. (opposite) **C5**, *Landscape Initiative*, 2001–present. Using the C5 GPS Media Player (in the bottom image), the project's online component, visitors to the website can access the GPS track logs of each C5 member's route in the different manifestations of the project, view associated media documentation (photographs/ video), and investigate multiple track logs to compare the landscapes. The GPS in itself has created new forms of relationships with the landscape, firmly positioning an individual or object in relation to a specific location while remaining a virtual data set. The Media Player's virtual track logs and overlapping paths form their own kind of landscape, which is rooted in a personal interaction with the actual landscape but translates into a virtual set of data that becomes a relational database, a potential index of connections. The online project suggests a trajectory from personal experience and live performance to a data representation of this very experience and the possible contexts for understanding it.

development. It has been the site of casinos, hotels, and a city dump, but in the early 1990s it was given a makeover: materials excavated during the construction of a tunnel were used to create additional land, and sea defences were put in place. *Core Sample* uses the Global Positioning System (GPS) to create a factual and fictional interactive audio narrative which mixes natural and processed sounds with voices of former residents to tell a unique story of the island and highlight its natural soundscape.

The use of GPS and mobile technologies for new experiences of landscape takes a very different form in the *Landscape Initiative* (2001–7) by the San Jose-based art group C5 (1997–2007). In its multiple manifestations, *Landscape Initiative* straddles conceptual, performance, and land art, as well as research, business, and exploratory adventure. The project consists of three parts – *The Analogous Landscape*, *The Perfect View*, and *The Other Path* – for which the group has undertaken massive performative expeditions all over the world. For *The Analogous Landscape*, members of the C5 team climbed mountains such as Mt Whitney in California, Mt Shasta in the Cascade Range of North America, and Mt Fuji in Japan. The respective journeys were tracked by means of GPS and Digital Elevation Mapping (DEM), with the goal of establishing analogies between the journeys through the different terrains. For *The Perfect View*, C5 asked members of the geo-caching community – a worldwide network of outdoor enthusiasts who hide and seek containers or 'geo-caches' using GPS and other navigational techniques – to recommend locations that they experienced as sublime. One of the C5 members then went on a motorcycle ride around the continental US and revisited

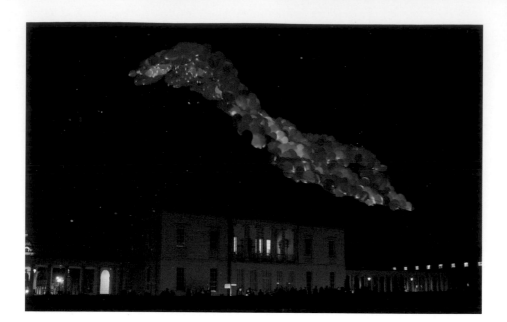

192. **Usman Haque**, *Sky Ear*, 2004

the places according to their original coordinates. The sites are documented in triptychs that show the respective location as a panoramic photograph, juxtaposed with an aerial satellite image and a rendering using USGS (United States Geographical Survey) data as its source. The goal of *The Other Path* was to accurately track the Great Wall of China and then use pattern-matching procedures to find an analogous 'significant path' in the US. In the digital age, our knowledge of the earth and landscape is largely shaped by GIS (Geographic Information Systems), together with personal experiences, which are by nature locative and limited. Representation increasingly shifts from a depiction of reality toward a visualization of data; and data has become the mediating agent between us and our surrounding landscape. *Landscape Initiative* explores the status of our relationship to landscape in a networked data world.

Mobile devices are also frequently used to give visual expression to information or data that could otherwise not be directly perceived. *Sky Ear* (2004) by Usman Haque (b. 1971) represents an interesting approach to the visualization and sonification of the electromagnetic spectrum. Haque visualizes this usually intangible force through a 'cloud' of helium balloons equipped with infra-red sensors and LEDs, which, respectively, measure the electromagnetic environment (influenced by factors such as weather and mobile phone usage) and change the colour

Status: Live will finish in 7:57 Messages in queue: 0 Total messages to date: 51 Total hits: 7917 Time in Japan: 21/9/03 22:03

○ Look ⊙ Go ↑ ↓ ← → + − Fall | Front ▾ Catch tool 🖑

v1.00

Please enter a message (64 characters maximum):
Hi Jackie, I am thinking about you now...

From: **Send this message to:**

Name | Chong Name | Jackie

Location | Yamaguchi Location | Tokyo

Email | chong@amodal.net Email | (optional)

☐ Notify me by email when the message is caught

Preview Send

IMPORTANT NOTE: all messages sent through this system are public and may be intercepted and read by anybody who visits this site
However, all email addresses will be kept strictly confidential and are only used for system notification

Applet started.

193. (above and below) **Rafael Lozano-Hemmer**, *Amodal Suspension*, 2003

of the balloons. Spectators on the ground could also cause variations in colour by calling the auto-answer mobiles in the balloon cloud and listening to the sounds of the sky.

In Rafael Lozano-Hemmer's *Amodal Suspension* (2003), a large-scale interactive installation developed for the opening of the Yamaguchi Center for Arts and Media (YCAM) in Japan (and a continuation of his *Relational Architecture* projects), users' text messages both gain visual form and control visual output. Twenty robotically controlled searchlights were installed outside the YCAM centre to visualize text messages, which people could send to each other by using their mobile phone or a Web interface. The messages were then encoded as unique sequences of flashes by the searchlights, creating a giant communication switchboard in the sky and transforming the materiality of text messaging. These unique light sequences continued to be circulated until the messages were 'caught' or read using a mobile phone or the 3D Web interface.

As both of the previous projects show, mobile devices can become an impromptu interface and a vehicle to create or participate in an artwork. Giselle Beiguelman (b. 1962) has used this form of interfacing in her video projects *Sometimes Always* and *Sometimes Never* (2005) [194], which consist of images shot

194. **Giselle Beiguelman**, *Sometimes Always* (top left) and *Sometimes Never* (above and right), 2005

195. (opposite) **Jenny Marketou**, *Flying Spy Potatoes*, 2005. Within a gallery environment, the inflated balloons are attached to the floor and floating, so that the public is moving through a red forest. The video cameras hidden inside the balloons continuously capture the surroundings, and visitors' movements through the installation are recorded as ephemera, traces, forms and patterns, which are broadcast live on TV monitors inside the exhibition space. In the live action street game part of the project, visitors are invited to take balloons on a walk, thereby building a connection between the exhibition space and its context and becoming both surveillant and object of surveillance.

on mobiles by visitors to the exhibition space. In the gallery, the audience can also use a keyboard and mouse to edit, in real time, the order and position of the frames on the screen and to impose coloured filters on the images. In *Sometimes Always*, the result is a dynamic mosaic palimpsest, while *Sometimes Never* creates unstable saturated palimpsests – the added colour saturation triggers a process of erasing, and no action can ever be repeated. Together, they create a (de)generative video that is composed and decomposed.

Mobile technologies ideally provide new platforms for communication and networking, but they also potentially allow for users to be monitored and tracked. The issues surrounding privacy and identity that emerge from tracking and surveillance capabilities have been critically explored by many artists and media practitioners. Artist Jenny Marketou (b. 1954) has created a series of projects – among them *Flying Spy Potatoes* (2005) and *99 Red Balloons: Be Careful Who Sees You When You Dream* (2005) – that involve large helium-filled balloons equipped with wireless cameras and address the darker aspects of surveillance with aesthetic playfulness. The project series is inspired by the German pop singer Nena's song '99 Red Balloons' from the early '80s, in which a catastrophic war erupts when army generals send planes to intercept a mass of unidentified objects (balloons). The installation also references pre-aviation 'reconnaissance balloons', such as those used in the American Civil War. The concept of play entails possibilities but also risks, rules, and limits, with the camera eye as 'spy' undermining the connotations of freedom

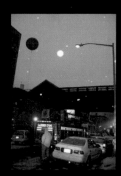

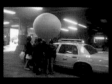

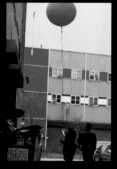
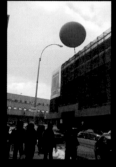

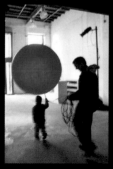

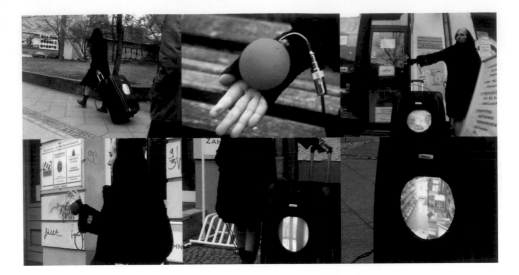

196. (top) **Michelle Teran**, *Life: A User's Manual (Berlin Walk)*, 2003. This project subverts existing surveillance tactics by transmitting camera footage to the public, thus commenting on the complexity of personal, cultural, social and physical boundaries and the act of crossing them.

197. (bottom) **Michelle Teran**, *Life: A User's Manual (Linz Walk)*, 2005

suggested by the game. In a playful way, Marketou's project raises serious issues about the relationship between the recorded image and the spectator, surveillance, and the contemporary society of spectacle. It addresses the technologically networked condition of contemporary society, the dynamic possibilities of doing and looking, and the role of technologies of surveillance and recording in art and culture.

In Michelle Teran's (b. 1966) series of public performances, *Life: A User's Manual* (2003–5), the use of surveillance cameras in contemporary urban settings is explored in the context of

boundaries between public and private space. The artist pushes a monitor around city streets in a shopping cart and, using a consumer-model video scanner, broadcasts footage from wireless surveillance cameras in public and private places that transmit on the easily intercepted 2.4 Ghz frequency band. Passers-by can see these camera views of the city and its inhabitants on the monitor in the cart. The project takes its title from a novel by Georges Perec, in which he metaphorically removes the wall of a Paris apartment building and tells the stories of each apartment and its inhabitants.

Both Marketou and Teran explore the topic of surveillance in predominantly aesthetic and conceptual terms. The issues they address are also recurring themes in art activism, which frequently makes use of mobile technologies to critique their implications or enhance the public's social and political agency or involvement. Today's digital mobile devices and locative media have certainly opened up a whole set of new possibilities for activist art, but mobility has always been an important factor in the realm of tactical media.

In the late 1980s, artist Krzysztof Wodiczko (b. 1943) created a series of *Homeless Vehicles* (1988–9), a mobile shelter reminiscent of a shopping cart that provided homeless people with a place to live and a 'work environment' for collecting cans and bottles for resale. Ricardo Miranda Zúñiga's (b. 1971) *Vagamundo* (2002) and *The Public Broadcast Cart* (2003–6) can be seen as extensions of this type of project for the digital age, giving a voice to marginalized groups or enhancing the agency of the public. Vagamundo is a mobile cart and online project featuring a video game that can be played by pedestrians or online and raises awareness of the predicament of undocumented immigrant labourers in New York City. *The Public Broadcast Cart* – a shopping

198. Ricardo Miranda Zúñiga,
The Public Broadcast Cart, 2003–6

199. **Marko Peljhan**, *Makrolab*, 1994–present. Over the years *Makrolab* has been shown in numerous venues, including the 50th Venice Biennale in 2003, illustrated here. Recently the Arctic and Antarctic *Makrolab* projects have been developed under the larger umbrella of the I-TASC (Interpolar Transnational Art and Science Consortium), conceived by Thomas Mulcaire and Marko Peljhan. Bringing together individuals and organizations in the fields of art, engineering, science, and technology, there is a focus on the development and deployment of renewable energy, waste recycling systems, sustainable architecture, and open-source media.

cart equipped with a wireless laptop, miniFM transmitter, microphone, speakers, and a mixer – reverses roles by turning pedestrians into producers of a radio programme. Audio is captured by the microphone and then simultaneously fed through the mixer to the speakers on the cart, a local FM frequency, and an online server such as thing.net.

A different form of mobility surfaces in Marko Peljhan's (b. 1969) *Makrolab* (1994–present), conceived in 1994 during the wars in the former Yugoslavia, which has been designed to serve as an autonomous and mobile performance and tactical media environment for artists, scientists, and activists. Users of the lab are supplied with the tools and means for developing projects and conducting research pertaining to telecommunications, climate, and migrations. *Makrolab* was first presented at ISEA 1994 and has since been shown in numerous venues, among them the 50th Venice Biennale (2003, above) where the lab was located on the island of Campalto in the Venice lagoon.

As previously mentioned, one strategy employed by activist projects is to turn technologies against themselves, for example by making mobile technologies' capacities for monitoring available to the public. *The Antiterror Line* (2003–4) by the Bureau of Inverse Technology (BIT, f. 1991) collects live audio data on civil liberty infringements from phone-in participants and thereby transforms phones (mobiles and landlines) into networked microphones. Users may record incidents while they are unfolding or leave spoken reports, and the recordings are directly uploaded into an online database. While individual incidents of civil liberty violation may go unnoticed or unreported, accumulatively they call for action. In an age of increased security measures designed to keep

200. (right) **Bureau of Inverse Technology**, *The Antiterror Line*, 2003–4

201. (below) **Konrad Becker and Public Netbase with Pact System**, *System-77 CCR*, 2004. *System-77 CCR* was first presented in Karlsplatz, a central square in Vienna, and created extensive public debate about the legitimacy of surveillance technologies. The project strives to provide the public with access to the control of technologies, proposing that tools of risk assessment should also be available to independent citizens rather than be predominately privately controlled.

citizens safe from harm and terrorist attacks, the project suggests the public's need for protecting itself at the point where official procedures begin to corrode the very liberties and society they are designed to preserve.

Similar issues are addressed by a consortium in *System-77 CCR* (Civil Counter-Reconnaissance) (2004), a project developed by Konrad Becker and Public Netbase in collaboration with Marko Peljhan's Pact System. The project, which is described as a tactical urban counter-surveillance system involving ground-controlled

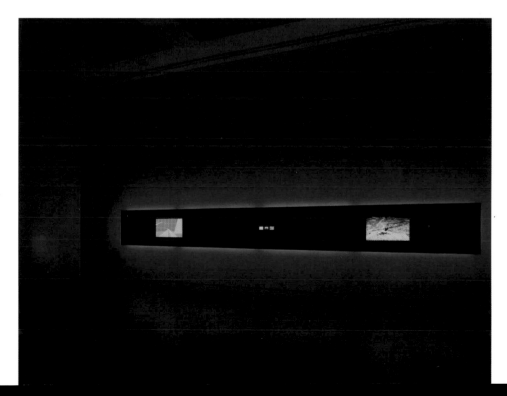

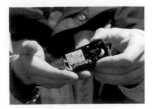

202. **Preemptive Media**,
Zapped!, 2006

(above) This keychain detector
was engineered by Preemptive
Media to address the use of Radio
Frequency Identification (RFID).
The device rings when RFID
readers are in the vicinity scanning
the airwaves for data.

(centre and bottom) Preemptive
Media runs workshops to inform
people about the widespread use
of RFID. Participants receive an
overview of the technology and its
related issues along with a *Zapped!*
workbook, and can even learn to
build their own RFID keychain
detector.

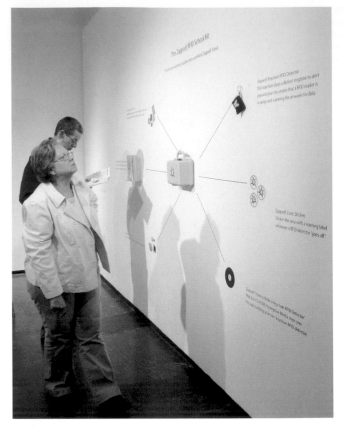

RFID: How it Works

the overview
Radio Frequency Identification (RFID) is a means of identifying a
person or object with microchips and radio waves. Typically RFID
systems use one of these frequencies: 125kHz, 13.56 MHz or 900MHz.
Using RFID, identification can occur automatically and at a distance.

2 **reader**
RFID readers are usually connected to a personal computer and
serve a similar purpose as a barcode scanner. They grab data
from the tags, but only those that are compatible and within
range. The main purpose of a RFID reader is to connect tag data
to a computer database. Readers sometimes are battery-powered
and can include a mini-computer to enable maximum mobility.

3 **database**
The computer database stores the tag data and often links it with
other information to enhance its power. The computer also generally
runs application software specifically designed to carry out other tasks
related to the RFID system, like inventory or account management.

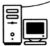

1 **tag**
The vast majority of RFID tags (also called transponders) consist of a
silicon microchip attached to an antenna. The microchip stores data
like a unique serial number. The antenna "speaks" to readers and
transmits data to them. The power of RFID is that this communication
is wireless and requires no human labor or input. Two main categories
of RFID tags are passive and active (see page 9 for more details).

203. (below) **Eric Paulos with Urban Atmospheres**, *Participatory Urbanism*, 2006– present. Urban Atmospheres gathered two weeks of environmental data from taxis in the Ghanaian capital of Accra which illustrated significant fluctuations in air quality. Air samplers with carbon monoxide, sulphur dioxide, and nitrogen dioxide sensors were mounted on taxis, and individuals also collected data by wearing a setup with similar air-quality sensors and a GPS unit. Air quality, noise pollution, UV levels, and water quality are among the data that could be collected with mobile devices, which the group believe could give communities more power and leverage in political decisions. This image shows carbon monoxide readings across Accra: colours represent individual taxis; the patch size indicates the intensity of carbon monoxide during a single day across this capital city. Note the variations across the city and within small neighbourhoods.

Unmanned Aerial Vehicles (UAVs) and airborne drones for monitoring public space, tackles the increasing privatization of security and calls for the democratization of surveillance technologies.

Surveillance and tracking technologies have also become increasingly commonplace in the day-to-day lives of consumers. Radio Frequency Identification (RFID) tags and systems have been developed and used not only to track animals or humans (by law enforcement or for protection) but also products. The use of shopping cards – store cards or 'membership' cards – to assess and monitor consumer habits has been the subject of much debate, and is just one example of how personal data is now accessed in order to maximize the effectiveness of information economies. The project *Zapped!* (2006) by Preemptive Media (f. 2002, with Beatriz da Costa, Heidi Kumao, Jamie Schulte, and Brooke Singer) critically addresses the mass deployment of Radio Frequency Identification through workshops, devices, and activities. The objective of *Zapped!* is, however, to inform about tags and encourage critical response and engagement rather than paranoia.

Mobile devices are also being used by activist groups to gather information – for instance, to compile data about the environment. An example would be the *Participatory Urbanism* (2006–present) project that is being developed by Eric Paulos and his colleagues from the Urban Atmospheres group at

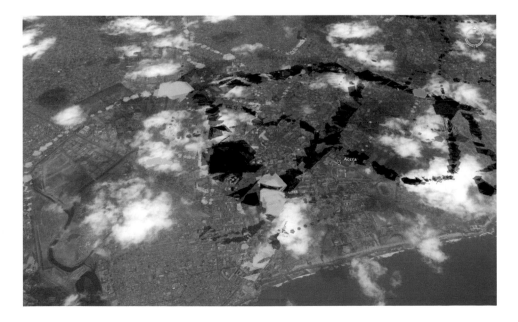

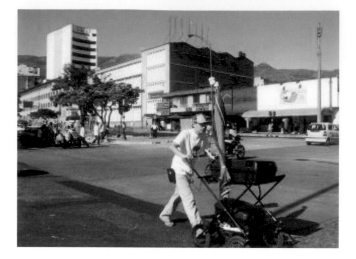

204. **Gabriel Zea, Andres Burbano, Camilo Martinez, and Alejandro Duque**, *BereBere*, 2007. This project uses a wireless device which is equipped with video and audio systems, sensors to monitor CO_2 emissions and electrosmog, and GPS instruments to map the gathered data. Through its set-up *BereBere* places more emphasis on engagement with passers-by in the street to create an awareness of urban issues, and connects with people who may not have access to or be familiar with the technologies used. The project functions as a tool both for data collection and the creation of experimental portraits of communities.

the Intel Research Lab. The project's goal is to enable new participatory urban lifestyles by transforming mobile devices from mere communication tools into what they call 'networked mobile personal measurement instruments'. By authoring, sharing, and remixing new or existing technologies, the project series strives to give citizens more agency in contributing to decision-making about their environment. Providing the average, non-expert user with hardware toolkits and physical sensors that can be easily attached to consumer mobile devices, *Participatory Urbanism* wants to enable citizens to collect and share data about their surroundings and environment. Engaging public participation in monitoring the urban environment is also the objective of the *BereBere* (2007) project by Gabriel Zea, Andres Burbano, Camilo Martinez, and Alejandro Duque, who walk the streets of Medellin, Colombia, with a mobile apparatus which includes CO_2 sensors. Another common strategy of environmentally focused activist projects is to employ frequently used devices such as mobile phones or recruit people who are travelling certain routes on a daily basis. An original and inventive twist on this strategy is the project *PigeonBlog* (2006) by Beatriz da Costa with Cina Hazegh and Kevin Ponto. Launched at the ISEA 2006 / 01 Festival in San Jose, California, *PigeonBlog* uses urban homing pigeons to gather data on air pollution levels. As technological platforms for social media, mobile devices have enabled a wider public to engage in the reporting of events or the monitoring of the environment, forms of agency that are now referred to as 'citizen journalism' and 'citizen science'.

The locative qualities of mobile media are complemented by the hybrid forms of location-based digital devices or technologies that people may now encounter in public spaces. These so-called public interactives become platforms for digitally mediated art and communication with audiences in a mostly urban context. Public interactives commonly make use of embedded and networked sensors or Bluetooth peripherals, as well as distributed audio and projection systems, and can incorporate large public displays, kiosks, touch screens, or furnitures with embedded sensors and technologies. They can take the form of urban screens, tangible displays, responsive environments, and large-scale projections that create architectural light works or cinema, and types of relational architectures such as those by Rafael Lozano-Hemmer discussed earlier in this book. Artworks incorporating public interactives commonly address the ways in which public space is both

205. **Beatriz da Costa with Cina Hazegh and Kevin Ponto**, *PigeonBlog*, 2006. In this project urban homing pigeons are equipped with lightweight backpacks containing GPS-enabled air-pollution sensors which send real-time location-based data to an online blog and mapping environment. Pigeons are also deployed to play the role of 'embedded reporters'; carrying small camera phones and a microphone, they send progress reports during the data-gathering mission.

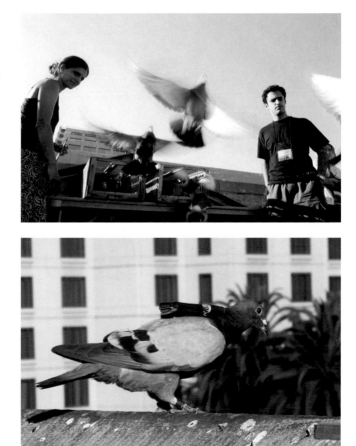

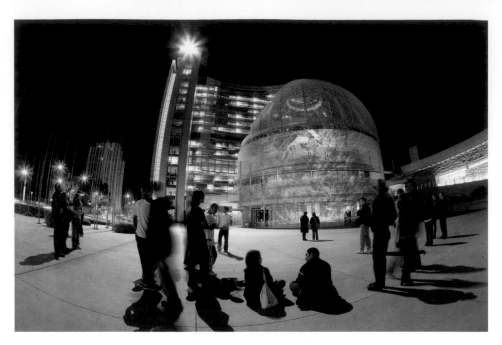

206. **Camille Utterback**, *Abundance*, 2007. This temporary public installation exhibited certain 'behaviours' that responded to the specifics of the site. One behaviour distinguished between individuals and groups: the cool colours of individuals' silhouettes switched to warm colours when a group of two or more people formed. Individuals moving in the projection space would erase the background colour, while groups would fill it back in.

constructed and redefined by digital technologies: they create awareness of the context of architectures, cities, and people's engagement with space; inscribe people and subjectivities into architectures; or address the problematic aspects of a mediated public space in which our movements are tracked and analysed.

In Camille Utterback's *Abundance* (2007) – a temporary public installation in San Jose, California – people's movements through City Hall Plaza are captured by a video camera and, at night, generate a dynamic visual composition that is projected onto the exterior of City Hall's three-storey rotunda. People walking through the Plaza first appear as brightly coloured silhouettes in the projection; their trajectories are inscribed into the background of the piece, web-like patterns emanate from clusters of people, and movements and paths through the Plaza become part of a collective visual record. *Abundance* allows people temporarily to register their presence within the site's architecture and visualizes the 'social space' created by people's movements in an urban environment.

A different example of an artwork in which the public is inscribed into a site is Rafael Lozano-Hemmer's *Voice Tunnel* (2013), a large-scale interactive installation that transformed the Park Avenue Tunnel in New York City. The project uses 300 theatrical spotlights that run along the walls and curved ceiling

of the tunnel to create vertical columns of flashing light, as well as 150 loudspeakers arranged throughout the tunnel and operating in synchronicity with the blinking bulbs. The flashing of the lights gives visual form to and is controlled by recordings of people's voices that echo through the tunnel. At an intercom located in the middle of the tunnel, visitors can make a brief voice recording that is then translated into light, with silence being interpreted as zero intensity and speech modulating the brightness proportionally in flashes. Recordings are played back as a loop, starting in the light fixtures closest to the intercom and the accompanying loudspeaker, then gradually being pushed down from position to position in the array of lights as other participants create recordings. After 75 recordings, the 'oldest' one disappears from the archive. As the tunnel lights up, the public's voices echo through it, creating a temporary 'memory' and narrative of thought fragments through modulated lights and sound.

Public interactives that are seemingly 'aware' of their users and the inhabitants of cities cannot ignore the impact of the pervasive surveillance and tracking systems that are linked to the very technologies that enable communication and agency. Marie Sester's (b. 1955) *ACCESS* (2003) [208] is a public art installation that uses web, sound and lighting technologies to allow web users to track individuals in public spaces via a unique

207. **Rafael Lozano-Hemmer**, *Voice Tunnel*, 2013

208. **Marie Sester**, *ACCESS*, 2003

robotic spotlight and acoustic beam system, and has become iconic among projects that address the complex implications of public spaces' responsiveness to their inhabitants. In *ACCESS*, the robotic spotlight automatically follows tracked individuals while an acoustic beam projects audio at them that only they can hear. Individuals 'in the spotlight' do not know who is tracking them, while the web users do not know that they are triggering sound files – featuring audio relating to surveillance or celebrity culture – that are projected at their target. Tracker and tracked are caught in a paradoxical communication loop.

A project addressing the notion of networked public space in a low-tech yet poignant way is Aram Bartholl's (b. 1972) *Dead Drops* (2010–present), which translates the notion of an anonymous, offline, peer-to-peer file-sharing network into a public setting. The project consists of USB flash drives that the artist embeds into walls, buildings, and kerbs that are accessible to anybody in the public environment. Members of the public are invited to plug in their laptops to walls or kerbsides and subsequently to find data or share their favourite files on a dead drop – the method used in espionage to pass information

209. Aram Bartholl, *Dead Drops*
2010–present

between spies without them having to meet directly. In a humorous way, Bartholl's work highlights the commonalities and differences between 'file sharing' in the virtual and physical environments and, to some extent, 'materializes' the Internet. The field of locative media projects that explore public space through physical interactives or projects distributed via mobile devices will continue to grow with the ongoing evolution of the technologies supporting them.

Augmenting the real: Augmented reality and mixed reality
Smart phones and tablets, along with the development of software platforms, have also opened up new possibilities for artists to explore Augmented Reality (AR) – the 'augmentation' of physical spaces and architectures by mapping virtual imagery onto location-

210. John Craig Freeman,
Orators, Rostrums, and Propaganda Stands, 2012. Augmented reality public art, Los Angeles County Museum, California. This virtual sculpture is based on Gustav Gustavovich Klucis's 1922 designs for 'Screen-radio Orators, Rostrums, and Propaganda Stands'. Klucis, a pioneer of the Russian Constructivist avant-garde, was pressured to devote his work to propaganda, and despite doing so was executed by Stalin in 1938. First shown in Singapore's Hong Lim Park, where people are allowed to speak freely with permits, Freeman's piece raises questions about the function of public speech.

211. **Will Pappenheimer and John Craig Freeman**, *SFMOMA AR Expansion*, 2013. This augmented reality application, experienced by visitors on-site through a smart phone or tablet, reimagines the San Francisco Museum of Modern Art during its expansion. The project provides an animated assemblage of the building's various parts, presenting it as a fluid, open architecture.

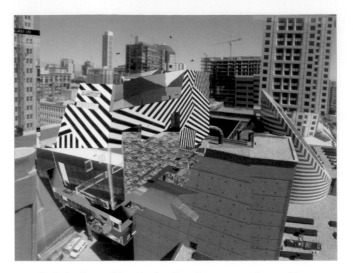

specific latitudes and longitudes. People can experience this virtual imagery as a layer superimposed onto physical locations via their mobile devices through browsers such as Layar and Junaio. Among the most active artists in the area of AR projects have been the Manifest.AR group and its key members Mark Skwarek (b. 1977), John Craig Freeman (b. 1959), Will Pappenheimer (b. 1954), Tamiko Thiel (b. 1957), Sander Veenhof (b. 1973), and John Cleater (b. 1969) [210, 211]. In 2010, Manifest.AR 'hijacked' the foyer of the Museum of Modern Art in New York as part of their exhibition 'We AR in MoMA', organized by Skwarek and Veenhof, which presented augmented reality art within the context of the traditional art museum, thereby both highlighting and questioning the physical boundaries of the institution and the virtuality of digital art. The group engaged in this form of institutional critique again when it showed works in the 54th Venice Biennale (2011). Questioning the Venice Biennale's status as one of the world's most important forums for the dissemination of current developments in international art, Manifest.AR constructed virtual AR pavilions as counterpoints to the actual pavilions in which artists represent their nations in the Giardini in Venice. Playing on the 54th Biennale's 'ILLUMInations' theme, the group positioned its intervention as one unbound by nation state borders, physical boundaries, or conventional art world structures. Tamiko Thiel's *Shades of Absence* (2011) [213] consists of virtual 'Pavilions of Absence' in which images of contemporary artists whose works have been censored in the twenty-first century are reduced to gold silhouettes. By touching the silhouettes, viewers can bring

212. **Manifest.AR**, 'We AR in
MoMA', 2010

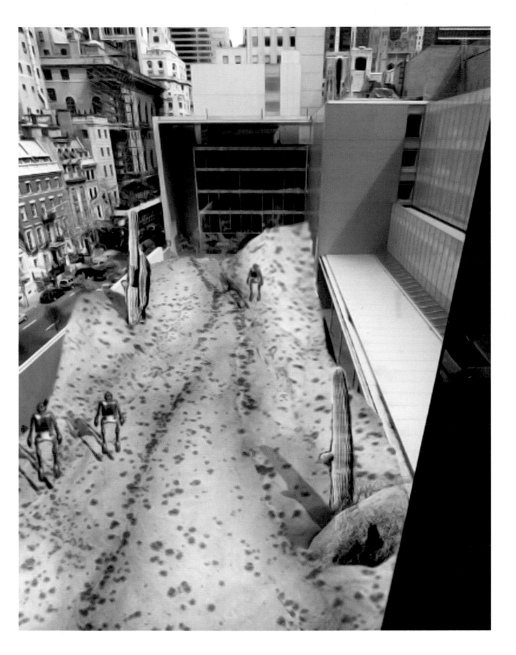

up a website with information on the censored artists, and instructions on how they themselves can add new names and information via the Web or Facebook. Given that AR can render the invisible visible, it does not come as a surprise that this media form is often used in contested territories or for activist purposes. In their AR project *Border Memorial: Frontera de los Muertos* (2012–present), for instance, John Craig Freeman and Mark Skwarek visualize the scope of the loss of life at the US/Mexico border by using virtual objects to mark each location along the border at which human remains have been recovered.

Augmented Reality technologies have also broadened the praxis of so-called Mixed Reality, which merges virtual and physical public space, thus creating a one-to-one relationship between these spaces, and has been explored mostly within a gaming context. The British art collective Blast Theory's landmark mobile game *Can You See Me Now?* (2001–present) was created in collaboration with the University of Nottingham's Mixed Reality Lab. It was first staged in Sheffield, UK, and has been shown around the world since then. It takes the form of a chase in which online players navigate their avatar through the streets of a city

213. **Tamiko Thiel**, *Shades of Absence: Public Voids*, 2011

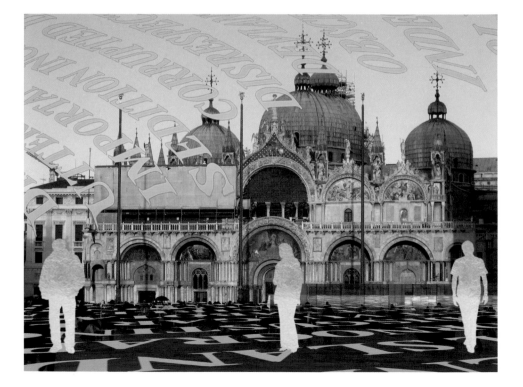

214. Blast Theory, *Can You See Me Now?*, 2001–present

map in order to escape from 'runners' in an actual city who are hunting them. The runners – each equipped with a handheld computer-cum-GPS tracker that sends their position to online players via a wireless network – attempt to 'catch' those online players, whose position is in turn sent to the runners' computers. The virtual players can send text messages to each other and receive a live audio stream from the runners' walkie-talkies. The game is over when runners 'sight' their virtual opponents and shoot a photo of them (which obviously just captures empty space). *Can You See Me Now?* achieves an impressive merging of physical and virtual space, and raises profound questions about embodiment in these different sites. As its title indicates, the project addresses the very process of seeing, suggesting a form of perception independent of embodiment. In more recent projects, such as *A Machine To See With* (2010), a locative cinema commission from the Sundance Film Festival that premiered at Zero1 San Jose in 2011, Blast Theory casts participants as stars in a real-world heist film, leading them through the city and asking them to make ethical decisions. The past decade has also seen the development of devices for augmenting reality, such as Google

Glass, and headsets combined with gestural control. These allow users to move and manipulate 3D virtual objects within the physical environment with their hands, and are increasingly available on the market, thus inviting artistic experimentation that will likely continue to grow.

Social media and the Web 2.0 era

The idea of linking and networking, be it through static or mobile technologies, is intrinsic to and arguably the essence of digital media. In terms of the development of digital platforms, there has been a shift of emphasis from the networking – that is, the linking and exchange – of media files (through e-mail or the World Wide Web) to the networking of people. For more than fifteen years, the websites of individuals, non-profit organizations, and companies have been an increasingly important way of publishing information. In the 2000s, Web logs (blogs), wikis (websites that allow multiple authors to edit the featured content), and social networking sites such as Facebook, YouTube, Twitter, Instagram, and Flickr have been hyped as a supposed 'second generation of Web-based services' under the umbrella term Web 2.0. Coined by O'Reilly Media in 2004, the term describes 'a business revolution in the computer industry' based on building 'applications that harness network effects to get better the more people use them'. As a corporate concept, Web 2.0 provides contextual 'warehouses' that allow for the filtering and networking of content provided by users, whether photos (Instagram, Flickr), videos (YouTube), or personal profiles (Facebook). One of the most problematic aspects of these social networking sites is the fact that users effectively grant extensive rights to the content they contribute, which raises interesting questions about authorship and the preservation of information. Rather than establishing a reconfigurable platform for networking and generating network effects, Web 2.0 sites largely provide a hyperlinked broadcasting environment with meta-tags that allow for easy filtering. The digital, networked commons include platforms that help creative and cultural communities stay informed and improve policies that shape cultural life. At the same time, the commercial construct of Web 2.0 has created a new, contemporary version of users as 'content providers' who fill contextual interfaces with data and make their personal data subject to datamining.

Blogs were an early form of what is now known as social networking and encouraged a mode of publishing – the online

215. Golan Levin with Kamal Nigam and Jonathan Feinberg, *The Dumpster*, 2006. From a pool of 20,000 teenage break-ups, the interface enables users to see which break-ups are comparable and reveals the similarities, differences, and underlying patterns of the end of the relationships. The similarities are determined by many linguistic, demographic, and thematic factors, and include aspects such as age and gender, the reasons for and dynamics of the break-up, as well as language use.

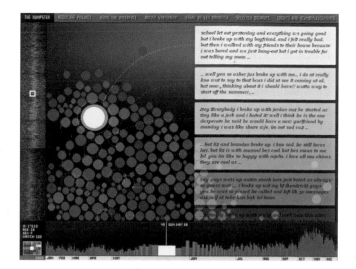

diary – that resonates with the increasing desire for self-exposure or voyeurism in the media which is at the core of reality TV. However, social networking sites surpass blogs as they can filter and match content across individual pages and profiles. The filtering of content to create a 'social portrait' of bloggers publicly sharing highly personal information was the idea behind *The Dumpster* (2006) by Golan Levin (b. 1972) [215] with Kamal

216. Antonio Muntadas, *On Translation: Social Networks* at the San Jose Convention Center, 2006

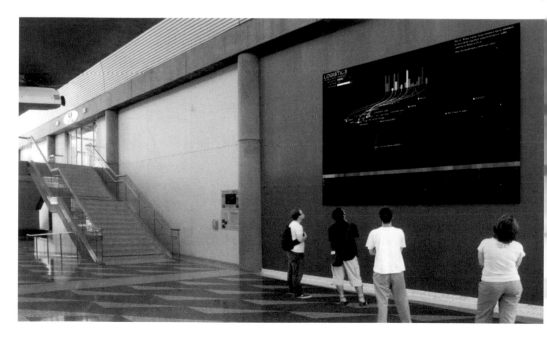

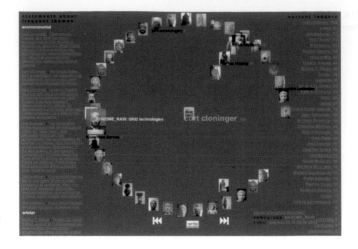

217. **Warren Sack**, *Agonistics: A Language Game*, 2005. Using any email program, players can post messages to online, public discussions, which the project then translates into a graphical display where participants are represented by thumbnail images. Players are assigned a position in a circle, depending on the content of their message, and are placed in relation to the other players who posted a message on the same theme. After each new message posted to the discussion, everyone's position is algorithmically recomputed. By posting a message to the discussion that voices a specific opinion about a theme, players can move themselves closer to or further away from other players.

Nigam and Jonathan Feinberg. The project is an interactive online visualization that portrays the romantic break-ups of mostly American teenagers. Gathering data from millions of online blogs, the artists assembled a collection of 20,000 romantic break-ups that occurred during 2005 and used custom language-analysis software to computationally evaluate the posts and classify them according to different characteristics. *The Dumpster* shows how an age group in a relatively defined geographic area addresses relationship problems in a process that Lev Manovich has referred to as 'social data browsing'.

Antonio Muntadas's networked projection *On Translation: Social Networks* (2006) [216] offers a different kind of social data browsing by interpreting the vocabulary that a selection of organizations use on their websites. Organizations ranging from Apple to Rhizome are placed on a world map, their text sampled, and their vocabulary analysed. Websites are ranked according to their level of technological, militaristic, cultural, and economic influence, and each of these four aspects is assigned a colour value (red, green, blue, and white respectively), which, in its mix, determines the colour of the website. A colour palette at the bottom of the projection shows trends in language; for example, a word may lean toward 'militaristic' in its colour due to the websites on which it has been used.

Warren Sack (b. 1962) also explores language and positioning in *Agonistics: A Language Game* (2005), this time in the context of large-scale online communications. The project is inspired by the concept of 'agonistics', the science of athletic combats, or contests in public games. Theorists such as Chantal Mouffe

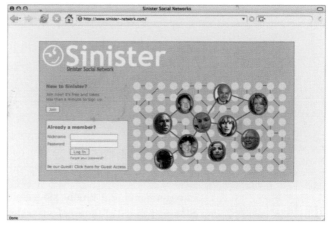

have been interested in the democratic potential of agonistic contests, using metaphorical images and actions to describe verbal contests as a language game. Sack's project draws on these ideas and applies them to online discussion forums or the Rhizome mailing list. By enabling participation and filtering on the basis of rules that are established by the artist (and the algorithms used), *Agonistics* creates an enhanced awareness of how individuals position themselves, be it in a social context or in the ways they express their opinion. The project is a public artwork in which participants are both the active producers of content as well as its recipients, and reveals how 'systems' and 'communities' can create narratives that highlight relationships between individuals.

219. **Angie Waller**, *myfrienemies. com*, 2007

220. **Paolo Cirio and Alessandro Ludovico**, *Face to Facebook*, 2011

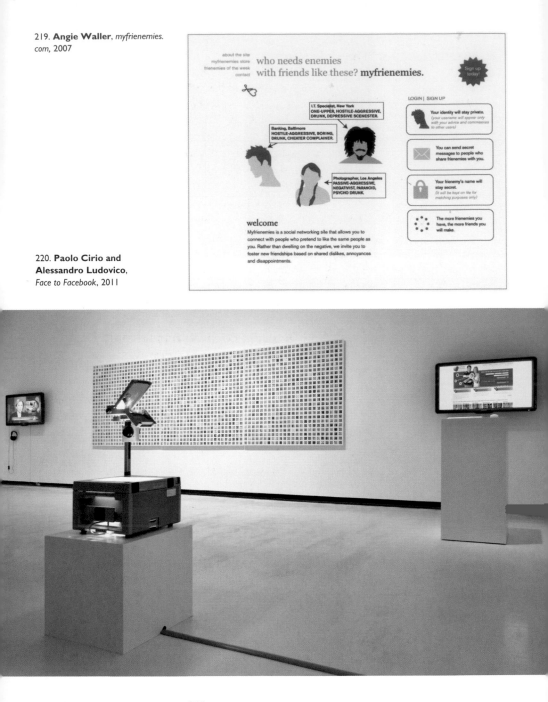

In the early 2000s, the growing popularity of social networking sites such as Friendster, MySpace, Facebook, and others inspired art projects that explicitly reference these sites and explore their underlying paradigms. *Sinister Social Network* (2006) by Annina Rüst (b. 1977) [218], who is working with the Computing Culture research group at MIT in Boston, establishes a connection between data-surveillance (or dataveillance) and social networking by using research on software that identifies and analyses suspicious behaviour on the basis of communication patterns. *Sinister Social Network* points to the moments of suspicion and conspiracy that are intrinsic to networking sites. The site incorporates online chat bots that infiltrate chat networks and, aside from discussing banal topics, occasionally make suspicious, potentially conspiratorial remarks. By telephoning the bots, users can insert their own messages into the bots' conversations. Software analyses and maps the online conversations, detecting unfriendly uses of the social network.

Angie Waller's *myfrienemies.com* (2007) also subverts and questions the 'friendly' social networking environment, in this case by pointing to the more negative premises on which alliances and friendships are often built. Mimicking a secret society, *myfrienemies.com* is designed to cultivate new friendships on the basis of shared dislikes. The site connects users who share feelings of aversion towards the same person and lets them peruse testimonials based on profiles such as the 'hostile-aggressive' personality or the one that is 'eager to please'. While taking a deliberately negative approach, the project creates an awareness of the complexities of emotions that foster bonding.

Since its founding in 2004, Facebook has gradually superseded other social networking sites of its type such as Friendster and MySpace. Social media and networked platforms of data aggregation have redrawn the boundaries between the public and the private, as the messages and images that we casually distribute, along with the likes and dislikes that we share with friends and family, help us to construct profiles that are accessible to corporations and subject to commercial and social datamining. What was once considered personal and private has become increasingly public in a cultural shift entailing a reformulation of our identities as individuals.

Various art projects have addressed these shifts induced by the social media landscape. For their mixed media installation *Face to Facebook* (2011), Paolo Cirio (b. 1979) and Alessandro Ludovico (b. 1969) 'stole' one million Facebook profiles, filtered

221. **Ben Grosser**, *Facebook Demetricator*, 2012–present

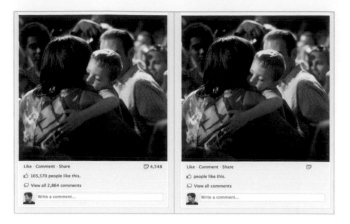

them with face recognition software and then posted them on a custom-made dating website, sorted according to the characteristics of their facial expressions. Cirio and Ludovico's artistic activism explores the contested space of ownership rights to personal data, approaching this from multiple perspectives. While no Facebook log-in was required to retrieve any of the profiles, the act of analysing and repurposing them led to multiple disputes. The *Face to Facebook* installation includes prints of the stolen faces, a local version of the 'Lovely Faces' dating website, media coverage of the project, as well as exchanges between Facebook's and the artists' lawyers, and reactions from the public. Ben Grosser's (b. 1970) *Facebook Demetricator* (2012–present), by contrast, 'deconstructs' the framework of Facebook: the project takes the form of a browser extension that can be installed by anyone and removes all metrics from the respective users' Facebook page, highlighting how much the appeal of the social media platform depends on the quantification of friends, and on liking and being liked.

Among social media platforms, the microblogging site Tumblr, founded by David Karp in 2006, has become particularly popular as a stimulus for artistic creation. The fact that Tumblr allows for quick and easy reblogging of content, is highly customizable, and provides a continuous feed from the blogs one is following, creates an image space that is both non-hierarchical and that undermines authorship and attention to singular imagery. Artists have engaged with the platform for both of these reasons. Joe Hamilton's (b. 1982) Tumblr *Hyper Geography* (2011) is a highly customized collage that makes images flow together in a continuous space, thereby forming a landscape that simultaneously flattens the

222. (opposite) **Joe Hamilton**, *Hyper Geography*, 2011

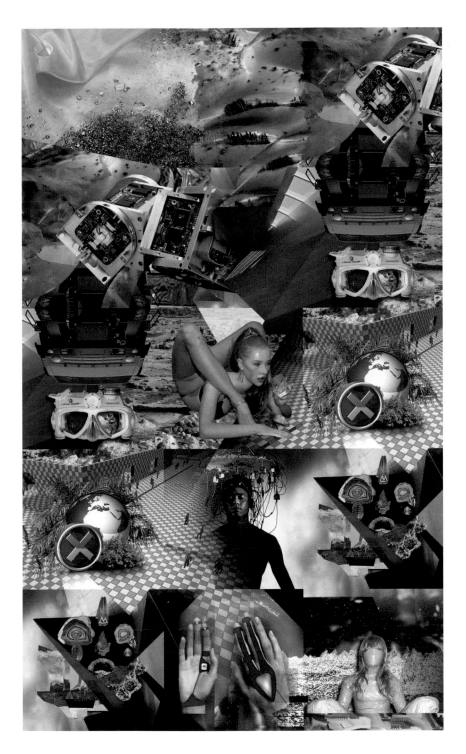

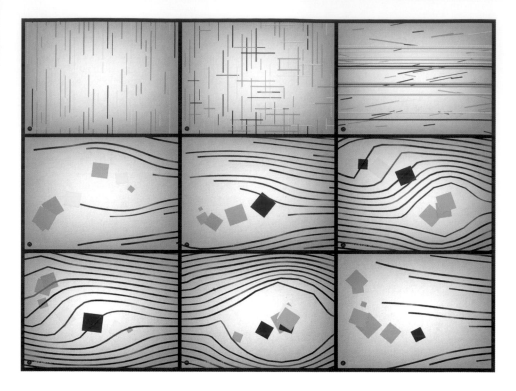

223. **Scott Snibbe**, *Philip Glass REWORK_APP*, 2012

distinctive qualities of images and provides a portrait of the Tumblr environment itself and the aesthetics of its imagery. Brad Troemel (b. 1987) and Jonathan Vingiano's (b. 1986) project *Echo Parade* (2011) also questioned hierarchies by using a bot that scanned and then posted content on the *Echo Parade* Tumblr according to a numerically defined popularity. The bot was originally fed 200 art Tumblrs and every post that was able to accrue fifteen rebloggings or likings (called 'notes') in under twenty-four hours would be automatically reblogged. The bot crashed a month after its launch, but the imagery processed by it is still available online.

In the era of social media and mobile devices, apps for smart phones and tablets have been used increasingly as a format for creating and distributing art, making use of the fact that people read and 'play' on these devices during their moments of free time throughout the day. Artist Scott Snibbe has created several award winning apps that take digital art's experimentation with collaborative drawing and remixing to the next level. Snibbe's *MotionPhone* (2012) allows people to collaborate in the creation of abstract animations by choosing forms and colours on the seemingly infinite canvas of their phone or tablet screen and

sharing them over the network. Snibbe's audio-visual app album *REWORK_(Philip Glass Remixed)* (2012) takes the remix album of composer Philip Glass's music created by Beck and twelve other musicians and translates it into an immersive experience. Users can interact with the eleven 'music visualizers' featured as part of the app and make their own visual remixes, or use a visual version of the 'Glass Machine', two discs or turntables that can be used to produce music inspired by Philip Glass.

The connectivity created by mobile devices and social networking sites finds its extension in the social spaces of virtual worlds, which have become increasingly sophisticated since the 1990s. Massive multi-player online games such as the popular World of Warcraft have set new standards for virtual worlds and the actions within them and have created new virtual forms of community. The text-based online MUDs and MOOs of the early 1990s were gradually superseded by 2D graphic chat environments and finally 3D virtual worlds. Launched in 2003, Second Life (SL), an online virtual world developed and maintained by San Francisco-based Linden Research, Inc. (Linden Lab), over time emerged as the most successful virtual world to date and received international coverage in the mainstream media. A downloadable client program enables the users and residents of SL to inhabit and explore the world, build their homes, and socialize making use of social networking services. Residents can also buy real estate and create and trade items, known as virtual property in the 'in-world' currency of Linden dollars, which are traded for 'real world' currency. From 2010 to 2013, 36 million accounts were created and $3.6 billion was spent on virtual assets. Since Linden Lab announced the layoff of 30 per cent of its workforce in 2010 and changed its terms of service to be able to make use of user-generated content for any purpose in 2013, the actual active userbase has declined and many people have moved to OpenSimulator, an open source virtual world. More than 1 million people visit Second Life monthly.

While SL is the first virtual world to have attracted such a critical mass of users, it has had many predecessors. *AVATARA* (2003) [224–25] by Donato Mancini and Jeremy Owen Turner, with editor Patrick 'Flick' Harrison, provided an insight into the dynamics of virtual worlds in the form of a movie, distributed on DVD. The feature-length documentary consists of interviews with the (mostly American) inhabitants of the voice-chat environment OnLive! Traveler, which was established in c. 1993 and later became accessible through The Digital Space Commons as

224. (top) **Donato Mancini and Jeremy Owen Turner with Patrick 'Flick' Harrison**, *AVATARA: Portrait of VanGo at Baby's Pool*, 2003. AVATARA was recorded entirely 'in-world' (i.e. within the Traveler environment) and, according to its creators, is one of the first docudramas to be done in Machinima style – displaying its content from within a virtual world. The interviewer and guide Kalki (a bluish horse head) and the inhabitants of the Traveler environment appear as torso-size avatars in their natural virtual surroundings and comment on the topics Community, Identity, Art, War, and Loss.

225. (bottom) **Donato Mancini and Jeremy Owen Turner with Patrick 'Flick' Harrison**, *AVATARA: Fast Eddie Interviewed by Kalki at the Ozgate Entrance*, 2003

DigitalSpace Traveler. *AVATARA* features the online world at its best – a community-building technology that offers a creative outlet for everyone – yet doesn't neglect the darker aspects of its social fabric, which replicates the real world in many ways.

Avatars as a new form of self-representation have been fertile ground for artistic experimentation. Since 2006, artists Eva and Franco Mattes (b. 1976, aka 0100101110101101.org) have inhabited Second Life and created portraits of avatars, which are 'shot' in the virtual world but exhibited as high-end digital prints on canvas. Their series *13 Most Beautiful Avatars* (2006) portrays celebrated 'stars' of Second Life and explicitly alludes to Andy Warhol's series *The 13 Most Beautiful Boys and The 13 Most Beautiful Women* (1964), which captured a different period of stardom and pop celebrity. In transporting the aesthetics of the 3D world with its specific colours, light, shapes, and perspectives onto canvas

226. (top) **Eva and Franco Mattes (aka 010010111010101101.org)**, *Annoying Japanese Child Dinosaur*, 2006. The Matteses have referred to the idealized avatar images in *13 Most Beautiful Avatars* as 'pictures of self-portraits' rather than portraits. They continued their investigation into this form of representation with the series *Annoying Japanese Child Dinosaur*, which consists of portraits of avatars created by Japanese children and takes a look at a very specific subculture, its aesthetics, and cultural subtexts. The title references the novella *Mr. Boy* (1990) by James Patrick Kelly and the fantasy world of its protagonist, a genetically undersized 12-year-old.

227. (bottom) **Eva and Franco Mattes (010010111010101101. org)**, *13 Most Beautiful Avatars*, 2006

and into the gallery, the images raise interesting questions about the history of portraiture and conventions of photography and painting. As with many of their predecessors in traditional media, these self-portraits are based less on a realistic depiction than on an idealized self-image that is often stereotypical and largely matches the Western canon of beauty.

A more psychologically oriented, satirical investigation of avatar personality and its encoded nature unfolds in Will Pappenheimer and John Craig Freeman's *VF-Virta-Flaneurazine-SL ©* (2007) [228], a programmable 'mood-changing' drug for Second Life, which, once ingested, causes its consumer to wander aimlessly through the SL environment for up to a full

228. **Will Pappenheimer and John Craig Freeman**, *VF-Virta-Flaneurazine-SL* ©, 2007

day, erratically teleporting to random locations. The so-called 'prograchemistry' of the drug is based on a formula conceived and developed by the artists, who have been testing the effects of the drug in clinical studies where users register, download a custom desktop-active ingredient, and are directed to a site in SL for ingesting the second part of the drug. Users allegedly reported that the drug allows them 'to see SL freed from its limitations as a fast-growing grid of investment properties'. In a humorous way, the project points to the more serious implications of a (virtual) society whose inhabitants are at least partly coded by a corporate entity (Linden Lab), which determines their behavioural properties and the framework of their society.

The interconnection between the economies of the real world and virtual environments such as SL and online games also raises questions about the value of the art object. The project *Objects of Virtual Desire* (2005) by G+S (Simon Goldin and Jakob Senneby, b. 1981 and 1971 respectively) explores how value is transferred from the material to the immaterial and vice versa, and the ways in which the materialized object affects the perception of the virtual original. For the project, the artists started collecting immaterial objects created and owned by SL inhabitants. The objects, which were selected on the basis of their sentimental value to their owner, were acquired by the artists as a copy along with the personal story that went with them, and some have been reproduced in physical form. The physical recreations of a piece of jewelry (the choker of the avatar Jade Lily) and of the Penguin Ball (a transparent ball with a penguin inside it – the logo of the Linux operating system – which was

229. (top) **G+S**, *Objects of Virtual Desire: Jade Lily's <3> Choker*, 2005. This project strives to replicate the 'process of becoming' that takes place in a virtual world: objects in virtual worlds are often representations of physical counterparts, but gain new meanings through their site-specific functionality in virtual environments and become objects in their own right; similarly, the physical reproductions of the virtual objects are representations of the immaterial and remain virtual unless they emerge as objects with new functionality.

230. (centre and bottom) **G+S**, *Objects of Virtual Desire: Cubey Terra's Penguin Ball*, 2005

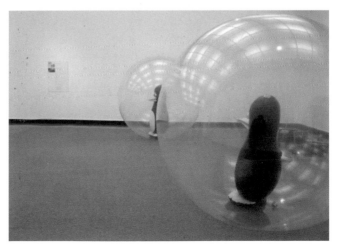

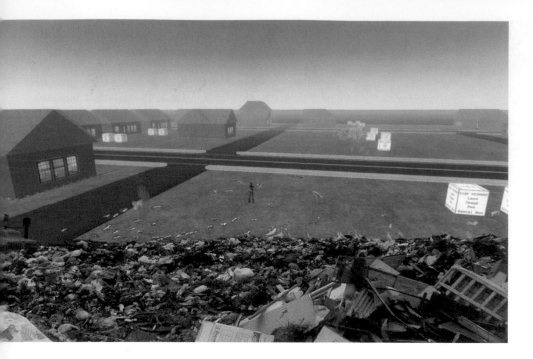

231. (above and opposite, top)
eteam, *Second Life Dumpster*,
2007

created in SL by Cubey Terra) were exhibited at the Bergen
Kunsthall in late 2005, together with interviews with the avatars
of the original owners.

The value of property – in this case, 'land' – is also at the
core of the time-based, performative project *Second Life Dumpster*
(2007) by eteam (Hajoe Moderegger and Franziska Lamprecht,
b. 1964 and 1975 respectively). The artists bought commercial
land in SL and, for the duration of a year, maintained a public
rubbish area for collecting the items from the trash folders that
avatars have by default, and need to empty regularly in order to
maintain their performance. This work gives 'materiality' to the
notion of waste, which is so easily obliterated in the virtual realm,
and addresses questions surrounding the quality and personal
'history' of the waste disposed (objects, messages, avatars,
behaviours, etc.) and the concepts of disposal, decomposition,
and recycling in the virtual realm.

Virtual worlds offer a performative environment for realizing
what is impossible or at least difficult to achieve in the physical
world. In their piece *Reenactment of Joseph Beuys' 7000 Oaks*
(2007), Eva and Franco Mattes (aka 0100101110101101.org) have
made use of this opportunity to continue – at least symbolically

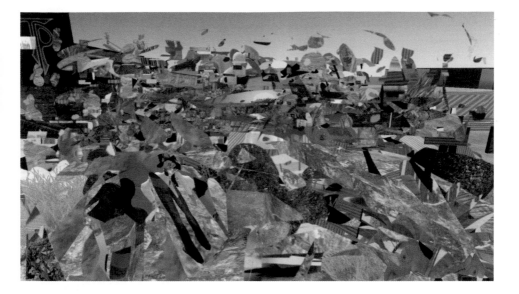

– the implementation of a Beuys piece that remained largely unrealized. On 16 March 1982, at Documenta 7 in Kassel, Germany, Beuys initiated the first stage of what he intended to be an ongoing, global process of planting 7,000 trees, each paired with a column of basalt stone, to initiate environmental and social change. The Matteses are re-enacting the piece on their virtual Cosmos Island in SL, where they planted the first virtual tree and stone on 16 March 2007. The stones have been stacked on the island, and SL inhabitants are invited to place stones and trees on their own land. The virtual continuance of

232. (below and right) **Eva and Franco Mattes (aka 010010111010110l.org)**, *Reenactment of Joseph Beuys' 7000 Oaks*, 2007

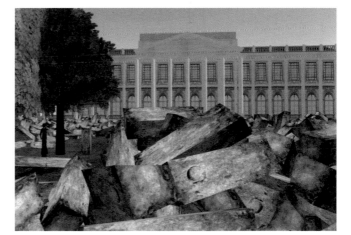

A bit bent out of shape...

the performance may not have the direct environmental effect of the original, but it keeps both the spirit of Beuys's project and an artistic heritage alive.

Like its graphic chat-room predecessors, worlds such as SL provide the stage for public performances. Supposedly the first performance group operating in SL is Second Front, founded in 2006. In their works, Second Front have continuously engaged with the underlying 'architecture' and economics of SL in often subversive and radical ways. Their three-act performance *Spawn of the Surreal* (2007), which was part of the Chaos Festival on the SL campus of the New Media Consortium, was a 'spectacle of self-consciousness' in which unsuspecting audience members were mutated into sculptural configurations reminiscent of Cubism whenever they sat in the chairs that were part of Second Front's installation. Second Front member Gazira Babeli came up with the idea after she found that one of her code scripts was acting up and kept on deforming her avatars. The group took this incident as a starting point for questioning the (Western) ideals of beauty that manifest themselves in the appearance of avatars, and they decided to tackle this idea by writing 'bad' code – named Code Deforma – which infected SL avatars and transformed them into surreal beings with elongated, contorted limbs and inverted heads. Some infected audience members fled the space in terror while others requested more extreme results. In their opening performance for John Craig Freeman's installation *Imaging Place SL: The U.S./Mexico Border* (2007) in Second Life's Ars Virtua Gallery, Second Front took the notion of the border quite literally and staged an aggressive *Border Patrol*, complete with

234. **Second Front**'s performance *Border Patrol*, on the occasion of John Craig Freeman's installation *Imaging Place SL: The U.S./Mexico Border*, 2007, in Second Life's Ars Virtua Gallery

helicopters and tanks, intended to reflect on the increasing militarization of the borders throughout North America. The performers finally set the space on fire, which caused the audience to flee and left the space littered with rubble. While the performance caused a significant amount of controversy, it quite effectively rendered 'real' the simulation of violence – a common premise of many computer games. Crossing the borders of acceptable behaviour within a virtual world, *Border Patrol* made simulated violence a questionable act.

None of the current social networking services will be definitive models and all are continuously evolving and inspiring their own competitors. As the so-called 2.0 phase of network technologies, they represent a new stage in the development of the connectivity that is one of the crucial features of digital media and will continue to play a dominant role in digital art. Presumably mobile technologies will become even more pervasive in the future and enable more sophisticated forms of networking that will be creatively and critically explored by art and commerce. Digital art, probably more so than before, will exist in multiple contexts – the public spaces of networks, cities, and natural environments. It remains to be seen if and how traditional art institutions will open up to these varied contexts in support of digital art forms.

Glossary

AIML Artificial Intelligence Markup Language, created by Dr Richard Wallace, is a scripting language (*see below*) that enables verbal communication with a computer. It allows pattern-based, stimulus-response knowledge content to be served, received, and processed on the Web and offline in the same way as documents are published and processed with HTML (*see below*).

algorithm Algorithms are step-by-step procedures of formal instructions that solve problems and tasks and accomplish a 'result' in a finite number of steps. Any software and computer operation is the realization of algorithms with the help of a programming language.

artificial life The reproduction of biological processes or organisms and their behaviours through computer systems.

ASCII The American Standard Code for Information Interchange, the standard computer code, which was first proposed in 1963 and finalized in 1968. The ASCII character set consists of 128 decimal numbers ranging from zero through 127 assigned to letters, numbers, punctuation marks, and the most common special characters.

augmented reality The augmentation of the physical reality surrounding us through computer-generated elements. As opposed to virtual reality, which is aimed at creating immersive, completely computer-generated worlds, augmented-reality systems add visual information to the physical world (through a head-mounted display or mobile devices).

autonomous characters Computer-controlled characters or entities that are able to exhibit autonomous behaviours and navigate around their world in a lifelike and improvisational manner. The behaviour of the characters allows them to react independently to the specifics of their surroundings. Craig Reynolds is one of the influential researchers who has developed steering behaviours for autonomous characters, which have found their application in games and feature films. The flocking of the dinosaurs in *Jurassic Park*, for example, was based on his work, and he subsequently won the Scientific and Engineering Award at the 1998 Academy Awards.

cellular automata Cellular automata are an array of identically programmed 'cells' (simple computing units) that each obey their own sets of rules and interact with one another. The term 'cellular automaton' was introduced in the 1950s by Arthur Burks, who, with his wife Alice, helped build and program ENIAC, the first computer. By building appropriate rules into a cellular automaton, one can simulate many kinds of complex behaviour, ranging from the motion of fluids to the movements of fish on a coral reef. (*see also 'autonomous characters'*)

cyberspace A term coined by William Gibson in his novel *Neuromancer* for an entirely computer-generated, immersive world.

data layers Different types or levels of information (from computer code or a database to visuals and audio) that can be combined or inserted into one system. For example, any computer program can be understood as a combination of data layers, from the underlying code to the interface that allows the user to perform operations.

dataspace A virtual space constructed from and containing computer-generated information. A dataspace, also known as an information space, can manifest itself as anything ranging from the 3D world of a game to a visual interface for a library catalogue.

GPS The Global Positioning System is a navigation system made up of a network of twenty-four satellites orbiting the Earth and transmitting coded signals to users' receivers on the ground. Four GPS satellite signals compute the three dimensions and the fourth dimension of time to pinpoint a user's exact position on the globe. Though funded and controlled by the US Department of Defense, most uses of the system are civilian. Aircrafts, ships, ground vehicles, and pedestrians all employ the system to track their movements and navigate.

HTML Hypertext Markup Language is a scripting language (*see below*) that makes it possible to establish links between documents and arbitrary nodes (computers hooked up to a network). HTML is the underlying language of the World Wide Web.

hypertext Linked segments of text that can be navigated by a user. Hypertext originated in Theodor Nelson's concept of the 'docuverse', a space of writing and reading where texts could be electronically interconnected by anyone contributing to the networked text. While the World Wide Web essentially is a hypertext environment, hypertext software existed before HTML.

hypermedia An environment of linked multimedia elements, such as text, audio, visuals, movies. Anything from an interactive CD-ROM to the World Wide Web can be considered a hypermedia environment.

information space see '*dataspace*'

intelligent agent Software programs to which users can delegate tasks and which automatically filter and customize information on behalf of their user. As opposed to conventional software, intelligent agents are semi-autonomous, proactive, and adaptive.

PDA Personal digital assistants (PDAs), such as Palm Pilots and Handspring Visors, are portable, hand-held computing devices that store data and transmit information.

rapid prototyping A process that automates the fabrication of an object from a CAD (computer-aided design) model. The three main categories of fabrication processes are subtractive, additive, and compressive. In a subtractive process, the desired object is carved from a block of material. The additive process builds an object through layer-by-layer fabrication from plastic, starch-based, or wax materials. In the compressive process a semi-solid or liquid material is compressed into a form and then hardened or solidified (for example, through the use of lasers).

scripting language Scripting languages are computer languages designed to 'script' operations of a computer application to perform specific repetitive tasks.

SMS SMS stands for Secure Message System or Short Message Service and gives users the ability to send and receive text messages to and from mobile telephones.

telematics The combination of computers and telecommunications.

telepresence Telepresence (from the Greek *tele*, meaning 'far off', 'distant') describes the ability to be present in a remote location, for example in a chat room on the Internet, through technological means.

telerobotics The operation of a local robotic device by a user in a remote location over the Internet.

wiki A wiki is a website and writing platform that provides easy linking of pages and documents and can be collaboratively edited by anyone with access to it. One of the best-known wikis is the online encyclopedia Wikipedia. The first wiki, WikiWikiWeb, was developed by Ward Cunningham in 1994 and was launched in 1995. Wiki is a Hawaiian term for fast and is said to have been chosen by Cunningham to avoid the name 'quick Web'.

Artists' websites and online art projects

0100010111010110l.org http://0100010111010110l.org

Rebecca Allen Emergence http://emergence.design.ucla.edu/

Mark Amerika http://www.markamerika.com; Grammatron http://www.grammatron.com; Filmtext http://www.markamerika.com/filmtext

Cory Arcangel http://www.coryarcangel.com/

Art+Com http://www.artcom.de

ASCII Art Ensemble http://www.ljudmila.org/~vuk/ascii/aae.html

Asymptote http://www.asymptote.net

Aram Bartholl http://datenform.de

Konrad Becker System-77 Civil Counter Reconnaissance http://s-77ccr.org/

Giselle Beiguelman http://www.desvirtual.com

David Blair WAXWEB http://www.iath.virginia.edu/wax

Blast Theory http://www.blasttheory.co.uk

Julian Bleecker http://www.techkwondo.com

Christian-A. Bohn Liquid Views http://on1.zkm/zkm/werke/LiquidViews

Natalie Bookchin http://www.calarts.edu/~bookchin/; Intruder http://www.calarts.edu/~bookchin/intruder/; Metapet http://www.metapet.net

Lisa Brenneis Desktop Theater http://www.desktoptheater.org

James Buckhouse Tap http://www.diacenter.org/buckhouse/

Heath Bunting http://www.irational.org; Read Me http://www.irational.org/heath/_readme.html

Andres Burbano, Alejandro Duque, Camilo Martinez & Gabriel Zea BereBere http://berebere.info/

Bureau of Inverse Technology http://www.bureauit.org/

Nancy Burson http://www.nancyburson.com

C5 http://www.c5corp.com

John Canny PRoP, Personal Roving Presence http://www.prop.org

Adam Chapman Impermanence Agent http://www.impermanenceagent.com

Paolo Cirio http://www.paolocirio.net

Janet Cohen The Unreliable Archivist http://www.walkerart.org/gallery9/three/

Brody Condon Velvet-Strike http://www.opensorcery.net/velvet-strike/

Vuk Cosic http://www.ljudmila.org/~vuk/

Luc Courchesne http://www.din.umontreal.ca/courchesne

LiseAnne Couture http://www.asymptote.net

Critical Art Ensemble http://www.critical-art.net/

Nick Crowe http://www.nickcrowe.net

Walter van der Cruijsen http://www.ljudmila.org/~vuk/ascii/aae.html

Charles Csuri http://www.csurivision.com

Peter D'Agostino http://www.temple.edu/newtechlab

Beatriz da Costa PigeonBlog http://pigeonblog.mapyourcity.net/

Charlotte Davies http://www.immersence.com

Joshua Davis http://www.praystation.com

Jaap de Jonge Speakers Corner http://www.speakerscorner.org.uk

Tennessee RiceDixon Scrutiny in the Great Round http://www.thing.net/~relay/scrutiny/

Judith Donath http://smg.media.mit.edu/people/Judith/

Toni Dove http://www.tonidove.com

Electronic Café International http://www.ecafe.com

Electronic Disturbance Theater http://www.thing.net/~rdom/ecd/ecd.html

Entropy8Zuper! http://www.entropy8zuper.org

eteam (Hajoe Moderegger & Franziska Lamprecht) http://meineigenheim.org/

etoy http://www.etoy.com

Faces http://www.faces-l.net/

Fakeshop http://www.fakeshop.com

Ken Feingold http://www.kenfeingold.com/

Monika Fleischmann http://www.imk.fraunhofer.de/sixcms/detail.php?template=&id=1187; Liquid Views http://on1.zkm.de/zkm/werke/LiquidViews

Keith Frank The Unreliable Archivist http://www.walkerart.org/gallery9/three/

John Craig Freeman http://pages.emerson.edu/Faculty/J/John_Craig_Freeman/

Luka Frelih http://www.ljudmila.org/~vuk/ascii/aae.html

Benjamin Fry http://acg.media.mit.edu/people/fry/; Valence http://acg.media.mit.edu/people/fry/valence

Matthew Fuller http://www.axia.demon.co.uk/; TextFM, WebStalker http://www.backspace.org/iod/

Alex Galloway Carnivore http://www.rhizome.org/carnivore

Kit Galloway http://www.ecafe.com

Jim Gasperini Scrutiny in the Great Round http://www.thing.net/~relay/scrutiny/

Jesse Gilbert Adrift http://www.turbulence.org/adrift/

Ken Goldberg http://www.ieor.berkeley.edu/~goldberg/art/

Jeff Gompertz http://www.fakeshop.com

Colin Green http://www.backspace.org/iod/

Scott Griesbach http://www.scottgriesbach.com

Ben Grosser http://bengrosser.com

G+S (Simon Goldin and Jakob Senneby) http://www.goldinsenneby.com

Kazuhiko Hachiya http://www.petworks.co.jp/~hachiya/works/

Joe Hamilton http://www.joehamilton.info

Usman Haque http://www.haque.co.uk/

Emily Hartzell Alice sat here http://www.cat.nyu.edu/parkbench/alice

Graham Harwood http://www.mongrelx.org; TextFM, Rehearsal of Memory, Uncomfortable Proximity http://www.tate.org.uk/netart/mongrel/home/default.htm

Joan Hemskeerk http://www.jodi.org; My Boyfriend Came Back from the War (Wolfenstein version), SOD http://sod.jodi.org/, Untitled Game http://www.untitled-game.org

Jochem Hendricks http://www.jochem-hendricks.de

Lynn Hershman http://www.lynnhershman.com

Perry Hoberman http://www.perryhoberman.com

Dieter Huber http://www.dieter-huber.com

I/O/D http://www.backspace.org/iod/

Institute for Applied Autonomy http://www.appliedautonomy.com/; iSee http://www.appliedautonomy.com/isee/

Jon Ippolito The Unreliable Archivist http://www.walkerart.org/gallery9/three/

Irational.org http://www.irational.org

Toshio Iwai http://www.iamas.ac.jp/~iwai/iwai_main.html

Mervin Jarman http://www.mongrelx.org

Adriene Jenik Desktop Theater http://www.desktoptheater.org

Natalie Jeremijenko http://entity.eng.yale.edu/nat/; One Tree http://www.onetrees.org/

Lisa Jevbratt http://www.jevbratt.com; 1:1 http://www.c5corp.com/1to1

jodi http://www.jodi.org; My Boyfriend Came Back from the War (Wolfenstein version), SOD http://sod.jodi.org/, Untitled Game http://www.untitled-game.org

Eduardo Kac http://www.ekac.org

Andruid Kerne http://www.andruid.com

John Klima http://www.cityarts.com; Glasbead http://www.glasbead.com

Knowbotic Research http://www.krcf.org/

Joan Leandre Velvet-Strike http://www.opensorcery.net/velvet-strike/

George Legrady http://www.georgelegrady.com/; Pockets Full of Memories http://www.pocketsfullofmemories.com

Golan Levin http://www.flong.com

Olia Lialina http://www.teleportacia.org; My Boyfriend came back from the war/The Last Net Art Museum http://myboyfriendcamebackfromth.ewar.ru

Matt Locke Speakers Corner http://www.speakerscorner.org.uk

Rafael Lozano-Hemmer http://www.lozano-hemmer.com

John Maeda http://www.maedastudio.com/

ManifestAR http://manifestarblog.wordpress.com

Steve Mann http://www.wearcam.org

Jenny Marketou http://www.jennymarketou.com/

Jennifer and Kevin McCoy http://www.mccoyspace.com

Alex McLean http://www.slab.org

Mongrel http://www.mongrelx.org

Brion Moss Impermanence Agent http://www.impermanenceagent.com

Mouchette http://www.mouchette.org

Andreas Müller-Pohle http://www.equivalence.com

Antonio Muntadas The File Room www.thefileroom.org; On Translation: Social Networks http://switch.sjsu.edu/mambo/switch22/on_translation_social_networks.html

Prema Murthy http://www.fakeshop.com

Michael Naimark http://www.naimark.net

Mark Napier http://www.potatoland.org, Riot http://www.potatoland.org/riot

Nettime http://www.nettime.org

Robert Nideffer PROXY http://proxy.arts.uci.edu

Old Boys Network http://www.obn.org

Josh On They Rule http://www.theyrule.net

Dirk Paesmans http://www.jodi.org; My Boyfriend Came Back from the War (Wolfenstein version), SOD http://sod.jodi.org/, Untitled Game http://www.untitled-game.org

W. Bradford Paley *TextArc* http://www.textarc.org

Will Pappenheimer http://www.willpap-projects.com/

ParkBench http://www.cat.nyu.edu/parkbench/index.html

Nancy Paterson http://nancy.thecentre.centennialcollege.ca

Scott Paterson http://sgp-7.net

Eric Paulos *PRoP, Personal Roving Presence* http://www.prop.org

Marco Peljhan *Makrolab* http://makrolab.ljudmila.org

Richard Pierre-Davis http://www.mongrelx.org

Simon Pope http://www.backspace.org/iod/

Preemptive Media (Beatriz da Costa, Heidi Kumao, Jamie Schulte & Brooke Singer) *Zapped!* http://www.zapped-it.net/

Sherrie Rabinowitz http://www.ecafe.com/

Radical Software Group (RSG) *Carnivore* http://www.rhizome.org/carnivore

Tom Ray *Tierra* http://www.isd.atr.co.jp/~ray/tierra/

Michael Rees http://www.michaelrees.com

Kenneth Rinaldo http://www.accad.ohio-state.edu/~rinaldo

David Rokeby http://homepage.mac.com/davidrokeby/home.html

®Tmark http://www.rtmark.com/

Teri Rueb http://www.terirueb.net/

Annina Rüst *Sinister Social Network* http://www.sinister-network.com

Warren Sack *Conversation Map* http://www.sims.berkeley.edu/~sack/CM/publications.html; *Agonistics: A Language Game* http://www.whitney.org/arport/gatepages/april05.shtml

Anne-Marie Schleiner *Velvet-Strike* http://www.opensorcery.net/velvet-strike/

Lilian Schwartz http://www.lillian.com

Second Front http://slfront.blogspot.com/

Q.S. Serafijn and Lars Spuybroek *D-tower* http://www.d-toren.nl/

Marie Sester http://www.sester.net

Jeffrey Shaw http://www.jeffrey-shaw.net

Alexei Shulgin http://www.easylife.org

John F. Simon, Jr. http://www.numeral.com

Karl Sims *Galapagos* http://www.genarts.com/galapagos/index.html

David Small http://www.davidsmall.com

Scott Snibbe http://www.snibbe.com

Nina Sobell *Alice sat here* http://www.cat.nyu.edu/parkbench/alice

Sommerer and Mignonneau http://www.iamas.ac.jp/~christa/index.html

Stelarc http://www.stelarc.va.com.au

Stahl Stenslie http://www.stenslie.net/stahl/

Storyspace http://www.eastgate.com

Wolfgang Strauss http://maus.gmd.de/imk_web-pre2000/people/strauss.mhtml; *Liquid Views* http://on1.zkm.de/zkm/werke/LiquidViews

Surveillance Camera Players http://www.notbored.org/the-scp.html

Michelle Teran http://www.ubermatic.org/misha/index.html

The THING http://bbs.thing.net

Tamiko Thiel http://mission.base.com/tamiko/

Thomson & Craighead http://www.thomson-craighead.net

Helen Thorington *Adrift* http://www.turbulence.org/adrift/

Brad Troemel http://main.bradtroemel.com/

Tsunamii.net (Charles Lim, Tien Woon, Tay Hak Peng, Charles Moy, Melvin Phua, Tan Kok Yam) http://www.tsunamii.net/

Urban Atmospheres http://www.urban-atmospheres.net/

Camille Utterback http://www.camilleutterback.com

Victoria Vesna http://vv.arts.ucla.edu/; *Bodies, Inc.* http://www.bodiesinc.ucla.edu; *n0time* http://notime.arts.ucla.edu

Marek Walczak http://www.mw2mw.com; *Adrift* http://www.turbulence.org/adrift/; *Apartment* http://www.turbulence.org/Works/apartment/

Angie Waller *Myfrienemies.com* http://www.myfrienemies.com

Adrian Ward http://www.adeward.com; *Auto-Illustrator* http://www.auto-illustrator.com/

Noah Wardrip-Fruin *Impermanence Agent* http://www.impermanenceagent.com

Martin Wattenberg http://www.mw2mw.com; *Apartment* http://www.turbulence.org/Works/apartment

Grahame Weinbren http://www.grahameweinbren.com

Duane Whitehurst *Impermanence Agent* http://www.impermanenceagent.com

Maciej Wisniewski *netomat™* http://www.netomat.net

Adrianne Wortzel *Camouflage Town* http://www.camouflagetown.tv

Matsuo Yokoji http://www.mongrelx.org

Ricardo Miranda Zuñiga http://www.ambriente.com

Marina Zurkow http://www.o-matic.com/

Digital arts organizations and networks, galleries, and archives

Archive of Digital Art, Austria, https://www.digitalartarchive.at/nc/home.html

Arshake, Italy, http://www.arshake.com/en/

Art Center Nabi, South Korea, http://www.nabi.or.kr

Artport, Whitney Museum of American Art Portal to Net Art, USA, http://artport.whitney.org

ASCI (Art & Science Collaborations, Inc.), USA, http://www.asci.org/

BANFF Centre New Media Institute, Canada, http://www.banffcentre.ca/bnmi/

Beall Center for Art + Technology, Irvine, California, http://beallcenter.uci.edu/

Bitforms, USA, http://www.bitforms.com

Borusan Contemporary, Turkey, http://www.borusancontemporary.com/current-exhibitions.aspx

Boston Cyberarts Gallery, USA, http://gallery.bostoncyberarts.org/

C3 Center for Culture and Communication, Hungary, http://www.c3.hu

Carroll/Fletcher, UK, http://www.carrollfletcher.com

CRUMB (Curatorial Resource for Upstart Media Bliss), UK, http://www.newmedia.sunderland.ac.uk/crumb

DAM (Digital Art Museum), Berlin,

Germany, http://www.dam.org/

Digital Craft, Museum of Applied Arts Frankfurt, Germany, http://www.digitalcraft.org

Edith Russ Site for Media Art, Germany, http://www.edith-russ-haus.de

Eyebeam, USA, http://www.eyebeam.org

Faces, http://www.faces-l.net

FACT (Film, Art & Creative Technology), UK, http://www.fact.co.uk

Franklin Furnace, USA, http://www.franklinfurnace.org

Harvestworks Media Arts Center, USA, http://www.harvestworks.org

IAMAS (Institute of Advanced New Media Arts and Sciences), Japan, http://www.iamas.ac.jp/

InterCommunication Center (ICC), Japan, http://www.ntticc.or.jp

ISEA (International Symposium on Electronic Arts), UK, http://www.isea-web.org

Java Museum, http://www.javamuseum.org

Laboral Centre for Art and Industrial Creation, Gijon, Asturias, Spain, http://www.laboralcentrodearte.org

Leonardo/International Society for the Arts, Sciences and Technology, http://mitpress2.mit.edu/e-journals/Leonardo/index.html

Ljubljana Digital Media Lab, http://www.ljudmila.org

MECAD (Media Centre of Art & Design), Spain, http://www.mecad.org

Media Art Net, Germany, http://www.medienkunstnetz.de/mediaartnet/

Medialab Madrid, Spain, http://www.medialabmadrid.org/

Nettime, http://www.nettime.org

Netzspannung, Germany, http://netzspannung.org/index_en_static.html

New Media Scotland, http://www.mediascot.org

Postmasters Gallery, USA, http://www.postmastersart.com

Rhizome, USA, http://www.rhizome.org

Run Me Software Art Repository, http://runme.org/

SFMOMA e-space, http://www.sfmoma.org/espace/espace_overview.html

SIGGRAPH (Special Interest Group for Graphics of the Association for Computing Machinery, USA, http://www.siggraph.org/

Tate Webart, UK, http://www.tate.org.uk/webart/

The THING, USA, http://post.thing.net

Turbulence, USA, http://turbulence.org

V2_Organisation, Institute for the Unstable Media, Netherlands, http://www.v2.nl

Walker Art Center Gallery 9, USA, http://gallery9.walkerart.org

Web Net Museum, France, http://webnetmuseum.org/

xpo Gallery, France, http://www.xpogallery.com/en/

ZKM (Zentrum für Kultur und Medien/ Center for Culture and Media), Germany, http://www.zkm.de

Digital art festivals

01SJ, ZER01 global festival of art on the edge, San Jose, CA, USA, http://www.01sj.org/

Abandon Normal Devices, UK, http://www.andfestival.org.uk/

Ars Electronica, Linz, Austria,

http://www.aec.at
Boston Cyberarts Festival, Boston, USA, http://www.bostoncyberarts.org
Click Festival, Denmark, http://clickfestival.dk/location
DEAF (Dutch Electronic Arts Festival), Rotterdam, Netherlands, http://deaf.v2.nl
EMAF (European Media Arts Festival), Osnabrück, Germany, http://www.emaf.de
Future Everything, UK, http://futureeverything.org/festival/
ISEA (Inter-Society for the Electronic Arts), Canada, http://www.isea-web.org
Multimedia Art Asia Pacific, http://www.maap.org.au/
Next 5 Minutes, Netherlands, http://www.n5m.org
Read_Me Festival, http://www.m-cult.org/read_me/
Re-New, Denmark, http://re-new.org/
Stuttgarter Filmwinter, Festival for Expanded Media, Stuttgart, Germany, http://www.filmwinter.de
Transitio MX Festival for Electronic Arts, Mexico City, Mexico, http://transitiomx.net/index_en.html
Transmediale, Berlin, Germany, http://www.transmediale.de

Select new media art exhibitions

'Computer-generated pictures', Howard Wise Gallery, New York, 1965
'Computergrafik', Galerie Wendelin Niedlich, Stuttgart, Germany, 1965
'Generative Computergrafik', Technische Hochschule Stuttgart, Germany, 1965
'Cybernetic Serendipity', curated by Jasia Rechardt, Institute of Contemporary Art, London, 1968
'Software', curated by Jack Burnham, Jewish Museum, New York, 1970
'Electronic Print', curated by Martin Reiser, Arnolfini Museum, Bristol, UK, 1989
'New York Digital Salon' (annual exhibition), School of Visual Arts, New York, 1992–present
'Mediascape', curated by John Hanhardt and Jon Ippolito, Guggenheim Museum SoHo, New York, 1996
'Serious Games: Art Interaction Technology', curated by Beryl Graham, Laing Art Gallery, Newcastle/Barbican Art Gallery, London, 1996–7, http://www.sunderland.ac.uk/~as0bgr/serious/index.htm
'PORT: Navigating Digital Culture', curated by Robbin Murphy and Remo Campopiano, MIT List Visual Arts Center, Massachusetts, 1997, http://artnetweb.com/port/
'Beyond Interface', curated by Steve Dietz, Walker Art Center, Minneapolis, Minnesota, 1998, http://www.archimuse.com/mw98/beyondinterface/
'Portable Sacred Grounds: Telepresence World', curated by Toshiharu Itoh, 1998
'Adding Media Subtracting Signs', ICC Tokyo, 1999
'Contact Zones: The Art of CD-ROM', curated by Timothy Murray, Cornell University, New York, 1999, http://contactzones.cit.cornell.edu/
'Cracking the Maze: Game Plug-ins and Patches as Hacker Art', curated by Anne-Marie Schleiner, 1999, http://switch.sjsu.edu/CrackingtheMaze
'Digital Bauhaus', curated by Toshiharu Itoh, ICC Tokyo, 1999
'net_condition', curated by Peter Weibel, Walter van der Cruijsen, Johannes Goebel, Hans-Peter Schwarz, Jeffrey Shaw, Golo Föllmer, Benjamin Weil, ZKM, Germany, 1999, http://on1.zkm.de/netCondition.root/netcondition/start/language/default_e
'Shock of the View', Walker Art Center in collaboration with the Davis Museum and Cultural Center, Wellesley College, San Jose Museum of Art, the Wexner Center for the Arts, Ohio State University, and Rhizome, 1999, http://www.walkerart.org/salons/shockoftheview/
'Alien Intelligence', curated by Erkki Huhtamo, Kiasma Museum of Contemporary Art, Helsinki, Finland, 2000
'Art Entertainment Network', curated by Steve Dietz, Walker Art Center, Minneapolis, Minnesota, 2000, http://aen.walkerart.org/
'Media City Seoul Biennial', Seoul Museum of Art, South Korea, 2000 and 2002
'New Media New Face', ICC, Tokyo, 2000, 2001, 2002
'Paradise Now: Picturing the Genetic Revolution', curated by Marvin Heiferman and Carole Kismaric, Exit Art, New York, 2000, http://www.geneart.org/pn-home.htm
'Refresh: The Art of the Screen Saver', curated by James Buckhouse, Iris and B. Gerald Cantor Center for Visual Arts at Stanford, California, 2000
'Shift Control', curated by Antoinette LaFarge and Robert Nideffer, University of California at Irvine, 2000, http://beallcenter.uci.edu/shift/home.html
'Through the Looking Glass', curated by Patrick Lichty, Beachwood Center for the Arts, Beachwood, Ohio, 2000, http://www.voyd.com/ttlg/
'vision.ruhr', curated by Axel Wirths, Westfälisches Industriemuseum Zeche Zollern II/IV and Museum am Ostwall, Dortmund, Germany, 2000
'010101: Art in Technological Times', curated by Aaron Betsky, Janet Bishop, Kathleen Forde, John S. Weber, Benjamin Weil, San Francisco Museum of Modern Art, 2001, http://010101.sfmoma.org
'BitStreams', curated by Lawrence Rinder and Debra Singer, Whitney Museum of American Art, New York 2001, http://www.whitney.org/bitstreams
'::contagion::', curated by Linda Wallace, The New Zealand Film Archive, 2001, http://www.filmarchive.org.nz/viewing/fc_past_exhibits.html#contagion
'Credit Game', curated by Hiroshi Masuyama, ICC, Tokyo, 2001, http://www.ntticc.or.jp/Calendar/2001/Credit_Game/index.html
'Data Dynamics', curated by Christiane Paul, Whitney Museum of American Art, New York, 2001, http://artport.whitney.org/exhibitions/past-exhibitions.shtml
'Digital Printmaking Now', curated by Marilyn S. Kushner, Brooklyn Museum of Art, New York, 2001
'Game Show', MASS MoCA, Massachusetts, 2001–2
'[re]distributions', curated by Patrick Lichty, 2001, http://www.voyd.com/ia
'telematic connections: the virtual embrace', curated by Steve Dietz, travelling exhibition, 2001, http://telematic.walkerart.org/
'Under_score, Net art, Sound and Essays from Australia', curated by Wayne Ashley, Brooklyn Academy of Music, New York, 2001
'Ctrl [Space], Rhetorics of Surveillance from Bentham to Big Brother', curated by Thomas Y. Levin, ZKM, Karlsruhe, Germany, 2001–2, http://ctrlspace.zkm.de/e/
'Animations', curated by Carolyn Christov-Bakargiev, Larissa Harris, Anthony Huberman, PS1, New York, 2002, http://www.ps1.org/cut/animations/main.html
'CODeDOC', curated by Christiane Paul, Whitney Museum of American Art's 'artport', 2002, http://artport.whitney.org/commissions/codedoc/
'Future Cinema: The Cinematic Imaginary after Film', curated by Jeffrey Shaw and Peter Weibel, ZKM, Germany, 2002, http://www.zkm.de/futurecinema/
'I love you - computer_viruses_hacker_culture', curated by Franziska Nori, Museum of Applied Arts Frankfurt, Germany, 2002, http://www.digitalcraft.org/index.php?artikel_id=283
'net.narrative', curated by Marisa Olsen, SF Cameraworks, San Francisco, 2002
'Open_Source_Art_Hack', curated by Steve Dietz and Jenny Marketou, The New Museum, New York, 2002, http://www.netartcommons.net
'Special Effects', curated by Lawrence Rinder, Daejeon Municipal Museum of Art, Daejeon, South Korea, 2002
'Web as Canvas', curated by Roberta Bosco and Stefano Caldana, Art Futura 2002, Barcelona, http://www.artfutura.org/expo_lared_e.html
'Plaything', Firstdraft Gallery, Sydney, Australia, 2003
'(re:Play)', curated by Radioqalia, Institute for Contemporary Art, Cape Town, South Africa, 2003, http://www.radioqualia.net/replay
'Translocations', curated by Steve Dietz, Walker Art Center, Minneapolis, Minnesota, 2003, http://translocations.walkerart.org
'Killer Instinct', curated by Anne Barlow and Rachel Greene, New Museum of Contemporary Art, New York, 2003–4
'Bang the Machine: Computer Gaming Art and Artifacts', Yerba Buena Center for the Arts, San Francisco, 2004, http://www.ybca.org/exhibitions/archive/
'Database Imaginary', curated by Sarah Cook and Steve Dietz, Banff Center, Canada, 2004, http://databaseimaginary.banff.org
'Game as Critic as Art', curated by Laura Baigorri, Mediateca Caixaforum, Spain, 2006, http://www.mediacaonline.net/jocs/
'Algorithmic Revolution. On the History of Interactive Art', curated by Peter Weibel, Dominika Szope, Katrin Kaschadt, Margit Rosen, Sabine Himmelsbach, ZKM, Karlsruhe, Germany, 2004, http://on1.zkm.de/zkm/stories/storyReader$4189
'Game/Play', Q Arts, Derby, & HTTP Gallery, London, 2006, http://blog.game-play.org.uk/
'Next Level: Art, Games & Reality', Stedelijk Museum, Amsterdam,

Netherlands, 2006, http://www.stedelijk.nl/oc2/page.asp?pageid=1334&url=/detectflash.asp

'Feedback', curated by Christiane Paul and Jemima Rellie with Charlie Gere, Laboral Centre for Art and Industrial Creation, Gijon, Asturias, Spain, 2007, http://www.laboralcentrodearte.org/en/exposiciones/feedback

'Games: Computergames by artists', curated by Tilman Baumgärtel, Hans Christ, Iris Dressler, hartware, Dortmund, Germany, 2007, http://www.hartware-projekte.de/programm/inhalt/games_e.htm

'Google Art, or How to Hack Google', curated by Ana Otero for Rhizome.org, New York, 2007, http://rhizome.org/art/exhibition/googleshow/

'My Own Private Reality', curated by Sarah Cook and Sabine Himmelsbach, Edith Russ Haus für Medienkunst, Oldenburg, Germany, 2007, http://myownprivatereality.wordpress.com/

'Ecomedia - Ecological Strategies in Today's Art', Edith Russ Haus für Medienkunst, Oldenburg, Germany, 2007–8, http://www.edith-russ-haus.de/english/ecomedia.html

'Synthetic Times: Media Art China 2008', curated by Zhang Ga, National Art Museum of China, Beijing, China, 2008, http://mediartchina.org/

'Feedforward – The Angel of History', crated by Steve Dietz and Christiane Paul, Laboral Centre for Art and Industrial Creation, Gijon, Asturias, Spain, 2009, http://www.laboralcentrodearte.org/en/exposiciones/feedforward.-el-angel-de-la-historia

'Cory Arcangel: Pro Tools', curated by Christiane Paul, Whitney Museum of American Art, New York, USA, 2011, http://whitney.org/Exhibitions/CoryArcangel/

'transLife: International Triennial of New Media Art', curated by Zhang Ga, National Art Museum of China, Beijing, China, 2008, http://mediartchina.org/

'Digital Art Works The Challenges of Conservation', curated by Bernhard Serexhe, Chiara Marchini Camia, Arnaud Obermann, ZKM, Karlsruhe, Germany, 2011, http://on1.zkm.de/zkm/stories/storyReader$7716

'Art and Artificial Life: VIDA 1999–2012', Espacio Fundación Telefónica, Madrid, Spain, 2012, http://www.fundacion.telefonica.com/en/arte_cultura/exposiciones/2012/vida_1999-2012.htm

'The Algorithm of Manfred Mohr. 1963–now', curated by Margit Rosen, ZKM, Karlsruhe, Germany, 2013, http://on1.zkm.de/zkm/stories/storyReader$8350

'thingworld: International Triennial of New Media Art 2014', curated by Zhang Ga, National Art Museum of China, Beijing, China, 2014, http://mediartchina.org/

'Digital Revolution', curated by Barbican International Enterprises, Barbican Centre, London, UK, 2014, https://www.barbican.org.uk/artgallery/event-detail.asp?ID=15608

Select bibliography

Amerika, Mark, META/DATA: A Digital Poetics (MIT Press: Cambridge, Massachusetts, 2007)

Anders, Peter, 'Anthropic Cyberspace: Defining Electronic Space from First Principles' in Leonardo, vol. 35, no. 1, edited by Christiane Paul (2001)

Anders, Peter, Envisioning Cyberspace, Designing 3D Electronic Spaces (McGraw-Hill: New York, 1999)

Apprich, Clemens, Berry Slater, Josephine, Iles, Anthony and Schultz, Oliver Lerone (eds), Provocative Alloys: A Post-Media Anthology (Post-Media Lab Leuphana University and Mute Books: Lüneburg, Germany / UK, 2013)

Ascott, Roy, and Shanken, Edward A., Telematic Embrace: Visionary Theories of Art, Technology, and Consciousness (University of California Press: Berkeley, California, 2003)

Baumgärtel, Tilman, INSTALL.EXE/JODI (Gva & Frieden: Bremen, 2002)

Baumgärtel, Tilman, net.art: Materialien zur Netzkunst (Institut für moderne Kunst Nürnberg: Nuremburg, 1999)

Beckmann, John (ed.), The Virtual Dimension, Architecture, Representation, and Crash Culture (Princeton Architectural Press: New York, 1998)

Benedikt, Michael (ed.), Cyberspace, First Steps (MIT Press: Cambridge, Massachusetts, 1991)

Benjamin, Walter, 'The Work of Art in the Age of Mechanical Reproduction' in Illuminations, edited by Hannah Arendt (Schocken Books: New York, 1969)

Berners-Lee, Tim, Weaving the Web: The Origins and Future of the World Wide Web (Orion: London, 1999)

Bogost, Ian, Persuasive Games: The Expressive Power of Videogames (MIT Press: Cambridge, Massachusetts, 2007)

Bogost, Ian, Unit Operations: An Approach to Videogame Criticism (MIT Press: Cambridge, Massachusetts, 2006)

Bolter, Jay David, and Grusin, Richard, Remediation: Understanding New Media (MIT Press: Cambridge, Massachusetts, 2000)

Bolter, Jay David, and Gromala, Diane (eds), Windows and Mirrors: Interaction Design, Digital Art, and the Myth of Transparency (MIT Press: Cambridge, Massachusetts, 2003)

Burnett, Ron, How Images Think (MIT Press: Cambridge, Massachusetts, 2005)

Burnham, Jack, 'Real Time Systems' in Artforum, vol. 8, no. 1 (September 1969)

Burnham, Jack, 'Systems Aesthetics' in Artforum, vol. 7, no. 1 (September 1968)

Burnham, Jack, Beyond Modern Sculpture: The Effects of Science and Technology on the Sculpture of This Century (George Braziller: New York, 1968)

Bush, Vannevar, 'As We May Think' in Atlantic Monthly (July 1945), http://www.theatlantic.com/unbound/flashbks/computer/bushf.htm

Chadabe, Joel, Electric Sound, The Past and Promise of Electronic Music (Prentice Hall: Upper Saddle River, New Jersey, 1997)

Cook, Sarah, Graham, Beryl, and Martin, Sarah (eds), Curating New Media: Third Baltic International Seminar (BALTIC: Gateshead, 2002)

Cook, Sarah and Graham, Beryl, Rethinking

Curating: Art after New Media (MIT Press: Cambridge, Massachusetts, 2010)

Cosic, Vuk, net.art per se, book project as part of the Slovenian Pavilion at the 49th Venice Biennale (MGLC: Ljubljana, 2001)

Couchot, Edmond, 'Between the Real and the Virtual' in Annual InterCommunication '94 (ICC: Tokyo, 1994)

Coyne, Richard, Technoromanticism (MIT Press: Cambridge, Massachusetts, 1999)

Cubitt, Sean, The Cinema Effect (MIT Press: Cambridge, Massachusetts, 2004)

Cubitt, Sean and Thomas, Paul (eds), Relive: Media Art Histories (MIT Press: Cambridge, Massachusetts, 2013)

Druckrey, Timothy (ed.), Ars Electronica, Facing the Future, A Survey of Two Decades (MIT Press: Cambridge, Massachusetts, 2001)

Flanagan, Mary, and Booth, Austin (eds), reskin (MIT Press: Cambridge, Massachusetts, 2007)

Flanagan, Mary, and Booth, Austin (eds), Reload, Rethinking Women + Cyberculture (MIT Press: Cambridge, Massachusetts, 2002)

Fuller, Matthew, Media Ecologies: Materialist Energies in Art and Technoculture (MIT Press: Cambridge, Massachusetts, 2005)

Fuller, Matthew (ed.), Software Studies: A Lexicon (MIT Press: Cambridge, Massachusetts, 2008)

Fuller, Matthew, 'Visceral Facades: taking Matta-Clark's crowbar to software', http://bak.spc.org/iod/Visceral.html

Galloway, Alexander and Thacker, Eugene, The Exploit: A Theory of Networks (University of Minnesota Press: Minneapolis, Minnesota, 2007)

Galloway, Alexander, The Interface Effect (Polity Press: Cambridge, UK / Malden, Massachusetts 2012)

Galloway, Alexander, Protocol: How Control Exists After Decentralization (MIT Press: Cambridge, Massachusetts, 2006)

Ghosh, Rishab Aiyer (ed.), CODE: Collaborative Ownership and the Digital Economy (MIT Press: Cambridge, Massachusetts, 2005)

Goldberg, Ken (ed.), The Robot in the Garden: Telerobotics and Telepistemology in the Age of the Internet (MIT Press: Cambridge, Massachusetts, 2000)

Goldberg, Ken, and Siegwart, Roland (eds), Beyond Webcams: An Introduction to Online Robots (MIT Press: Cambridge, Massachusetts, 2001)

Goriunova, Olga, Art Platforms and Cultural Production on the Internet (Routledge: Oxford, UK/New York, 2013)

Graham, Beryl, New Collecting: Exhibiting and Audiences after New Media Art (Ashgate: Surrey, UK, 2014)

Grau, Oliver (ed.), Imagery in the 21st Century (MIT Press: Cambridge, Massachusetts, 2011)

Grau, Oliver (ed.), MediaArtHistories (MIT Press: Cambridge, Massachusetts, 2007)

Grau, Oliver, Virtual Art: From Illusion to Immersion (MIT Press: Cambridge, Massachusetts, 2004)

Hansen, Mark, Bodies in Code: Interfaces with Digital Media (Routledge: London, 2006)

Hansen, Mark, New Philosophy for New Media (MIT Press: Cambridge, Massachusetts, 2006)

Haraway, Donna J., Simians, Cyborgs, and Women: The Reinvention of Nature (Routledge: New York and London, 1991)

Harris, Craig (ed.), *Art and Innovation: The Xerox PARC Artist-in-Residence Program* (MIT Press: Cambridge, Massachusetts, 1999)

Hayles, N. Katherine, *How We Became Posthuman: Virtual Bodies in Cybernetics, Literature, and Informatics* (University of Chicago Press: Chicago, 1999)

Hayles, N. Katherine, *Writing Machines* (MIT Press: Cambridge, Massachusetts, 2002)

Hocks, Mary E., and Kendrick, Michelle R. (eds), *Eloquent Images: Word and Image in the Age of New Media* (MIT Press: Cambridge, Massachusetts, 2005)

Huhtamo, Erkki, *Illusions in Motion: Media Archaeology of the Moving Panorama and Related Spectacles* (MIT Press: Cambridge, Massachusetts, 2013)

Huhtamo, Erkki and Parikka, Jussi (eds), *Media Archaeology: Approaches, Applications, and Implications* (University of California Press: Berkeley, California, 2011)

Ippolito, Jon and Rinehart, Richard, *Re-collection: Art, New Media, and Social Memory* (MIT Press: Cambridge, Massachusetts, 2014)

Jenkins, Henry, and Thorburn, David (eds), *Democracy and New Media* (MIT Press: Cambridge, Massachusetts, 2004)

Kwastek, Katja, *Aesthetics of Interaction in Digital Art* (MIT Press: Cambridge, Massachusetts, 2013)

Landow, George P. (ed.), *Hyper/Text/Theory* (The Johns Hopkins University Press: Baltimore and London, 1994)

Landow, George P., *Hypertext: The Convergence of Contemporary Critical Theory and Technology* (The Johns Hopkins University Press: Baltimore and London, 1992)

Lanier, Jaron, 'Agents of Alienation', http://www.well.com/user/jaron/agentalien.html

Lanier, Jaron, *Who owns the Future?* (Simon & Schuster: New York, 2013)

Levy, Steven, *Artificial Life: A Report from the Frontier Where Computers Meet Biology*, reprint edition (Vintage Books: New York, 1993)

Lovejoy, Margot, Paul, Christiane and Vesna, Victoria (eds), *Context Providers: Conditions of Meaning in Media Arts* (Intellect / University of Chicago Press: Chicago, Illinois, 2011)

Lovejoy, Margot, *Postmodern Currents: Art and Artists in the Age of Electronic Media*, revised edition (Prentice Hall: Upper Saddle River, New Jersey, 1996)

Lovink, Geert, *Dark Fiber: Tracking Critical Internet Culture* (MIT Press: Cambridge, Massachusetts, 2002)

Lovink, Geert, *Uncanny Networks: Dialogues with the Virtual Intelligentsia* (MIT Press: Cambridge, Massachusetts, 2003)

Lunenfeld, Peter (ed.), *The Digital Dialectic: New Essays on New Media* (MIT Press: Cambridge, Massachusetts, 1999)

Lunenfeld, Peter, *Snap to Grid: A User's Guide to Digital Arts, Media, and Cultures* (MIT Press: Cambridge, Massachusetts, 2000)

Manovich, Lev, *The Language of New Media* (MIT Press: Cambridge, Massachusetts, 2002)

Manovich, Lev, *Software Takes Command* (Bloomsbury Academic: New York, London, New Delhi, and Sydney, 2013)

Mitchell, William J., *City of Bits: Space, Place and the Infobahn* (MIT Press: Cambridge, Massachusetts, 1995)

Mitchell, Robert, and Turtle, Phillip (eds), *Data Made Flesh, Embodying Information* (Routledge: New York, 2004)

Moser, Mary Anne, and MacLeod, Douglas (eds), *Immersed in Technology: Art and Virtual Environments* (MIT Press: Cambridge, Massachusetts, 1995)

Munster, Anna, *Materializing New Media: Embodiment in Information Aesthetics* (Dartmouth College Press: Lebanon, New Hampshire, 2006)

Murray, Janet Horowitz, *Hamlet on the Holodeck: The Future of Narrative in Cyberspace* (MIT Press: Cambridge, Massachusetts, 1998)

Nelson, Theodor, *Computer Lib/Dream Machines* (Tempus Books: Redmond, Washington, 1987)

Nelson, Theodor, *Literary Machines* (Mindful Press: Sausalito, California, 1982)

Packer, Randall, and Jordan, Ken (eds), *Multimedia: From Wagner to Virtual Reality*, expanded edition (W. W. Norton & Company: New York, 2002)

Parikka, Jussi, *What is Media Archaeology?* (Polity Press: Cambridge, UK / Malden, Massachusetts 2012)

Paul, Christiane (ed.), *New Media in the White Cube and Beyond* (University of California Press: Berkeley, California 2008)

Popper, Frank, *Origins and Development of Kinetic Art* (Studio Vista: London, 1968)

Quaranta, Domenico, *Beyond New Media Art* (Link Editions: Brescia, Italy, 2013)

Reas, Casey, and Fry, Ben, *Processing: A P Programming Handbook for Visual Designers and Artists* (MIT Press: Cambridge, Massachusetts, 2007)

Rheingold, Howard, *The Virtual Community: Homesteading on the Electronic Frontier*, revised edition (MIT Press: Cambridge, Massachusetts, 2000)

Schwarz, Hans-Peter, *Media Art History, Media Museum ZKM, Karlsruhe* (Prestel: Munich and New York, 1997)

Shanken, Edward, *Art and Electronic Media* (Phaidon Press: London, UK, 2009)

Shaw, Jeffrey, and Weibel, Peter (eds), *Future Cinema: The Cinematic Imaginary After Film* (MIT Press: Cambridge, Massachusetts, 2003)

Stone, Allucquere Rosanne, *The War of Desire and Technology at the Close of the Mechanical Age* (MIT Press: Cambridge, Massachusetts, 1995)

Stubbs, Phoebe (ed.), *Art and the Internet* (Blackdog Publishing: London, UK, 2014)

Turing, Alan, and Ince, D. C. (ed.), *Collected Works of A. M. Turing: Mechanical Intelligence* (North-Holland: New York, 1992)

Turkle, Sherry, *Alone Together* (Basic Books: New York, 2011)

Turkle, Sherry, *Life on the Screen: Identity in the Age of the Internet* (Simon & Schuster: New York, 1995)

Vesna, Victoria (ed.), *Database Aesthetics: Art in the Age of Information Overflow* (University of Minnesota Press: Minneapolis, Minnesota, 2007)

Wardrip-Fruin, Noah, and Harrigan, Pat (eds), *First Person: New Media as Story, Performance, and Game* (MIT Press: Cambridge, Massachusetts, 2006)

Wardrip-Fruin, Noah, and Montfort, Nick, *The New Media Reader* (MIT Press: Cambridge, Massachusetts, 2003)

Weibel, Peter, and Druckrey, Timothy (eds), *net.condition: art and global media* (MIT Press: Cambridge, Massachusetts, 2001)

Weizenbaum, Joseph, *Computer Power and Human Reason: From Judgment to Calculation* (W. H. Freeman: San Francisco, California, 1976)

Wiener, Norbert, *Cybernetics: Or Control and Communication in Animal and the Machine*, second edition (MIT Press: Cambridge, Massachusetts, 1965)

Wilson, Stephen, *Information Arts: Intersections of Art, Science, and Technology* (MIT Press: Cambridge, Massachusetts, 2001)

Youngblood, Gene, *Expanded Cinema* (E. P. Dutton: New York, 1970)

List of illustrations

Dimensions of works are given in centimetres and inches, height before width.

Lazzarini, *skull*, 2000. Resin, bone, pigment, 33 × 12.7 × 15.2 (13 × 5 × 6). Courtesy Whitney Museum of American Art, photo John Berens. **63** Michael Rees, *Anja Spine Series 5*, 1998. Polycarbonate sintered plastic, 50.8 (20) high. Process: selective laser sintering. **64a** Michael Rees, *A Life Series 002*, 2002. Digital sculpture. **64b** Michael Rees, *A Life movie (monster Series)*, 2002. Digital animation. **65** Karin Sander, *Bernhard J. Deubig 1:10*, 1999. Three-dimensional bodyscan of the original person, FDM (Fused Deposition Modelling), rapid prototyping, ABS (Acrylonitrile – Butadiene – Styrene) plastic, airbrush. Courtesy of the artist and D'Amelio Terras, New York. **66** Jim Campbell, *5th Avenue Cutaway #2*, 2001. Custom electronics, 768 LEDs, plexiglas, 60 × 80 × 5 (23⅝ × 31½ × 2). With the financial assistance of The Daniel Langlois Foundation for Art, Science and Technology. Courtesy of the artist. **67** John F. Simon Jr, *Color Panel v1.0*, 1999. Software, Apple Powerbook 280c and acrylic, edition of twelve, 34.3 × 26.7 × 7.6 (13½ × 10½ × 3). Courtesy of the artist and Sandra Gering Gallery, New York. **68** Jeffrey Shaw, *The Legible City (Manhattan)*, 1989. Digital installation. Courtesy of the artist. **69** Jeffrey Shaw, *The Distributed Legible City*, 1998. Digital installation. Courtesy of the artist. **70a** Rafael Lozano-Hemmer, with Will Bauer and Susie Ramsay, *Displaced Emperors (Relational Architecture #2)*, 1997. Intervention on the Habsburg Castle in Linz, Austria. Photo Dietmar Tollerind. **71** Rafael Lozano-Hemmer, *Vectorial Elevation (Relational Architecture #4)*, 2002. New version of the telematic installation for the Artium Square in the city of Vitoria, Basque Country. Light sculptures submitted by participants on the net and rendered in the sky by eighteen robotic searchlights. The website www.alzado.net contains all the archived designs. Photo David Quintas. **72** Erwin Redl, *Shifting, Very Slowly*, 1998–9. Computer-controlled LED light installation exhibition image, 444, Apex Art, New York, 1219.2 × 762 × 487.7 (40 ft × 25 ft × 16 ft). Courtesy of Erwin Redl. **73** Erwin Redl, *MATRIX IV*, 2001. LED light installation exhibition image, 'Creative Time – Massless Medium: Explorations in Sensory Immersion', Brooklyn Anchorage, Brooklyn, New York, 1524 × 1524 × 609 (50 ft × 50 ft × 20 ft). Courtesy of Erwin Redl. **74** Asymptote, *Fluxspace 3.0 Mscape City*, 2002. Digital installation. Photo Christian Richters. **75** Masaki Fujihata, *Global Interior Project*, 1996. Interactive digital installation. Masaki Fujihata and Keio University. **76a, b** Polar, Artlab 10, Hillside plaza, Tokyo, Marko Peljhan in collaboration with Carsten Nicolai, 2000. **77** Jesse Gilbert, Helen Thorington, and Marek Walczak, with Hal Eager, Jonathan Feinberg, Mark James and Martin Wattenberg, *Adrift*, 1997–2001. Multimedia installation. Images from *Adrift* (2000) by Helen Thorington and Marek Walczak. **78** Knowbotic Research, *Dialogue with the Knowbotic South*, 1994–97. Interactive digital installation. **79** Knowbotic Research, *10_dencies*, 1997–99. Interactive digital installation and website. **80** Perry Hoberman, *Cathartic User Interface*, 1995/2000. Digital installation. **81** Perry Hoberman, *Bar Code Hotel*, 1994. Interactive digital projection. **82** Perry Hoberman, *Timetable*, 1999. Interactive digital projection. **83** Bill Seaman with Gideon May, *The World Generator/The Engine of Desire* (details generated with VR installation), c. 1995–present. Interactive digital projection. Funded in part by the Australian Film Commission. **84** Bill Seaman with Todd Berreth, *An Engine of Many Senses*, 2013. Generative installation, sample video/audio output from real-time engine (32:9 aspect ratio for two screens), custom software written in C++/OpenGL, digital video/audio source material. Courtesy Bill Seaman. **85** Jeffrey Shaw, *The Golden Calf*, 1994. Virtual sculpture installation. Courtesy of the artist. **86** Michael Naimark, *Be Now Here*, 1995–7. Interactive digital projection. Photo Composite Ignazio Morresco. **87** Jeffrey Shaw, *Place, a user's manual*, 1995. Interactive digital projection. Courtesy of the artist. **88** Luc Courchesne, *The Visitor – Living by Numbers*, 2001. Interactive digital projection. Photo Richard-Max Tremblay. **89** Rafael Lozano-Hemmer, *Body Movies (Relational Architecture #6)*, 2001.. Installation at the Schouwburg Square in Rotterdam featuring 1,200 square metres of interactive projections. Photo Arie Kievit. **90** Jennifer and Kevin McCoy, *Every Shot Every Episode*, 2001. Mixed media sculpture with electronics, custom video playback unit, 40.6 × 50.8 × 5.1 (16 × 20 × 2) with 275 video discs, edition of five + AP. Courtesy of Postmasters Gallery, New York. **91** Jennifer and Kevin McCoy, *How I learned*, 2002. Mixed media sculpture with electronics, 91.4 × 142.2 × 17.8 (36 × 57 × 7), edition of four + AP. Courtesy of Postmasters Gallery, New York. **92** Jim Campbell, *Hallucination*, 1988–90. Video installation. Courtesy of the artist. **93** Wolfgang Staehle, *Empire 24/7*, 2001. Video installation. Courtesy of the artist. **94** Grahame Weinbren, *Sonata*, 1991–3. Video screen grab from *Sonata*. © Grahame Weinbren. **95** Toni Dove, stills from the project *Artificial Changelings*, 1998. Interactive digital projection. Courtesy of Toni Dove, Bustlelamp Productions, Inc.. **96** Toni Dove, *Spectropia*, 2008. Live mix interactive cinema performance at the Experimental Media and Performing Arts Center, Troy, New York. Courtesy of Toni Dove. **97** David Blair, *WAXWEB*, 1993. Interactive online feature film. Courtesy of David Blair. **98** Nick Crowe, *Discrete Packets*, 2000. Interactive website. Courtesy of Nick Crowe. **99** Philippe Parreno and Pierre Huyghe, *No Ghost, Anywhere out of the World*, 2000. Digital animation. Courtesy Air de Paris. **100** Oliana Lialina, *Summer*, HTML, GIF. Courtesy of Oliana Lialina **101** Olia Lialina, *My Boyfriend Came Back from the War*, 1996. Interactive website. Courtesy of Olia Lialina. **102** Jon Ippolito, Janet Cohen, and Keith Frank, *The Unreliable Archivist*, 1998. Interactive website. Courtesy of the artists. **103** Thomson & Craighead, *CNN Interactive Just Got More Interactive*, 1999. Interactive installation and website. Courtesy Mobile Home, London. **104** I/O/D, *Webstalker*, 1997– present. Alternative web browser. **105** Maciej Wisniewski, *netomat'*, 1999. Alternative web browser. Courtesy of the artist. **106** Mark Napier, *Riot*, 1999. Alternative web browser. www.potatoland. org/riot. **107** Adriene Jenik, Lisa Brenneis, and the Desktop Theater Troupe, *Desktop Theater*, 1997–present. Interactive website.

Production *waitingforgodot.com*, premiered live at the Second Annual Digital Storytelling Conference, September 1997. didi: Lisa Brenneis, gogo: Adriene Jenik, extras: The Palacians, graphics: Adriene Jenik and Lisa Brenneis, bg graphics: Jim Bumgarten, screen capture: Lisa Brenneis, 1997. **108** tsunamii.net, *alpha 3.4*, 2002. Multimedia installation. Photo Werner Maschmann. **109** James Buckhouse in collaboration with Holly Brubach, *Tap*, 2002. Sketch of a dancer from *Tap* performing on a PDA (personal digital assistant). **110a** Charlotte Davies, *Shadow Screen*. Immersant behind shadow screen during live performance of immersive virtual reality environment, *Ephémère*, 1998. **110b** Charlotte Davies, *Tree Pond*. Digital frame captured in real-time through HMD (head-mounted display) during live performance of immersive virtual reality environment, *Osmose*, 1995. **110c** Charlotte Davies, *Forest Grid*. Digital frame captured in real-time through HMD (head-mounted display) during live performance of immersive virtual reality environment, *Osmose*, 1995. **111a** Charlotte Davies, *Summer Forest*. Digital frame captured in real-time through HMD (head-mounted display) during live performance of immersive virtual reality environment, *Ephémère*, 1998. **111b** Charlotte Davies, *Seeds*. Digital frame captured in real-time through HMD (head-mounted display) during live performance of immersive virtual reality environment, *Ephémère*, 1998. **112** Jeffrey Shaw, *EVE*, 1993. Virtual reality interactive environment. Courtesy of the artist. **113** Agnes Hegedüs, *Memory Theater VR*, 1997. Interactive environment. © Agnes Hegedüs, Media Museum, ZKM Center for Art and Media, Karlsruhe. **114** Tamiko Thiel and Zara Houshmand, *Beyond Manzanar*, 2000. Interactive digital projection. © 2000 Tamiko Thiel and Zara Houshmand. **115** Peter d'Agostino, *VR/RV: A Recreational Vehicle in Virtual Reality*, 1993. Collection of the artist. © 1993, Peter d'Agostino. (The video version is distributed by Electronic Arts Intermix, New York, © 1994). **116** Golan Levin, *Scribble*, 2000. An audio-visual performance at Ars Electronica 2000 conducted on custom software by Golan Levin. Performers (left to right): Scott Gibbons, Gregory Shakar, Golan Levin. Photo Pascal Maresch. **117** John Klima, *Glasbead*, 1999. Multi-user collaborative musical interface. Courtesy of Postmasters Gallery, New York. **118** Golan Levin, *Telesymphony*, 2001. Premiere concert performed at Ars Electronica 2001. Performers (left to right): Gregory Shakar, Scott Gibbons, Golan Levin. Photo Pascal Maresch. **119** Chris Chafe and Greg Niemeyer, *Ping*, 2001. Digital sound installation. © Chris Chafe and Greg Niemeyer, 2001. **120** Toshio Iwai, *Piano – as image media*, 1995. Digital sound installation. Produced at the Artist in Residence program of the Institute for Image Media, ZKM Center for Art and Media, Karlsruhe. © 1995 Toshio Iwai. **121** Karl Sims, images from *Galápagos*, 1997. Interactive digital installation. **122** Christa Sommerer and Laurent Mignonneau, *A-Volve*, 1994. Interactive computer installation. Supported by NTT-ICC Japan and NCSA, USA, © 1994. **123** Christa Sommerer and Laurent Mignonneau, *Life Spaces*, 1997. Online

artificial life environment. Collection of the NTT-ICC Museum, Japan, © 1997. **124** Christa Sommerer and Laurent Mignonneau, *Interactive Plant Growing*, 1992. Interactive computer installation. Collection of the Media Museum, ZKM Center for Art and Media, Karlsruhe © 1992. **125** Thomas Ray, *Tierra*, 1998. Computer software program. Courtesy of Tom Ray. **126** Rebecca Allen, *Emergence: The Bush Soul (#3)*, 1999. Computer software program. Rebecca Allen and the Emergence Team. **127** Kenneth Rinaldo, *Autopoesis*, 2000. Digital sculpture installation. Alien Intelligence exhibition, Museum of Contemporary Art Kiasma, Helsinki, 2000. Photo Central Art Archives/ Petri Virtanen, Eweis Yehia. **128** Ken Feingold, *Self-Portrait as the Center of the Universe*, 1998–2001. Silicone, pigment, fibreglass, steel, electronics, digital projection, puppets, dimensions variable. Courtesy Postmasters Gallery, New York. Photo Patterson Beckwith. **129** Ken Feingold, *Sinking Feeling*, 2001. Silicone, pigment, fibreglass, steel, electronics, digital projection, 38.1 × 45.7 × 132.1 (15 × 18 × 52). Courtesy of Postmasters Gallery, New York. **130** Ken Feingold, *If/Then*, 2001. Silicone, pigment, fibreglass, steel, electronics, 61 × 71.1 × 61 (24 × 28 × 24). Private collection, USA. **131** David Rokeby, *Giver of Names*, 1991–present. Interactive digital installation. Photo Robert Keziere. **132** Noah Wardrip-Fruin, Adam Chapman, Brion Moss, and Duane Whitehurst, *The Impermanence Agent*, 1998–present. Software agent program. The Impermanence Agent Project. **133** Robert Nideffer, *PROXY*, 2001. Software agent program. Courtesy of the artist. **134** Ken Goldberg and Joseph Santarromana, *Telegarden*, 1995–2004. Interactive telematic installation, accessible at http://telegarden.aec.at. Co-directors: Ken Goldberg and Joseph Santarromana. Project team: George Bekey, Steven Gentner, Rosemary Morris, Carl Sutter, Jeff Wiegley, Erich Berger. Photo Robert Wedemeyer. **135** Ken Goldberg, *Mori*, 1999–present. Internet-based earthwork. Project team: Ken Goldberg, Randall Packer, Gregory Kuhn, and Wojciech Matusik. Photo Takashi Otaka. **136** Eduardo Kac, *Teleporting an Unknown State*, 1994–6. Interactive biotelematic work on the internet. Courtesy Julia Friedman Gallery, Chicago. **137** Masaki Fujihata, *Light on the Net*, 1996. Interactive digital sculpture and website. Masaki Fujihata, Keio University and Softopia, Gifu. **138** Eduardo Kac, *Uirapuru*, 1996–9. Interactive telepresence work on the internet. Courtesy Julia Friedman Gallery, Chicago. **139** Eduardo Kac, *Rara Avis*, 1996. Interactive telepresence work on the internet. Courtesy Julia Friedman Gallery, Chicago. **140** Eric Paulos and John Canny, *PRoP*, 1997–present. One of several different versions (1997–2002) of a Personal Roving Presence (PRoP) system enabling remote tele-embodiment, www. prop.org. **141** ParkBench (Nina Sobell and Emily Hartzell), *VirtuAlice: Alice Sat Here*, 1995. Interactive robotic installation. David Bacon, Fred Hansen, Toto Paxia. Thanks to NYU CAT LAB. **142** Adrianne Wortzel, *Camouflage Town*, 2001. Telerobotic installation. Commissioned by the Whitney Museum of American Art. Developed at

The Cooper Union for the Advancement of Science and Art with a grant from the National Science Foundation (Grant No. DUE 9980873) and support from the NSF Gateway Engineering Education Coalition at Cooper Union. **143** Lynn Hershman, *Tillie, the Telerobotic Doll*, 1995–8. Interactive robotic installation and website. Courtesy of Lynn Hershman. **144** Steve Mann, *Wearable Wireless Webcam*, 1980–present. Wireless telepresence device and website. **145** Tina LaPorta, *Re:mote_corp@REALities*, 2001. Website. **146** Stelarc, *Exoskeleton*, 1999. Event for extended body and walking machine. Cyborg Frictions, Dampfzentrale Bern, 1999. Robot Construction, F18, Hamburg, programming, Lars Vaupel. Sponsored by SMC Pneumatics (Australia and Germany). Photo Dominik Landwehr. **147** Stelarc, *Ping Body*, 1996. Internet activated/internet uploaded. 'Digital Aesthetics', Artspace, Sydney, 10 April 1996. Diagram, Stelarc, sound design, Rainer Linz, Melbourne, internet software interface, Gary Zebington, Dimitri Aronov and the Merlin Group, Sydney. **148** Victoria Vesna, *Bodies, Inc*, 1995. Interactive website. Courtesy of Victoria Vesna. **149** Monika Fleischmann, Wolfgang Strauss, and Christian-A Bohn, *Liquid Views*, 1993. Interactive digital sculpture. Christian-A Bohn. **150** Eduardo Kac, *Time Capsule*, 1997. Interactive biotelematic work on the internet and live television. Courtesy Julia Friedman Gallery, Chicago. **151** Stahl Stenslie, *The First Generation Inter_Skin Suit*, 1994. Interactive installation. © Stahl Stenslie, 1994. **152** Kazuhiko Hachiya, *Inter Discommunication Machine*, 1993. Interactive installation. Photo Kurokawa Mikio. **153** Scott Snibbe, *Boundary Functions*, 1998. Interactive installation. Photo courtesy of Scott Snibbe. **154** Marek Walczak and Martin Wattenberg, *Apartment*, 2001. Interactive digital installation. By Marek Walczak and Martin Wattenberg with additional programming by Jonathan Feinberg. **155** Benjamin Fry, *Valence*, 1999. Data-visualization software. MIT Media Laboratory, Aesthetics + Computation Group © 1999–2003. **156** W. Bradford Paley, *TextArc*, 2002. Data-visualization software. www.textarc.org. **157** George Legrady, *Pockets Full of Memories*, 2001. Installation and website, Centre Pompidou, Paris, 2001. Photo George Legrady http:// pocketsfullofmemories.com. **158a** Alex Galloway and RSG, *Carnivore: amalgatmosphere*, 2001–present. Data-visualization software. Courtesy of Josh Davis and Alex Galloway. **158b** Alex Galloway and RSG, *Carnivore: Black and White*, 2001–present. Data-visualization software. Courtesy of Mark Napier and Alex Galloway. **158c** Alex Galloway and RSG, *Carnivore: Guernica*, by Entropy8Zuper!, 2001–present. Data-visualization software. Courtesy of Entropy8Zuper! (Michaël Samyn and Auriea Harvey), http://entropy8zuper.org/ guernica, and Alex Galloway. **159** Lisa Jevbratt/C5, *1:1*, 1999–2001. Data-visualization software. Courtesy of Lisa Jevbratt/C5. **160** Nancy Paterson, *Stock Market Skirt*, 1998. Multimedia sculpture. Courtesy of the artist. **161** John Klima, *ecosystm*, 2000. Data-visualization software. Courtesy of Postmasters Gallery New York. **162** Lynn Hershman, *Synthia*, 2001.

Multimedia sculpture. Courtesy of Lynn Hershman. **163** ART+COM, *TerraVision*, 1994–present. Visual presentation, ART+COM AG, since 1994. **164** John Klima, *Earth*, 2001. Geo-spatial visualization system. Courtesy of Postmasters Gallery, New York. **165** ART+COM, *Ride the Byte*, 1998. Interactive installation, ART+COM, AG, 1998. **166** Warren Sack, *Images from the Conversation Map*, 2001–present. Communication mapping browser. © 2001 Warren Sack. **167** Fernanda Viégas and Martin Wattenberg, *Many Eyes: Treemap*, 2007. Interactive website. Courtesy of Fernanda Viégas and Martin Wattenberg (IBM Many Eyes). **168** Masaki Fujihata, *Beyond Pages*, 1995. Interactive installation. Courtesy of Masaki Fujihata. **169** Camille Utterback and Romy Achituv, *Text Rain*, 1999. Interactive installation. **170** John Maeda, *Tap, Type, Write*, 1998. Reactive graphics. Courtesy of the artist. **171** David Small, *Talmud Project*, 1999. Virtual reading space. **172** David Small and Tom White, *Stream of Consciousness/Interactive Poetic Garden*, 1998. Multimedia installation. © Webb Chappell. **173** Harwood, *Rehearsal of Memory*, 1996. CD-ROM. Courtesy of Harwood. **174** Noah Wardrip-Fruin, Josh Carroll, Robert Coover, Andrew McClain, and Ben 'Sascha' Shine, *Screen*, 2002–present. Collaborative playable media project. Courtesy of Noah Wardrip-Fruin, Josh Carroll, Robert Coover, Andrew McClain and Ben 'Sascha' Shine. **175** Natalie Bookchin, *The Intruder*, 1999. Online game. © Natalie Bookchin. **176** Natalie Bookchin, *Metapet*, 2002. Online game. © Natalie Bookchin. **177** Cory Arcangel, *Super Mario Clouds*, 2002–present. Handmade hacked Super Mario Brothers cartridge and Nintendo NES video game system, dimensions variable. Courtesy of Cory Arcangel. © Cory Arcangel. **178** jodi, *SOD*, 1999. Online game. Courtesy of jodi. **179** Feng Mengbo, *Q4U*, 2002. Online game. Courtesy of the artist. **180** Anne-Marie Schleiner, Joan Leandre, and Brody Condon, '*Shoot Love Bubbles*' from *Velvet-Strike*, 2002. Online game. **181** Josh On, *They Rule*, 2001. A map by a visitor to www. theyrule.net, which allows users to make maps of the interconnecting directories of the 2001 Fortune 100 companies. **182** Antonio Muntadas, *The File Room*, 1994. Installation at the Chicago Cultural Center, Chicago. **183** etoy, *Share-certificates*, etoy CORPORATION, 1999, etoy CORPORATION, #124. Courtesy of etoy. SHAREHOLDER Richard Zach. **184** 0100101110101101.org, http://0100101110101101.org, 2002. No Copyright 2002 0100101110101101.org. **185** Eduardo Kac, *Genesis*, 1999. Interactive transgenic work on the internet. Courtesy Julia Friedman Gallery, Chicago. **186** Natalie Jeremijenko, *OneTrees*, 2000. Cloned tree installation. **187** Marina Zurkow, Scott Paterson and Julian Bleecker, *PDPal*, 2003. Quicktime movie on Panasonic Astrovision screen, Times Square, New York. Courtesy of the artists. Photo © 2003 Cameron Wittig. **188** Q.S. Serafin with Lars Spuybroek, *D-Toren (D-tower)*, 1998–2004. Illuminated epoxy structure, questionnaire and website. Courtesy of the artists. **189** Julian Bleecker, *WiFi.ArtCache*, 2003. Custom device hardware and digital media. © 2003

Julian Bleecker, nearfuturelaboratory.com. **190** Teri Rueb, *Core Sample*, 2007. GPS-based interactive sound walk (Spectacle Island, Boston Harbor), with corresponding sound sculpture (ICA Boston, Founders Gallery), 1200 × 40 (304.8 × 101.6), aluminium, steel, electric components. Sound design Ean White and Peter Segerstrom. Courtesy of the artist. **191** C5, *Landscape Initiative*, 2001–present. Media installation involving information visualization, database processing, sculpture and video projection. C5 Corporation: Joel Slayton, Amul Goswamy, Geri Wittig, Brett Stalbaum, Jack Toolin, Bruce Gardner and Steve Durie. **192** Usman Haque, *Sky Ear*, 2004. Helium balloons, infra-red sensors and LEDs. Usman Haque/Haque Design + Research Ltd. **193** Rafael Lozano-Hemmer, *Amodal Suspension*, 2003. Project for the opening of the Yamaguchi Center for Art and Media, Japan, featuring robotically controlled searchlights, mobile devices and website, accessible at www.amodal.net. Photo Archi Biming. **194** Giselle Beiguelman, *Sometimes Always/Sometimes Never*, 2005. Cell phone, Bluetooth, screen, variable dimensions. Courtesy ZKM (Media Museum). www.desvirtual.com. **195** Jenny Marketou, *Flying Spy Potatoes: Mission 21st Street*, Public Game, Poster with Super Agents, Eyebeam, 2005. Photos from Public Game with inflated red weather balloon and wireless spy cams. Poster design Nunny Kim. Courtesy of the artist. **196** Michelle Teran, *Life: A User's Manual (Berlin Walk)*, 2003. Video scanner, battery, antenna, found materials. Commissioned for the Transmediale05 Festival. **197** Michelle Teran, *Life: A User's Manual (Linz Walk)*, 2005. Video scanner, battery, antenna, found materials. Commissioned for the Ars Electronica Festival, 2005. **198** Ricardo Miranda Zúñiga, *Public Broadcast Cart*, 2003–6. Shopping cart outfitted with a dynamic microphone, mixer, amplifier, six speakers, mini FM transmitter and laptop with wireless card. Produced by Ricardo Miranda Zúñiga, funded by the Franklin Furnace and supported by thing.net. **199** Marko Peljhan, *Makrolab*, markIIex Campalto Operations, Venice Biennale, Campalto Island, Venice, June to November 2003. Mobile performance and tactical media environment. Courtesy of the artist. **200** Natalie Jeremijenko, *The Antiterror Line*, 2003–4. Networked microphones and database. Courtesy of the artist. **201** Konrad Becker and Public Netbase with Pact System, *System-77 CCR*, SPECTRAL-SYSTEM TYO ON 2005, Open Nature, NTT-ICC, Tokyo, 2005. Surveillance and tracking technologies. Courtesy of the artists. **202** Preemptive Media, *Zapped!*, 2006. Workshops, devices and activities. Courtesy of the artists. **203** Eric Paulos, *Participatory Urbanism*, 2006–present. Networked mobile personal measurement instruments. Courtesy of the artist. **204** Gabriel Zea, Andres Burbano, Camilo Martinez and Alejandro Duque, *BereBere*, 2007. Wireless device, video and audio systems, sensors, GPS. Courtesy of the artists. **205** Beatriz da Costa with Cina Hazegh and Kevin Pronto, *PigeonBlog*, 2006. Hybrid media. Courtesy of the artists. Photo © Susanna Frohman/San Jose Mercury News. All rights reserved. **206** Camille Utterback, *Abundance*, 2006.

Interactive installation. Commissioned for the City of San Jose, CA by ZERO1. Courtesy of Camille Utterback. Photo Lane Hartwell. **207** Rafael Lozano-Hemmer, *Voice Tunnel*, 2013. Large-scale interactive installation. Commissioned by Park Avenue Tunnel, NYC DOT 'Summer Streets', New York. Photo James Ewing. **208** Marie Sester, *ACCESS*, 2003. Public art installation, internet, computer, sound and lighting technologies. Ars Electronica, Linz, Austria. Photo Marie Sester. **209** Aram Bartholl, *Dead Drops*, 2010–present. Offline, peer to peer file-sharing network in public space. Courtesy DAM Gallery, Berlin and XPO Gallery, Paris. **210** John Craig Freeman, *Orators, Rostrums, and Propaganda Stands*, 2013. Augmented reality public art, Los Angeles County Museum of Art, California. Courtesy of the artist. **211** Will Pappenheimer and John Craig Freeman, *SFMOMA AR*, 2013. Augmented reality installation, re-imagining the Snøhetta Architect's museum expansion at San Francisco Museum of Modern Art. Screenshot collage. Courtesy of the artists. **212** Manifest.AR, *We AR in MoMA*, 2010. Uninvited augmented reality intervention at the Museum of Modern Art, New York. Courtesy Manifest.AR. **213** Tamiko Thiel, *Shades of Absence: Public Voids*, 2011. Augmented reality intervention, Venice Biennale, Piazza San Marco. © Tamiko Thiel. **214** Blast Theory, *Can You See Me Now?*, 2001–present. Interactive installation. © Blast Theory. **215** Golan Levin with Kamal Nigam and Jonathan Feinberg, *The Dumpster*, 2006. Interactive online Java applet, 640 × 480 pixels. Courtesy of the artists, Whitney Artport and Tate Online. **216** Antonio Muntadas, *On Translation: Social Networks*, 2006. Mixed media, variable dimensions. Courtesy of the artist (in collaboration with CADRE SJSU). **217** Warren Sack, *Agonistics: A Language Game*, 2005. Jpeg screenshot. Courtesy of the artist. **218** Annina Rüst, *Sinister Social Network*, 2006. Web, IRC, and VoIP Software Art and Installation. Courtesy of the artist. **219** Angie Waller, *myfrienemies.com*, 2007. Screen capture, website. Courtesy of the artist. **220** Paolo Cirio and Alessandro Ludovico, *Face to Facebook*, 2011. Mixed media, dimensions variable. Courtesy of the artists. **221** Ben Grosser, *Facebook Demetricator*, 2012–present. Web browser extension. Courtesy Ben Grosser. **222** Joe Hamilton, *Hyper Geography*, 2011. Website and video. Courtesy of the artist. **223** Scott Snibbe, *Philip Glass REWORK_APP*, 2012. Motionphone app for iPad. Courtesy Scott Snibbe. **224** Donato Mancini and Jeremy Owen Turner, with Patrick 'Flick' Harrison (536 Arts Collective), *AVATARA: Portrait of VanGo at Baby's Pool*, 2003. DVD, 72 minutes. **225** Donato Mancini and Jeremy Owen Turner, with Patrick 'Flick' Harrison (536 Arts Collective), *AVATARA: Fast Eddie Interviewed by Kalki at the Ozgate Entrance*, 2003. DVD, 72 minutes. **226** Eva and Franco Mattes aka 0100101110101101.org, *Annoying Japanese Child Dinosaur, Tohru Kanami*, 2006. Digital print on canvas, 91.4 × 121.9 (36 × 48). Courtesy of the artists. **227** Eva and Franco Mattes aka 0100101110101101.org, *13 Most Beautiful Avatars, Nyla Cheeky*, 2006. Digital print on canvas, 91.4 × 121.9 (36 × 48). Courtesy of the artists. **228** Will Pappenheimer and

John Craig Freeman, *Virta-Flaneurazine-SL ©*, 2007. Digital still, 1425 × 1012 pixels. Will Pappenheimer and John Craig Freeman, Rhizome Commissions 2007. **229** Goldin + Senneby, *Objects of Virtual Desire: Jade Lily's <3> Choker*, 2005. Choker in oxidized silver with 63 red spinels and green perspex, 11.5 (4½) diameter. Project by Goldin + Senneby, design by Jade Lily, reproduction by Malena Ringsell. **230** Goldin + Senneby, *Objects of Virtual Desire: Cubey Terra's Penguin Ball*, 2005. Inflatable PVC balls with inflatable penguins inside, 200 (78⅝) diameter. Project by Goldin + Senneby, design by Cubey Terra. **231** eteam, *Second Life Dumpster*, 2007. 300 dpi still, 15 × 9.17 (5⅞ × 3⅝). eteam, *Second Life Dumpster* project commissioned by Rhizome Commissions 2007–8. **232** Eva and Franco Mattes aka 0100101110101101.org, *Reenactment of Joseph Beuys' 7000 Oaks*, 2007. Synthetic Performance in Second Life. Courtesy of the artists. **233** Second Front, *Spawn of the Surreal*, 2007. Digital still. Courtesy of the artists. **234** Second Front, *Border Patrol*, 2007. Digital still. Courtesy of the artists, and Marcos Cadioli.

Index